David Milne

WATERCOLOURS

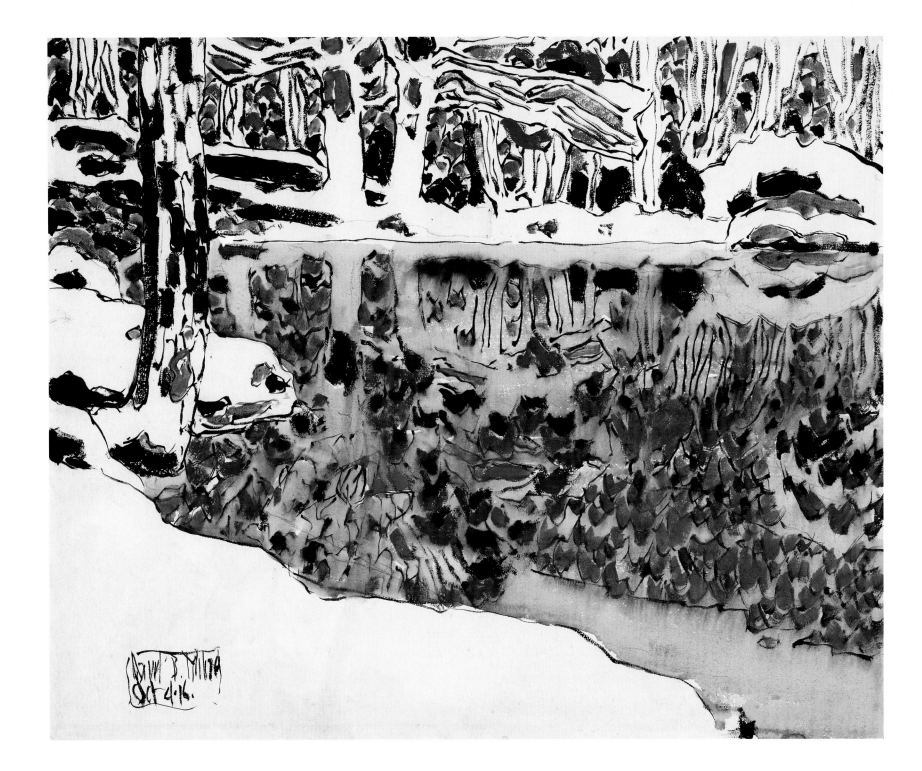

KATHARINE LOCHNAN

David Milne

WATERCOLOURS

"Painting toward the Light"

with contributions by John O'Brian, Dennis Reid,

David P. Silcox, Rosemarie L. Tovell, and Carol Troyen

Art Gallery of Ontario | Douglas & McIntyre

The Art Gallery of Ontario is funded by the Ontario Ministry of Citizenship, Culture, and Recreation. Additional operating support is received from the Volunteers of the Art Gallery of Ontario, Municipality of Metropolitan Toronto, the Department of Canadian Heritage, the Canada Council, and from Gallery members and many corporations, foundations, and individuals.

The exhibition and publication are supported at the Art Gallery of Ontario by the Department of Canadian Heritage Museums Assistance Program.

This book is published on the occasion of *David Milne Watercolours: "Painting toward the Light,"* the exhibition organized and circulated by the Art Gallery of Ontario.

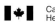 Canadian Heritage Patrimoine canadien

Library and Archives Canada
Cataloguing in Publication

Milne, David, 1882–1953.

David Milne watercolours : "painting toward the light" / Katharine Lochnan ; with contributions by John O'Brian . . . [et al.].

Includes bibliographical references and index.

Watercolour paintings by David Milne to coincide with exhibitions held at the British Museum, London, July 7–Sept. 25, 2005, the Metropolitan Museum of Art, New York, Nov. 8, 2005–Jan. 29, 2006, and the Art Gallery of Ontario, Toronto, Feb. 25–May 21, 2006.

ISBN 1-55365-100-6 (bound)
ISBN 1-55365-133-2 (pbk.)

1. Milne, David, 1882–1953. I. Lochnan, Katharine A. (Katharine Aileen), 1946– II. O'Brian, John, 1944– III. British Museum IV. Metropolitan Museum of Art (New York, N.Y.) V. Art Gallery of Ontario VI. Title. VII. Title: Watercolours. VIII. Title: Painting toward the light.

ND1843.M55A4 2005 759.11
C2004-907153-X

Library of Congress information is available on request.

The quotation "Painting toward the Light" is from David Milne's manuscript notes known as the A.B. Outline (1947), Milne Papers, Library and Archives Canada, Ottawa.

Design by Timmings & Debay
Editing by Alison Reid
Index by Edna Barker

Cover illustrations (front): *Dark Shore Reflected, Bishop's Pond* (detail), c. October 1920 (cat. 50), watercolour over graphite on wove paper, 36.8 × 54.5 cm, The Thomson Collection (PC-265); (back): Milne in a tweed cap (detail), c. 1942, in his Uxbridge studio, photo by Douglas Duncan, Milne Family Collection

Frontispiece: *Bishop's Pond*, October 4, 1916 (cat. 24), watercolour over graphite on wove paper, with watercoloured wove paper overlay, 44.2 × 54.2 cm, National Gallery of Canada, Ottawa, purchased 1955 (6380r)

Printed and bound in Canada by Friesens
Printed on acid-free paper
Distributed in the U.S. by Publishers Group West

Douglas & McIntyre gratefully acknowledges the financial support of the Canada Council for the Arts, the British Columbia Arts Council, and the Government of Canada through the Book Publishing Industry Development Program (BDIDP) for our publishing activities.

All dimensions of works of art are given in centimetres, height preceding width.

Art Gallery of Ontario
317 Dundas Street West
Toronto, Ontario, Canada M5T 1G4
www.ago.net

Douglas & McIntyre Ltd.
2323 Quebec Street, Suite 201
Vancouver, B.C., Canada V5T 4S7
www.douglas-mcintyre.com

Contents

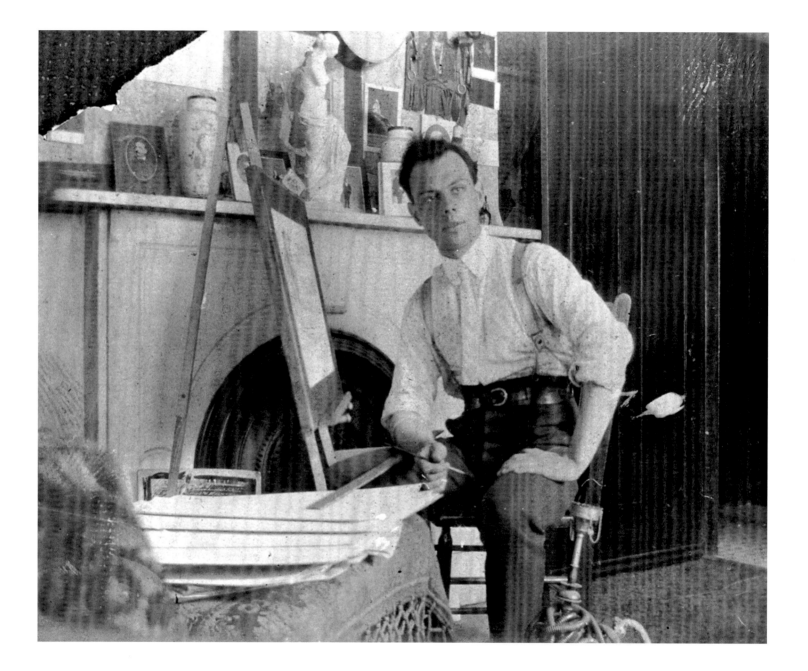

Milne in his New York studio, 20 East Forty-second Street, c. 1909, gelatin silver photograph,
Library and Archives Canada, Ottawa, David Brown Milne collection (C-057194)

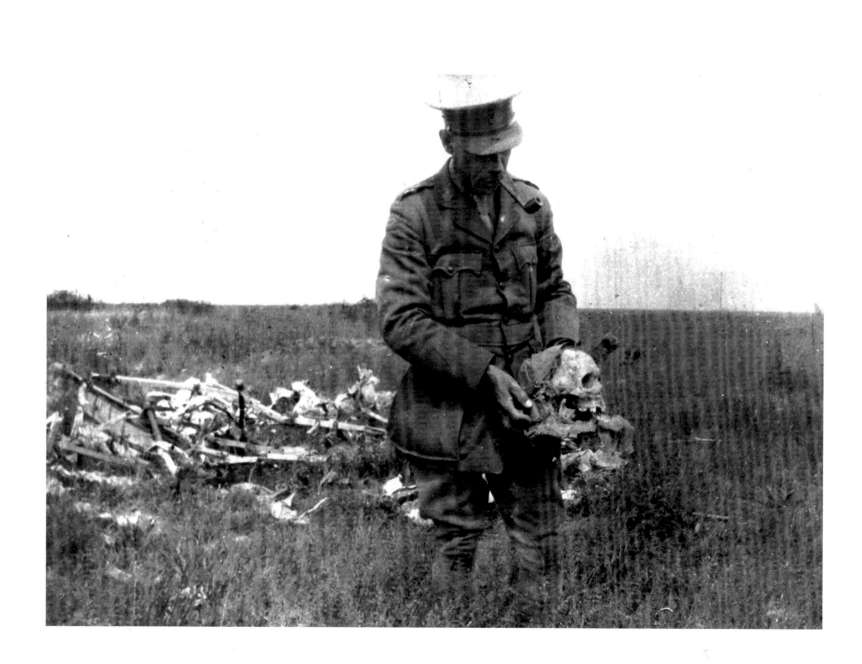

Milne on the battlefields of France or Belgium, contemplating a skull, undated, 12.3 × 17.5 cm,
Library and Archives Canada, Ottawa, David Brown Milne collection (C-057164)

Director's Foreword

David Milne has long been considered one of Canada's leading artists. Despite the fact that his paintings and prints were also well received in the United States during the first two decades of the twentieth century, this is the first exhibition devoted to his work to be presented by major institutions outside Canada. Thanks to the enthusiasm of Frances Carey, Assistant to the Director at the British Museum, who acquired three watercolours by Milne while she was the Deputy Keeper of Prints and Drawings, and William S. Lieberman, Jacques and Natasha Gelman Chairman Emeritus and Special Consultant to Modern Art, Department of Nineteenth-Century, Modern, and Contemporary Art, Metropolitan Museum of Art, New York, Milne is finally receiving the attention he deserves. Their museums are fitting venues as they were among his favourites.

This new look at Milne's artistic contribution in an international context has been facilitated by the publication of both a biography and a catalogue raisonné in recent years. The result of decades of research, *Painting Place: The Life and Work of David B. Milne* by David P. Silcox appeared in 1996, and *David B. Milne: Catalogue Raisonné of the Paintings* by David Milne Jr. and David P. Silcox was published in 1998. These milestones in Milne literature have been indispensable to our research, and the gracious advice and support of their authors has enabled us to realize this project.

This exhibition, would, of course, have been impossible without lenders who share our desire to bring some of David Milne's finest work to international attention. Watercolours are extremely light sensitive, and over time many of Milne's intense colours, especially his blues, have faded, but we have chosen to exhibit, for the most part, works that survive in pristine condition. The largest group of loans comes from the National Gallery of Canada, whose unrivalled holdings are due in part to gifts made by Milne's distinguished patron Vincent Massey and in part to the transfer of work from the Canadian War Memorials. The second-largest group of loans is from the Milne family, and we are especially appreciative of David Milne Jr.'s enthusiastic support of the project. We would like to thank the other institutional lenders, as well: the Agnes Etherington Art Centre, Queen's University, Kingston, Ontario; the Art Gallery of Greater Victoria; the Art Gallery of Hamilton; the Art Gallery of Windsor; the Art Gallery of York University, Toronto; the British Museum, London, England; Museum London, London, Ontario; the Museum of Modern Art, New York; and Victoria University in the University of Toronto. We are grateful to our private lenders,

Dr. Peter Chan and Mrs. Debbie MacKinnon-Chan, Jim Coutts, Mira Godard, Byrne and Laura Harper, Mr. and Mrs. J. Hill, Mucie and Ron Kaplansky, Greg Latremoille, and the Thomson Collection. Accepting the absence of their Milne works for over a year signals our lenders' generosity. The presentation of this exhibition at the Metropolitan Museum of Art in New York is generously supported by Rosamond Ivey, and we appreciate her contribution.

I would like to recognize Dr. Katharine Lochnan, Senior Curator and the R. Fraser Elliott Curator of Prints and Drawings, for her role in organizing this exhibition. She has collaborated with Frances Carey, William Lieberman, and our Chief Curator, Dennis Reid, to develop the concept and list of contents. As well, she has assembled the scholarly team of catalogue contributors and edited the publication.

Although David Milne also used oil and drypoint, his work in watercolour received the early recognition that launched his career and was central to his work in other media: his personal papers record his struggle to find ways of adapting ideas he developed in watercolour to oil on canvas and to coloured drypoint. David Milne's works on paper, filled with vivid hues in uniquely pleasing combination and with expressive line, are magical, and we are pleased to celebrate his achievement on the world stage.

Matthew Teitelbaum, Director and CEO, Art Gallery of Ontario

Acknowledgments

A major exhibition designed to raise the profile abroad of David Milne, one of Canada's most accomplished and respected artists, is long overdue. Unlike his work in oil and coloured drypoint, the watercolours, central to his artistic production, have not been examined in depth. This project, with that objective, arose from the conviction of Frances Carey at the British Museum, William S. Lieberman at the Metropolitan Museum of Art, and my colleagues at the Art Gallery of Ontario and I that it was time knowledge and appreciation of Milne's work in watercolour be spread to the United States and Britain, both of which played an important role in his artistic development.

Following her trips to Canada in the 1980s and 1990s, Miss Carey began to build a collection of Canadian drawings for the British Museum, and her admiration for Milne led to the acquisition of the first of his watercolours for a British public collection. Her enthusiasm was preceded by that of William S. Lieberman, who, while he was Curator of Prints and Drawings at the Museum of Modern Art, acquired the first and only Milne watercolour to enter a public collection in the United States.

David Milne lived outside Canada from 1903 to 1929. By bringing together specialists in American, Canadian, and European art, we have considered his work from both international and Canadian perspectives. Carol Troyen, John Moors Cabot Curator of American Paintings at the Museum of Fine Arts, Boston, has written about Milne's time in the United States, I have approached his work in relation to certain influential European artists, and Rosemarie Tovell, Curator of Canadian Prints and Drawings, National Gallery of Canada, and Dennis Reid, Chief Curator, Art Gallery of Ontario, have looked at Milne's work in a Canadian context. John O'Brian, Professor of Art History, University of British Columbia, has considered his discursive engagement with modernism. We are grateful to the authors not only for their contributions but for sharing their expertise through critical readings of one another's essays, my own included.

This project owes much to the groundbreaking publications, the advice and assistance of David Silcox and David Milne Jr. David Silcox made an initial selection of approximately three hundred watercolours and worked with Frances Carey and me to make a final selection. On visits to the National Gallery, the Milne family, and other public and private collections, Miss Carey and I continued to refine the list in consultation with David Silcox and David Milne Jr. We can't thank them enough for their essential contribution to the selection process and for their expertise, enthusiasm, generosity, and hospitality.

The authors would like to express their individual appreciation: Rosemarie Tovell to Laura Brandon, Curator of War Art at the National War Museum, Ottawa; Dennis Reid to John Sabean and Akira Yoshikawa for their help with research on Yoshida Seikido; and John O'Brian to Professor Rose Marie San Juan of the University of London. I would like to thank Marzio Apolloni, Director, Bruce County Public Library; Andrew Armitage, retired Chief Librarian of the Owen Sound Public Library, and his successor, Judy Armstrong; Bill Dennenbaum, Executive Director, Lake Placid–North Elba Historical Museum; Barbara Ribey and her staff at the Bruce County Museum and Archives; Kim Sloan, Assistant Keeper of Prints and Drawings, British Museum; Roberta Waddell, Curator of Prints, James Moske, Archivist, and Daniella Romano, Archival Intern, at the New York Public Library; Ian Warrell, Senior Curator of British Art, Tate Collections, and Matty Watton, formerly of the National Gallery Library, in London.

At the British Museum, Antony Griffiths, Keeper of Prints and Drawings, and Felicity Kerr, Curatorial Assistant, Modern Collection, Prints and Drawings Department, and at Metropolitan Museum of Art, Nan Rosenthal, Senior Consultant, and Lisa Messinger, Associate Curator, both of the Department of Nineteenth-Century, Modern, and Contemporary Art, have brought this exhibition to fruition in London and New York. We are also indebted to the staff of the Art Gallery of Ontario for the organization of the exhibition and publication.

They include Laura Brown, Curatorial Assistant, Chief Curator's Office, who assembled the manuscript, photographs, and figures; Georgiana Uhlyarik, for final publication coordination; Cindy Hubert, Manager, Exhibitions and Travelling Exhibitions, and Iain Hoadley, Manager, Exhibitions and Photographic Resources, who handled the organizational aspects of the exhibition; Brenda Rix, Assistant Curator of Prints and Drawings, who looked after the loan agreements, and Randall Speller, Documentalist in the E.P. Taylor Reference Library, who suggested valuable reference sources. We would also like to thank George Bartosik, Manager, Exhibition Services, and his staff; Lise Hosein, Administrative Assistant, Prints and Drawings; Dale Mahar, Traffic Coordinator; Sean Weaver, Photographer; Sherri Somerville, Assistant Manager, Design Studio; Curtis Strilchuk, Exhibitions Registrar; Joan Weir, Conservator, Works on Paper; Akira Yoshikawa, Art Storage Coordinator, Collections; and Zbigniew Gorzelak, Art Storage Assistant, Collections. As well, we are grateful to Mark Timmings, the designer, and Douglas & McIntyre for producing this beautiful book, and Alison Reid for editing the text.

Matthew Teitelbaum, Dennis Reid, and I are united in our desire to see the work of David Milne better known in Canada and abroad. We hope that this exhibition will help place Milne on the international map, and give him the attention we feel he so richly deserves when histories of twentieth-century art are amended to include not only Canadian artists but also works on paper.

Katharine Lochnan, Senior Curator and the R. Fraser Elliott Curator
of Prints and Drawings, Art Gallery of Ontario

Milne in his Six Mile Lake cabin (detail), 1938, with *The Yellow Coat* on the easel,
photo by Douglas Duncan, Milne Family Collection

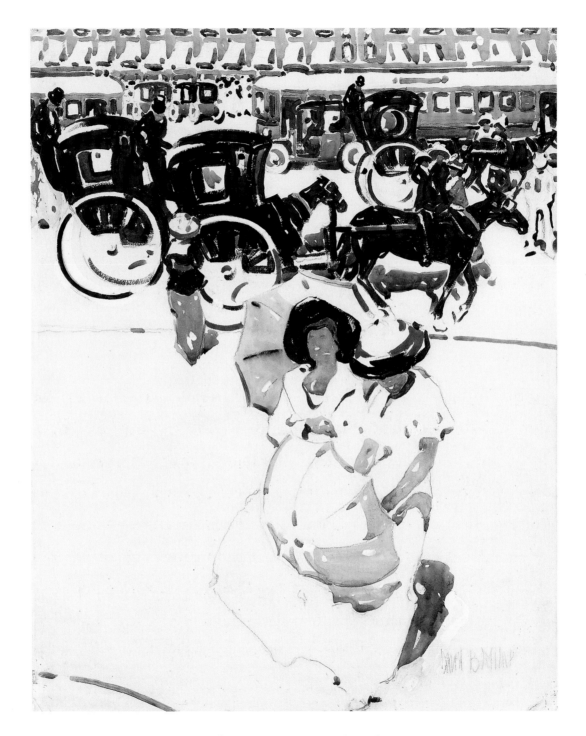

Three Hansoms, c. 1912 (cat. 7)

watercolour over graphite on wove paper, 61.3 × 51.8 cm

Private Collection

"A Welcome and Refreshing Note"
Milne and the New York
Art Scene, 1903–13

CAROL TROYEN

In October 1910, David Milne (or one of his friends) sent a clever story to the papers. "Why shouldn't a half moon be skyed?" ran the headline. "And then again are not autumnal tints on the line?" The article manufactured a friendly rivalry between Milne and his studio mate, Amos Engle, as to whose entry in the New York Water Color Club annual exhibition would be the more successful. The two men, "hosts to nightly gatherings of other artists and art 'appreciators,'" are portrayed as the centre of a community of young painters eager to make names for themselves in New York. Each had backers who placed bets on whether Milne's *Autumnal Tints in Bronx Park* or Engle's *The Half Moon at Night* would be hung more advantageously at the show. In the end, "Milne's 'Autumnal Tints' is unsold, though hung on the line, while

Engle's 'Half Moon,' though skyed, has been sold and he has the cash. Now which is better, a skyed half moon that brings the gold or Autumnal tints on the line that doesn't?"[1]

The article is full of amusing word play, jabs at art establishment practices and, above all, the sense of what fun it was to be a young artist in New York. It was also almost certainly a fabrication. Although Milne and Engle did hold "nightly gatherings," neither artist submitted such works that year, and neither succeeded in selling anything. Designed to get their names before the public, the account of their hijinks portrays Milne and Engle as up-and-coming and as bursting with energy, spirit, and potential.

This sort of self-promotion, long a tradition among New York painters, recently had been honed to a fine art by Robert Henri and his colleagues, who made themselves into Davids confronting the National Academy's Goliath in order to launch a group show—the now-famous exhibition of the Eight—held at Macbeth Gallery in 1908.[2] The photographer Alfred Stieglitz was equally enterprising, frequently publishing in his magazine, *Camera Work*, admiring reviews of the shows he staged at his Little Galleries of the Photo-Succession, known as 291. The "Half Moon" story was one of several attempts Milne would make over the years to draw attention to his work. He was not especially successful, and when he left New York City in 1916, he remained a peripheral figure in its artistic community. Whether or not the "Half Moon" episode had any effect on Milne's reputation, it did, uncannily, predict the course of his career in New York. While he would sell little, the watercolours he exhibited would generally be seen as "deserving of special mention . . . a welcome and refreshing note."[3]

The world Milne sought to break into was dominated by such larger-than-life personalities as William Merritt Chase and Childe Hassam on the one hand—establishment figures for whom painting was as much a social and entrepreneurial as an æsthetic occupation—and Stieglitz and Henri on the other—impresarios of the avant-garde who inspired passionate copy in the press and gathered around them a devoted band of younger artists. Milne was aware of them all, but at a distance. Twenty-eight years old in 1910, Milne was of the same generation as Marsden Hartley, Arthur Dove, and Georgia O'Keeffe, the artists who would form Stieglitz's inner circle; he seems not to have known them. Nor does he seem to have approached Stieglitz about his own work. He was ten to fifteen years younger than Henri's devotees, John Sloan, George Luks, and others. Although he admired Henri's dynamism and occasionally exhibited alongside Luks and Sloan at the watercolour annuals, he was not attracted to what he amusingly called Henri's "Salvation Army in paint," the "Hallelujah, I'm a Bum" aspect of their subject matter or their rollicking Hell's Kitchen life-styles.[4] Rather, in the early teens Milne planted himself in the middle of the road. This probably reflected both opportunity and preference. He first set his sights on exhibitions at the National Academy, the most establishment of venues, and when he was not successful he turned to the more accepting watercolour shows.[5] There his submissions generally conformed to the urban-genteel subjects for which Chase, Hassam, Maurice Prendergast, and others of the older generation were known, and which had been the mainstay of the annuals since the 1890s. At the same time, his watercolours were more forward-looking in style, as reviewers were quick to notice.

By background and training Milne was both an outsider and a fellow traveller. He attached himself neither to the establishment nor to those pushing hard against it, retaining a commitment to traditional subject matter while stylistically striving toward the modern. He claimed to have had little exposure to art in his birthplace near Paisley, Ontario, and what he knew was conventional and old-fashioned.[6] His assessments of his early pictures — preserved in his 1947 autobiographical notes — are modest to the point of being self-deprecating. ("They were nowhere as good as the children's art we see nowadays.") But he also reveals an independent streak, an impatience with traditional art education ("Drawing was the only subject I ever failed in at public school, perspective and copying never seemed interesting").[7] While these childhood memories are probably accurate, they also echo the dearly held romantic myth of the self-made artist, the untutored genius who emerges from unpromising beginnings. This myth was given a modernist twist by Stieglitz, who promoted his two favourites, John Marin and Georgia O'Keeffe, as "naturals." They were true artists, he proclaimed, because their development was corrupted by neither academic training nor foreign styles, and because they took their strength directly from the American landscape.[8] Milne similarly emphasizes his dedication to art despite isolation and discouragement, while quietly implying that his career was not pursued but somehow fated: "I kept up my interest in drawing on my own . . . in all this there was nothing out of the ordinary and I am sure no thought of being a painter." His immigration to New York in 1903 was likewise predestined ("the gravitation of the provinces[?] to the center"). And his characterization

of himself during his first few months there, in which he paid a huge fee to a fly-by-night art school that folded almost immediately thereafter, is of a naïf, a rube.[9]

Milne's real integration into the New York art world began in November 1903, when he enrolled in the Art Students League. As he remembered them, these years were not "one of the Golden Periods of the League" (though his time there coincided with a comeback for the school);[10] he noted that only a few students from his days went on to prominence. In fact, he overlapped with the American abstract painter Andrew Dasburg and with Marin; O'Keeffe enrolled the year after he left. Milne's own career at the League was rather unexceptional. He didn't paint for the first two years, showed only once at student exhibitions, won no prizes, and formed no friendships he thought worthy of mention.[11] He was aware of student activities and describes in particular the escapades of the American Society of Fakirs (a group that parodied the paintings at establishment exhibitions). He found them amusing but didn't join in: "I think my spare time was too much taken up with keeping alive (just)."[12]

Of his instructors at the League, the one who commanded Milne's greatest respect was Henry Reuterdahl, who taught illustration. He worked — as Milne would later — "in oil or gouache with lots of freedom and fluency."[13] Reuterdahl's work appeared not only in the magazines but also in various mainstream watercolour exhibitions; this provided Milne with a model for his own career.

That Milne aspired to be an illustrator by no means meant he was settling for a career of the second rank. Many distinguished nineteenth-century American artists, including Winslow Homer

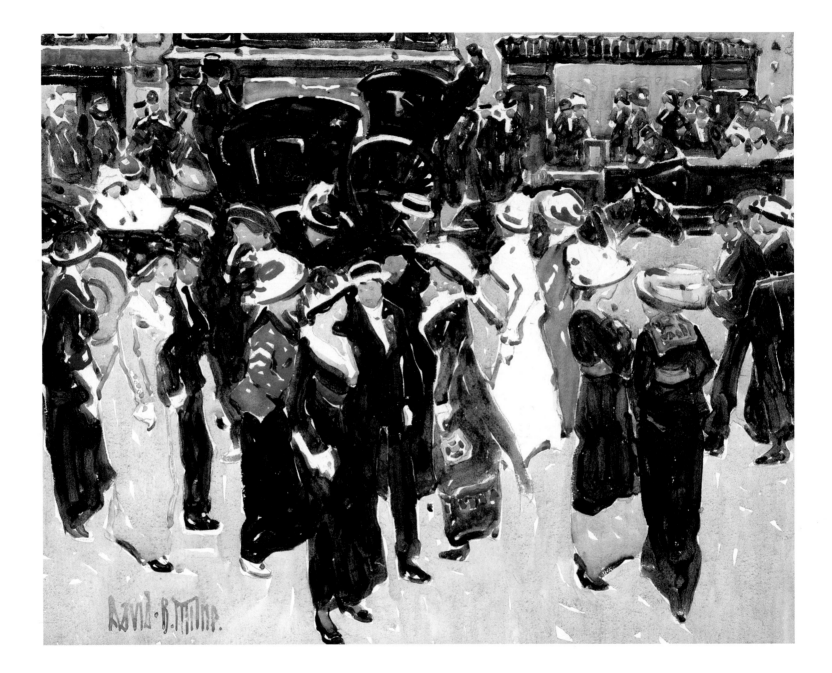

Black and White I, 1911 (cat. 1)

watercolour over graphite on wove paper mounted on illustration board, 46.2 × 58.2 cm

Collection of Byrne and Laura Harper

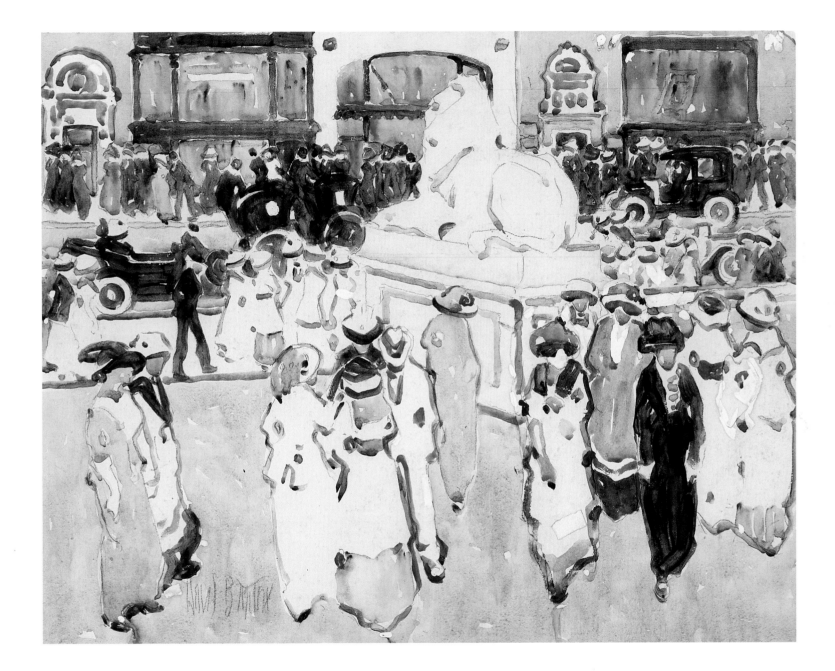

Black and White II, 1911 (cat. 2)

watercolour over graphite on wove paper mounted on illustration board, with watercoloured wove

paper overlays (watermark: "J Whatman"), 45.8 × 57.9 cm, Private Collection, Toronto

and John La Farge, worked as illustrators periodically. Of the artists prominent during Milne's student years, many of the Eight had begun their careers as newspaper illustrators, and several of the leading Impressionists—notably Hassam and Willard Metcalf—also had significant careers as illustrators. Advertising was on the rise, and many young artists recently arrived in New York—Arthur Dove, Edward Hopper, and William Zorach among them—not only contributed to magazines but also made posters and sign cards for shop windows. There was plenty of opportunity in the field.

Milne thus had every reason to expect that working as an illustrator would bring him prominence and a steady income. Yet his career did not flourish. He wrote to Patsy Hegarty, his future wife, of his frustrations in getting his drawings right, of slow sales, of having to redo designs to satisfy editors and especially of his discomfort in soliciting commissions. He made little money—frequently no more than $3 a week—and even the job that seemed like a bonanza, his sale in 1908 of five illustrations to *Cosmopolitan* magazine for a total of $75, ended in frustration, for the images were never published.[14]

Almost from the beginning, Milne enjoyed better success in the exhibition arena. In 1909 his pastel *Classon Point Road* (location unknown) was accepted at the annual exhibition of the American Water Color Society (which then showed drawings, etchings, and pastels as well as watercolours) and aggressively priced at $85. It didn't sell, but that didn't dissuade Milne from pricing the next year's entries to the Society's show at $100 and $125 (his teacher, Reuterdahl, had a watercolour in the show for $75). That same year,

he had three works accepted by the New York Water Color Club and one by the Philadelphia Water Color Club. While the Philadelphia entry was described as "clever, if bilious," the pictures at the New York show were praised for being "impressionistic in handling and brilliantly colored."[15] Shortly thereafter, the Philadelphia picture, *The Defiant Maple* (fig. 1), sold, together with a watercolour, for $45.[16] But $45 for two pictures was better than $75 for five; even back-handed praise from the press was better than dealing with dyspeptic editors. Milne soon abandoned his career as an illustrator and concentrated on the fine arts.

The principal outlets for artists favouring works on paper in the early twentieth century were, first, the annual exhibitions sponsored by the American Water Color Society and its rival, the New York Water Color Club, and second, shows mounted by dealers. The more avant-garde galleries, such as Alfred Stieglitz's 291, maintained a special commitment to works on paper as part of their modernist program of dismantling traditional art hierarchies.[17] Establishment galleries occasionally showed watercolours by their blue-chip artists. Thus, Hassam exhibited watercolours at the N.E. Montross Gallery in 1911 and 1915; Homer's watercolours were shown at Knoedler's, and so on.

Both the American Water Color Society and the New York Water Color Club had annual exhibitions, the former in the spring and the latter in the late fall.[18] For many years the shows were held in the same facility, the American Fine Arts Building, where the Art Students League was also located. The annuals were gargantuan affairs—in 1909, when Milne made his debut with both

organizations, the American Water Color Society presented nearly 600 works by some 250 artists, the New York Water Color Club, more than 350 by nearly 200 artists. They featured a broad range of subjects. There was a preponderance of moody landscapes, sentimental figure subjects, Chase-like still lifes, and views of exotic locales; however, few works depicted the energy of modern urban life. The entries were rendered in a variety of styles, but sketchy, atmospheric pictures tended to be outnumbered by highly finished compositions that were precisely drawn and painted with opaque pigments.

Despite the great achievements of many American watercolour painters, at the turn of the century the medium was still not considered quite of the first rank. It was rarely taught in art schools except in women's classes. It was a medium associated with amateurs and with artists on vacation. What was expected of the medium was spelled out in a review of the well-known painter F. Hopkinton Smith's 1910 watercolour show. The critic enthused that Smith's watercolours were "painted by a man who knows how to seize impressions and how to transfer them to canvas [*sic*], whose heart sings to the tune of joyous summer time in quaint far off and artistic or picturesque lands."[19] Watercolour, in other words, was still regarded as painting lite.

Nonetheless, Milne took the medium seriously. As would O'Keeffe, Marin, Charles Demuth, and others beginning their careers at this time, Milne used watercolour for many of his greatest innovations. He associated it with directness, clarity, and independent expression — in short, with modernism. As he later wrote, "In those days [in New York City] . . . watercolours were regarded

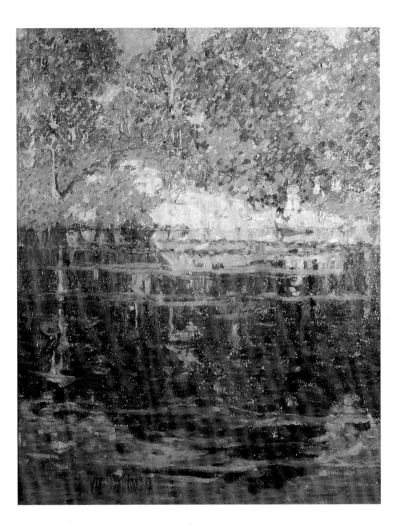

Fig. 1 David Milne, *The Defiant Maple*, 1909–10, M&S 102.54, pastel on paper, 57.8 × 45.8 cm, Private Collection, Toronto

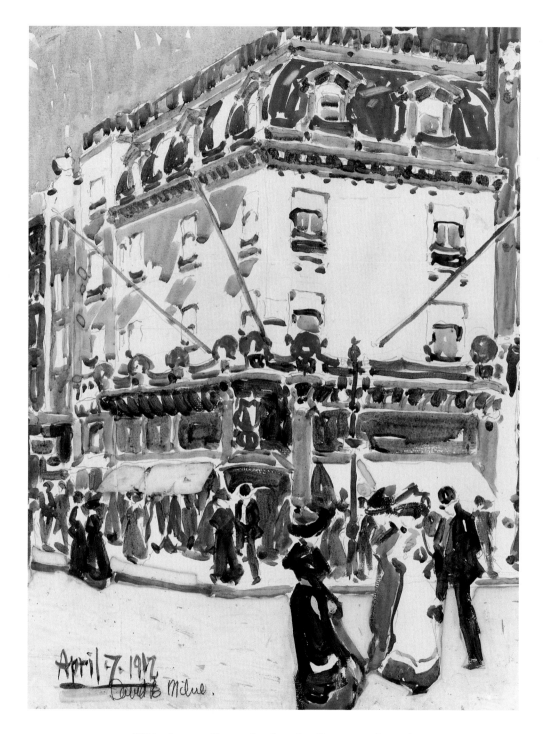

Fifth Avenue, Easter Sunday, April 7, 1912 (cat. 3)

watercolour on illustration board, 57.1 × 43.8 cm

Private Collection

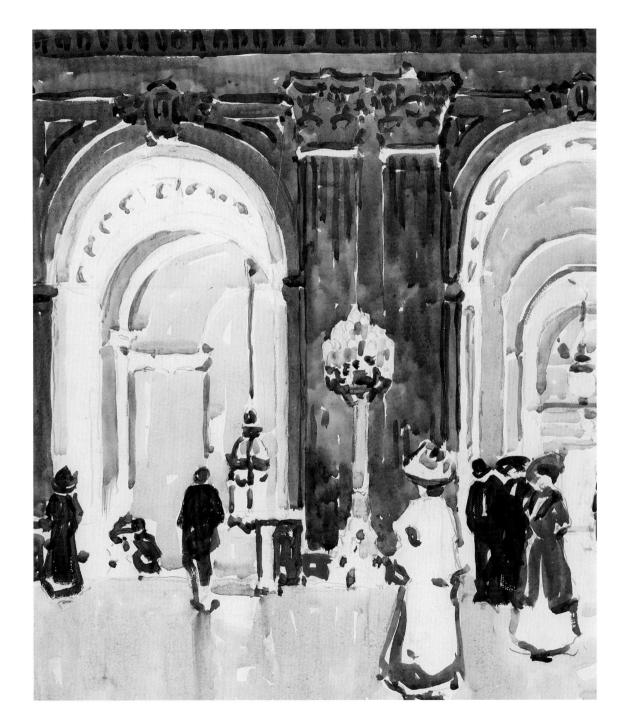

42nd Street Library, c. 1911–13 (cat. 12)

watercolour over graphite on wove paper, 42.9 × 36.5 cm

Milne Family Collection

23

as sketches, not serious painting . . . Exhibition societies, such as the National Academy . . . were not inclined to exhibit anything with even a mild modernist tendency. Their counterparts in the water-colour field . . . were less rigid, admitting pictures that were far from academic, with the soothing reflection that they were only sketches anyway. So the younger painters, anxious to exhibit, leaned more strongly than they otherwise would, to watercolor." Elsewhere he noted, "[Watercolour] is so direct, so powerful, even brutal . . . it should be *the* painting medium because it is faster, and painting is the instantaneous art."[20]

Milne began working seriously in watercolour about 1908-09. In some of the early watercolours, especially those he then selected for exhibition (e.g., *Spuyten Duyvil II*, c. 1910, M&S 103.11, Milne Family Collection) he worked conservatively, in a soft, tonalist man-ner, using layers of transparent washes to suggest atmosphere and pencil line to define shapes. Watercolours like *Hudson River Palisades* (c. 1910, M&S 103.27, private collection, Toronto) are more daring. He painted these pictures out of doors and in them attempted to emu-late the broken brushwork typical of Impressionism. He may have sought reinforcement for these practices in the paintings of Monet, which he saw at Durand-Ruel's New York gallery in 1907. Milne admired the French painter for the "unity of his pictures," whose im-pact was "purely æsthetic, abstract."[21] In fact, Milne's 1909-10 produc-tion was probably affected as much by general exposure to the work of the Ten (a group of artists, including Metcalf, Hassam, and J. Alden Weir, that had exhibited together since the turn of the century) and other American Impressionists as it was by Monet's paintings.

The Ten exhibited at the Montross Gallery, which by 1910 was located at Forty-fifth Street and Fifth Avenue, only a few blocks from Milne's studio at 8 West Forty-second Street. Although few of the Ten worked in watercolour, a number were pastellists (which may explain Milne's brief flirtation with the medium); densely ren-dered landscapes featuring short, distinct brushstrokes and rich autumnal colours were their specialty. Milne's *Defiant Maple*, how-ever, is far more experimental than those works in its all-over colour and—despite its heroic title—its lack of a central motif. It achieves some of the flat, patternistic quality that Milne admired in Monet.

Milne's watercolours from the next several years were even more innovative, if not always as successful. They reveal him, like many young painters, grappling with the lessons offered by Matisse and Cézanne, whose work Stieglitz recently had shown at 291. Milne would later comment on the boldness of these artists: "at Stieglitz's little 'packing box' gallery we met Cézanne, Van Gogh, Gauguin, Matisse, Brancusi. For the first time, we saw courage and imagination bare, not sweetened by sentiment and smothered in technical skill."[22] Although he doesn't explain what—in formal or compositional terms—inspired him, he drew from Cézanne a penchant for diaphan-ous washes, forms breaking free of pencil outlines, and especially the evocative power of paper left unpainted. Matisse's watercolours had been praised for their "brilliant stroke, subtle elimination, and . . . interesting composition."[23] The best of Milne's 1911 watercolours— among them *Apple Blossoms* (fig. 2) and *Reflected Spots* (M&S 103.70, Milne Family Collection)—display a similar brightness and liquid-ity, but his brushwork doesn't yet attain the lyricism of Matisse's.

Reflected Spots is a reprise of *The Defiant Maple*. The difference in their titles indicates that Milne's interest in abstraction had begun to prevail over the obligation to description that remained from his training as an illustrator. *Apple Blossoms* and *Reflected Spots* are an early meditation on a pictorial problem that would preoccupy him for many years: how to use the transparency of watercolour and the absorbency of the paper to evoke forms and their reflections on the same sheet. Here the contrast is a simple one: half the sheet—the reflections half—is painted wet-on-wet, that is, with thinned-down pigment laid onto already dampened paper, which causes the colour to pool and spread. The other half of the sheet contains a great deal of reserved (that is, unpainted) paper, in a sense wet-on-wet's technical opposite.

Milne's submissions to the 1911 New York Water Color Club's annual also indicate a dedication to abstraction. He continued to name many of his watercolours for their formal organizing principles; thus he insisted on *Black and White* rather than "Outside the Public Library." Milne wanted to be seen as experimental, as modern, and he succeeded: critics called his works "ultra impressionistic." He was paid the ultimate modernist compliment of incomprehensibility: "That [Milne's watercolours] may be said to be 'clever' is much more certain than that they may be said to be 'art.'"[24] Elsewhere, Milne was described as "getting even with one of the Library lions . . . which he pictures looking in the other direction"[25]—the first of many jokes that would be made at his expense. But he was also included among a group of young artists (Stuart Davis was another) labelled "the Incoherents." This was a term of both derision and affiliation, for it was what the Fauves had been called in an

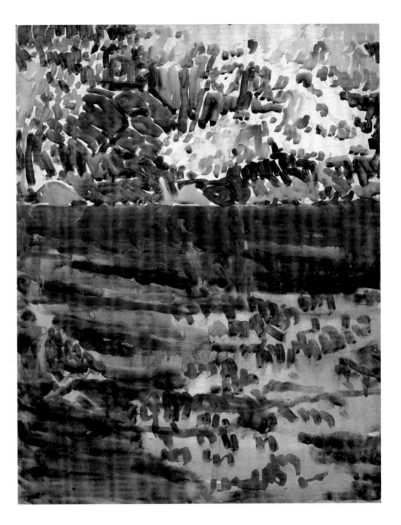

Fig. 2 David Milne, *Apple Blossoms*, c. 1911, M&S 103.69, watercolour over graphite on illustration board, 47.8 × 38.2 cm, Milne Family Collection

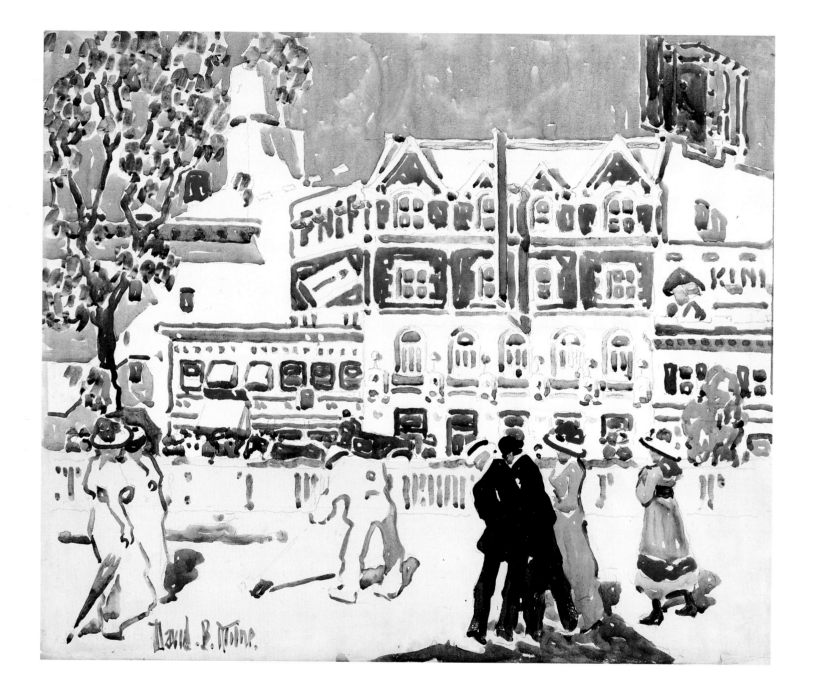

White Matrix, c. 1912 (cat. 5)
watercolour over graphite on wove paper (watermark: "J Whatman"), 51.0 × 60.6 cm
Milne Family Collection

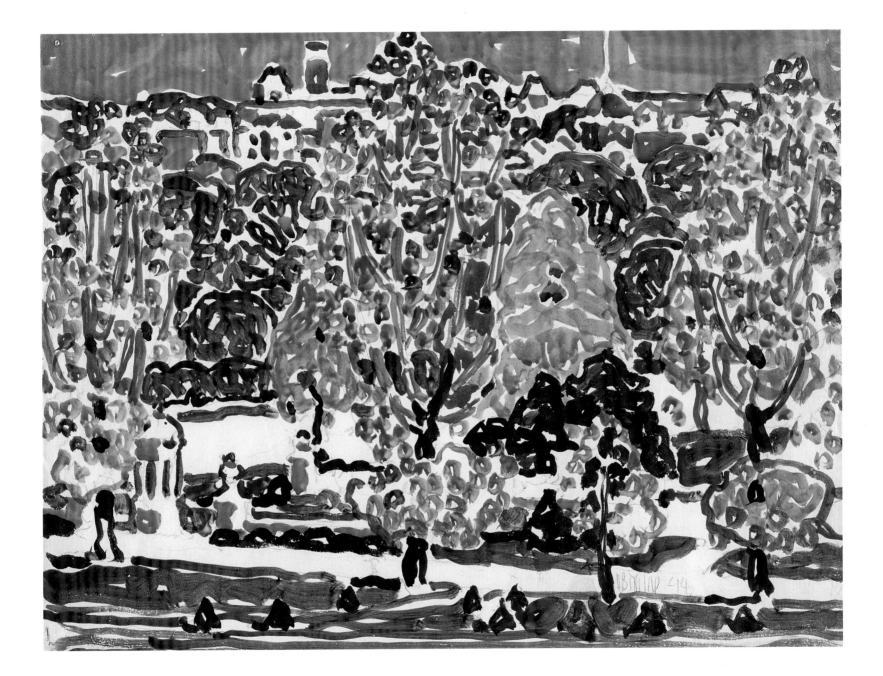

Bronx Park, 1914, 1914 (cat. 18)

watercolour over graphite on cream wove paper, 38.0 × 50.7 cm

Milne Family Collection

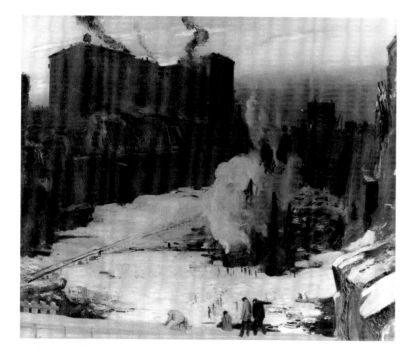

Fig. 3 George Bellows (American, 1882–1925),
Pennsylvania Station Excavation, 1909, oil on canvas, 79.4 × 97.2 cm,
Brooklyn Museum, A. Augustus Healy Fund B, 1967 (67.205.1)

Whereas they aren't as topographically minded as his etchings from this period, neither are they truly modernist, especially when compared with other recent city views made at the same time. George Bellows's muscular images of the demolition of old neighbourhoods and the creation of new — notably his pictures documenting the construction of Pennsylvania Station (fig. 3) — were painted about 1909. The exciting transformation of New York into the city of the future was documented poetically by Stieglitz in his *Old and New New York* and other photographs of about 1910. In 1911 Marin began his brilliant watercolours of the Brooklyn Bridge (fig. 5) and the Woolworth Building. Milne does not seem to have been caught up in the spirit of the new New York so apparent in those pictures. He doesn't depict buildings going up or capitalize on the soaring perspectives afforded by skyscrapers. Rather, he views the passing parade from just above ground level, and depicts the landmarks of midtown as though they were in late-nineteenth-century Paris.[27] In so doing, he has more in common with artists of the previous generation who had exhibited such themes regularly in New York since the 1890s. The comparison with Prendergast's watercolours of that era — for example, *Madison Square* (fig. 4) — is irresistible.[28] Broad public spaces serve as stage sets for rhythmically grouped figures, their costumes — see especially *Black and White I* — are orchestrated colouristically as though they were characters in a play. Equally relevant were Hassam's widely shown images of New York's fashionable boulevards. Like Hassam, whose career as an illustrator had trained him to populate his scenes with little dramatic incidents and character studies (and like Prendergast, for that matter), Milne scattered telling vignettes

influential article titled "The Wild Men of Paris."[26] Whereas Milne's subject matter is tame compared with the Fauves', to some critics, his intense colour merited association with the international avant-garde.

Black and White I and *II* (pp. 18 and 19) also mark the beginnings of Milne's engagement with urban themes. He followed with *Fifth Avenue, Easter Sunday* (p. 22); *Fifth Avenue* (M&S 104.52, private collection, Vancouver); *White Matrix* (p. 26); and *42nd Street Library* (p. 23), images that record what Milne saw in his own neighbourhood.

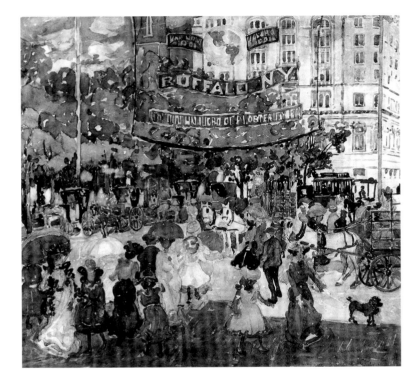

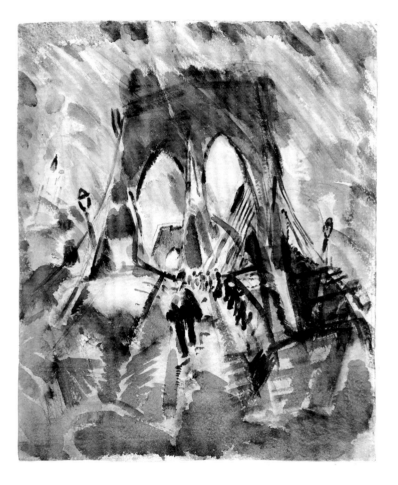

throughout his watercolours. Some provide a compositional focus in a sea of activity, as, for example, the conversation between two white-hatted women in *Black and White I*; others amuse, such as the determined procession across *Fifth Avenue* of a little girl in blue, mother with pram, and gawky adolescent. These are images of a pleasurable, elegant New York, with little acknowledgment of its newness, its grit, or its edge.

Milne did insert gentle tokens of modernity in a few of these watercolours — the billboards advertising a Robin Hood film in *Fifth Avenue*, the street sweeper with his back to the viewer in *White*

Fig. 4 Maurice Prendergast (American, 1858–1924), *Madison Square*, c. 1901, watercolour and pencil on paper, 38.1 × 41.9 cm, Whitney Museum of American Art, New York, Joan Whitney Payson Bequest, 1976 (76.14)

Fig. 5 John Marin (American, 1870–1953), *Brooklyn Bridge*, 1912, watercolour and graphite on paper, The Metropolitan Museum of Art, The Alfred Stieglitz Collection (49.70.105)
© Estate of John Marin/SODRAC (Montreal) 2005

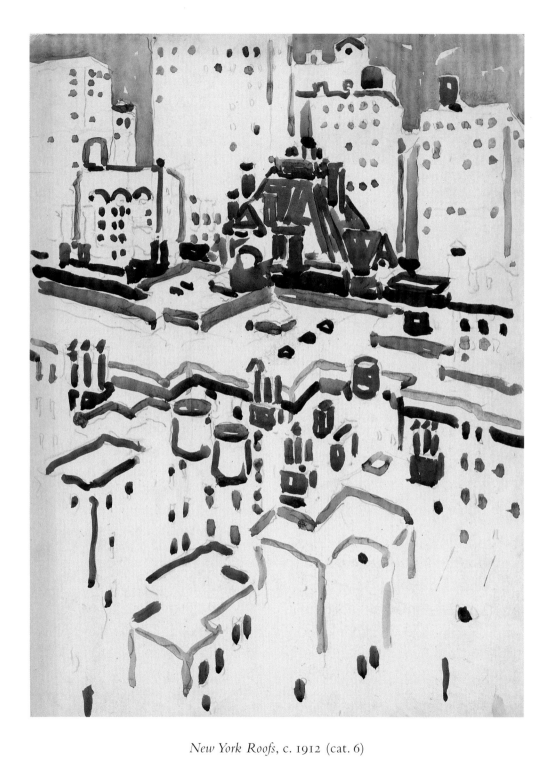

New York Roofs, c. 1912 (cat. 6)

watercolour over graphite on illustration board, 50.8 × 38.1 cm

Art Gallery of Ontario, Toronto, purchase with assistance from Wintario, 1977 (77/156)

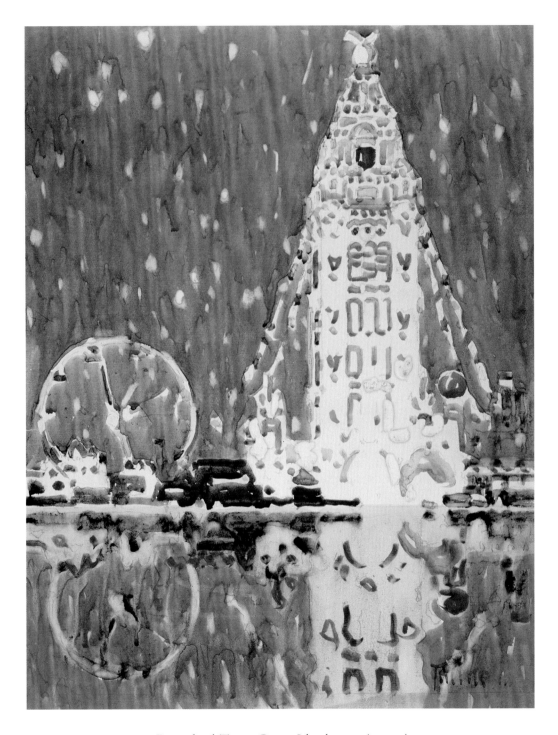

Dreamland Tower, Coney Island, 1912 (cat. 11)

watercolour with bodycolour over black chalk on illustration board, 49.0 × 37.6 cm

The British Museum, London, England, purchased 1993 (1993-10-2-23)

Fig. 6 Alfred Stieglitz (American, 1864–1946), *From the Back Window—* *"291" (2)*, 1915, photograph, platinum print, 23.8 × 18.7 cm, Museum of Fine Arts, Boston, gift of Miss Georgia O'Keeffe, 1950 (50.835)

Matrix, the automobiles sharing the street with pedestrians and horse-drawn cabs in *Black and White I* and *II*. In two of his major watercolours from 1912, however, Milne tackles bona fide modernist subjects with breathtaking originality.

The buildings in *New York Roofs* (p. 30) have not been identified, but they were likely in Milne's neighborhood; the Beaux-Arts roof line of the principal structure suggests it was part of the ambitious architectural campaign along Fifth Avenue during the late nineteenth century.[29] Rather than revelling in the massive grandeur of these buildings, however, Milne portrays them as scaffolding, or as a series of plain boxes stacked up on the picture surface. He views the scene from an elevated vantage point—perhaps his only attempt at using the modernist skyscraper perspective—and the resulting push-pull of the space and the contrast between open shapes created from reserved paper and densely coloured heavy ones can only be described as cubist.

This watercolour anticipates by several years Alfred Stieglitz's and Paul Strand's photographs of New York's roofs and backyards (see, for example, Stieglitz's *From the Back Window—"291" [2]*, fig. 6). Like those works, the architectonic abstraction of *New York Roofs* reflects exposure to the cubist drawings by Picasso that had been shown at 291 in 1911. At the same time, Milne's cheerful palette and confetti-like dabs of colour representing windows mitigate the structural intensity of his design.

New York Roofs achieves its abstraction with minimal means. There is no deliberate virtuosity, no technical display: it is, in essence, a drawing in watercolour. The use of white paper to indicate both

empty space and architectonic form introduces questions of the ephemeral and the material, the momentary and the permanent. The same issues arise in Milne's other "modernist" watercolour, a painting that is in many ways the pendant to *New York Roofs*.

When Milne painted *Dreamland Tower, Coney Island* (p. 31), Coney Island was already regarded as a symbol of the new New York.[30] It epitomized the excitement, the raw energy, and the technological prowess of contemporary America. And it offered both vulgarity and romance. While its more rowdy patrons gravitated toward its nickelodeons, its cheesy exotic dancers, and its mock-terrifying roller-coaster rides, the park was also a mecca for courting couples who could stroll along the boardwalk, get an inexpensive meal, lay claim to a certain refinement by touring Dreamland's "Canals of Venice" and other "cultural" attractions, and gaze in awe at the seemingly millions of stars, real and artificial, in the night sky. Milne's focus, the 375-foot-tall Beacon Tower, stood at the centre of Dreamland, one of four amusement parks at Coney Island. The tower overlooked a lagoon surrounded by a racetrack. Illuminated with nearly forty-five thousand light bulbs, it proclaimed the marvels of electricity and thus the promise of modern American life. Milne may well have brought Patsy to Dreamland, for he makes it a magical, fairy-tale place.

Like Marin's watercolours of the Woolworth Building (fig. 7), painted just at this time, *Dreamland Tower* is a tribute to the wonder and majesty of New York. Both artists depict an ethereal structure that rises magically out of a jumble of shapes at ground level and stands against an animated sky. Milne's tower, however, is as

Fig. 7 John Marin (American, 1870–1953), *Woolworth Building No. 31*, 1912, watercolour over graphite, 47.0 × 39.8 cm, National Gallery of Art, Washington, gift of Eugene and Agnes E. Meyer, 1967 (1967.13.9) © Estate of John Marin/SODRAC (Montreal) 2005

St. Lawrence after Taddeo Gaddi's "Madonna and Child Enthroned with Saints," c. 1912–13 (cat. 9)

Madonna and Child after Taddeo Gaddi's "Madonna and Child Enthroned with Saints," c. 1912–13 (cat. 8)

watercolour over graphite on illustration board, 50.7 × 26.4 cm / 50.8 × 27.6 cm, Milne Family Collection

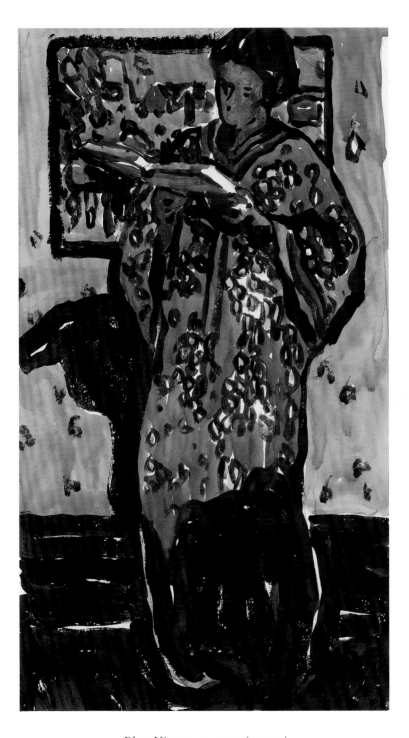

Blue Kimono, c. 1913 (cat. 13)

watercolour over graphite on wove paper, 41.0 × 22.6 cm

Milne Family Collection

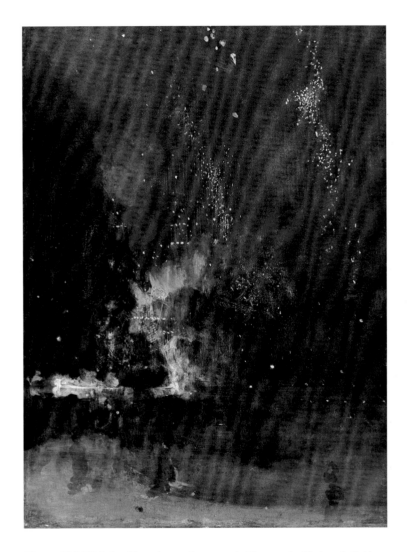

Fig. 8 J.M. Whistler (American, 1834–1903), *Nocturne in Black and Gold: The Falling Rocket*, c. 1875, oil on wood, 60.2 × 46.7 cm, The Detroit Institute of Arts, gift of Dexter M. Ferry Jr., 1946 (46.309)

monumental and solid as Marin's is vibrant and jazzy. While the *Woolworth Building*, a whirl of scaffolding, is constructed with pale washes and bright dabs of paint, Milne's tower is defined by a shaft of unpainted paper surrounded by blue washes. Creating the tower without paint makes it all the more fantastic, massive yet insubstantial, both an icon and a stage set, like the building itself.

Milne pushed the tower off centre to make room for the Ferris wheel and to leave more space for the starry sky. The stars, which seem to flicker and fall, are made from commas and ovals of reserved paper; he made them even more dazzling by highlighting some of them with opaque white. The thin cascading washes of blue enhance the mystery: are these shooting stars or a fireworks display, with the ghost of earlier explosions still vaguely visible? The whole—tower, Ferris wheel, falling stars—is echoed in watery terms in the lagoon.

But if *Dreamland Tower, Coney Island* is, like Marin's Woolworth Building pictures, a progressive, technically innovative and above all modern image, it also looks back. Milne here pays homage to J.M. Whistler, whom he admired and whose work was on view frequently in New York during these years.[31] In 1910 Whistler's celebrated *Nocturne in Black and Gold: The Falling Rocket* (an image of the nightly fireworks display at Cremorne Gardens in London, fig. 8) was on loan to the Metropolitan Museum of Art, where Milne probably saw it. Like Whistler's visions of Cremorne Gardens, painted when the park was in decline and capturing its "melancholy poetry,"[32] Milne's *Dreamland Tower* is also somewhat melancholy, for it, too, is a memory image. Dreamland, and its tower, burned to the ground in 1911, the year before the watercolour was painted.

Milne shifted styles frequently during his New York years, trying out notions gleaned from other painters, then moving on. He copied panels from a newly acquired altarpiece by Taddeo Gaddi in the Metropolitan Museum of Art, delighting in its Gothic ornamentation (p. 34). He followed his city views of 1912 with figure studies that are as dense and opaque as the street scenes were liquid and airy. These pictures have been linked with Édouard Vuillard's in their quiet intimacy;[33] their intense, sometimes dissociated colour was no doubt influenced by the Fauves. At the same time, the subject — attractive, contemplative young women in comfortably appointed interiors — was a mainstay of more conservative painters, among them Hassam and the artists of the Boston School (fig. 9).[34]

In at least one of the figure studies, *Blue Kimono* (p. 35), Milne again tipped his hat to Whistler[35] and that artist's infatuation with Japonisme (acknowledged in the costume worn by the figure and the unusually tall, narrow format of the sheet). But as much as he responded to other artists in these watercolours, Milne also commented on his own past work, demonstrating the kind of creative insularity and self-awareness that would lead him to some of his most important innovations. On the wall behind the figure in *Blue Kimono*, Milne included one of his own recent pictures,[36] *White Matrix*, which he reworked in the dense, all-over manner of his new figurative style. The original *White Matrix* demonstrated his "joy in a blank piece of paper";[37] when it became a picture within a picture its airiness was replaced by richly painted interlocking forms in the same quartet of colours as the rest of the watercolour. The effect is as decorative as it is modern.

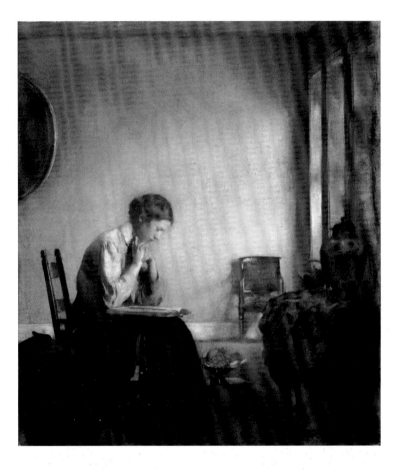

Fig. 9 Edmund Charles Tarbell (American, 1862–1938), *Girl Reading*, c. 1909, oil on canvas, 81.9 × 72.4 cm, Museum of Fine Arts, Boston, The Hayden Collection — Charles Henry Hayden Fund, 1909 (09.209)

A Barge, 1915-16 (cat. 20)

watercolour over graphite on wove paper (watermark: "J Whatman"), 45.7 × 55.7 cm

Milne Family Collection

"*The Best Essays in Modernism*"
New York and Boston
Corners, 1913-17

CAROL TROYEN

The year 1913 was eventful for Milne. He sent five works to the Armory Show, three watercolours and two oils, all from 1912.[1] Given the size of the show (there were nearly thirteen hundred works), Milne was mentioned often in reviews, and in distinguished company. One critic saw him as the successor to contemporary French painters and linked his watercolours to Marin's. *The Christian Science Monitor* connected Milne with "such American 'extremists'" as Walter Pach, William Zorach, and Maurice Prendergast.[2] In fact, compared with others in the Armory Show, such as Picasso, Duchamp, and Kandinsky, Marin and Hartley, these artists were hardly extremists. Prendergast was by this time fifty-four years old; Pach, one of the exhibition's organizers, showed a tame floral still life. Milne had been assigned a place among the transitional figures on the road to modernism.

Fig. 10 Joseph Stella (American, 1877–1946), *Battle of Lights*, 1913 (later inscribed 1914), oil on canvas mounted on cardboard, The Museum of Modern Art, New York, Elizabeth Bliss Parkinson Fund (143.1958)

Milne's confidence at this point is indicated by the prices he put on his work. His oils were listed at $200; for one called "The Garden" (now titled *Canadian Garden*, August 1912, M&S104.29, Milne Family Collection), he asked $150.[3] While nothing sold, his paintings, especially the watercolours, received a great deal of attention from the press. In addition to the Armory Show, in 1913 he exhibited in watercolour annuals in New York, Philadelphia, and Chicago, and was routinely lauded as progressive (according to the New York *Sun*, "The best essays in modernism . . . were those of David B. Milne").[4] But this accolade simply placed him among the most forward-looking of the old guard, for the annuals were becoming increasingly moribund. With a few exceptions, the more inventive artists (such as Davis and Marin) no longer submitted work to these shows, even though they remained vitally active as watercolour painters.

The excitement of the New York art scene had long since moved elsewhere. Immediately before and then following the Armory Show, Marin's vibrant, liquid views of New York were at 291; Joseph Stella's paintings of Coney Island were at Montross (fig. 10); and ex-hotelkeeper Charles Daniel opened a gallery at 2 West Forty-seventh Street, just blocks from Milne's studio, with a show featuring painters, both abstract and representational, of Milne's generation, including Demuth, Davis, and Leon Kroll.

But while critics frequently associated Milne and Marin,[5] and while Stella's kaleidoscopic Coney Island pictures might have reinforced the dazzle and energy of Milne's abstract patterned tree series, there is nothing to link Milne to their work. Did he see them? He doesn't say. His recorded admiration for what was shown

at 291 was restricted to the Europeans; he doesn't acknowledge the work of his American contemporaries. He regarded himself not as a modernist but as someone with "leanings in that direction."[6] He remained apart, by circumstance and by choice: "It would be possible to look at an exhibition through the crack in a door and be influenced for life."[7]

Milne's closest involvement with modernism came through a gallery owner later described as "a leader among conservative dealers in promoting progressive art."[8] Newman Emerson Montross began his career by selling artists' materials; Milne would buy his supplies from Montross's shop. By the turn of the century Montross was showing paintings by the Ten and the Boston School; special favourites were Hassam, Metcalf, Dwight Tryon, and Edmund Tarbell. However, beginning in 1914, he alternated exhibitions of these establishment figures with more adventurous fare.[9] Thus, in the winter and spring of 1914 Montross followed "Paintings and Drawings by Modern Americans" (featuring Stella's Coney Island paintings) with "A Special Exhibition of Pictures by American Artists" (including works by Thomas Dewing, John Twachtman, Hassam, and Weir). His second modernist show (October 1914) was more conventional than the first without being old guard. It included two portraits by George Wesley Bellows, a Fauvist landscape by Ambrose Webster, paintings by Jonas Lie, and a recent oil by Edward Hopper — and two oils and two watercolours by Milne.

Between 1914 and 1916 Milne showed four times with Montross. As his only gallery representation, it was a critical — and comfortable — association. Montross was familiar, and his group shows were widely inclusive, combining avant-garde work with more middle-of-the-road modernism. And his shows were covered extensively in the press. The October 1914 exhibition was given nearly a full page in *The New York Times*, with Milne's oil *Red* (1914, M&S 105.92, Milne Family Collection) reproduced just beneath the masthead.

The *Times* reviewer gave Milne several column inches, and his comments identify a leitmotif in Milne's production: conventional subject, unconventional style: "How many times have we not seen that slim girl in a library, pots of flowers on the window bench, and the light falling in warm patches on the floor and furniture. But Mr. Milne has made himself master of the art of patterning and builds up his blocks of color as precisely as the modern doctor diagrams your heart action . . . Whatever he may have to say you feel that he makes no mistake in the form of his statement."[10]

Before Montross agreed to show his work, Milne had found no outlets other than the watercolour annuals, and remained on the periphery of the New York art world. Perhaps this is why he joined forces with Engle, Marguerite and William Zorach (who, like Milne, had difficulty finding representation), and three other artists to form a group called the Contemporaries. In January 1914 they organized an exhibition in a borrowed space on West Thirty-seventh Street, on the fringes of the art gallery neighbourhood.

There is no indication that Milne sold anything from the Contemporaries show, or from the watercolour annuals in which he religiously exhibited. He did sell from the show he put on in his apartment probably in the spring of 1915 — some $300 worth, crowed his wife, Patsy. This kind of exhibition — in the artist's own rooms —

Cobalt Trees, c. 1913 (cat. 14)

watercolour over graphite on wove paper, 42.9 × 37.5 cm, Art Gallery of Ontario, Toronto,
gift of Robert Dirstein and James Robertson, Toronto, in memory of Mrs. Jessie Ambridge, 1986 (86/313)

Wood Interior IV, 1914 (cat. 17)

watercolour over graphite on wove paper, 46.9 × 45.5 cm

Collection of Greg Latremoille, Toronto

had a long tradition in New York, going back to the mid-nineteenth century, when the Hudson River School artists painted and displayed their work in the Tenth Street Studio building. From the 1880s, William Merritt Chase used his elegant apartment as studio, salon, and salesroom. In Milne's day, it was more often a method used by artists without regular representation to create a showplace for their work. Friends and colleagues could be counted on to drop by; sometimes the press came. Milne's show, which would be his only solo exhibition in New York, not only generated better sales than any other show he had participated in but also attracted attention for the theatricality of his presentation. He painted the walls black and set off the watercolours with gold mats; as a result, the pictures "looked like stained glass windows . . . the brilliant color stood out . . . [they were] jewel-like."[11]

The period following the Armory Show was a heady time for Milne. He was extremely prolific, producing nearly one hundred paintings—most of them watercolours—in 1914 and more than sixty the following year. He moved easily from densely painted interiors to broader landscape views; he alternated between opaque colour covering the picture surface almost entirely and loose washes with generous use of reserved paper. His watercolour style was original and self-assured, a fact that critics recognized: "The American Water Color Society . . . has many an agreeable thing to show, but none more invigorating than David B. Milne's red-haired woman in a garden with a parasol [*Canadian Garden*]. Mr. Milne does his work as much with white spaces as with spots of color . . . and his work is always brilliant and beautiful."[12]

In 1914 Milne was elected to membership in the New York and Philadelphia Water Color clubs. He won a silver medal for the seven watercolours he showed at the 1915 Panama-Pacific Exposition in San Francisco; two pictures, priced at $120, apparently sold. In 1915 and 1916 Milne served on the jury for the New York Water Color Club annual, and in 1915 for the Philadelphia club's annual as well. He especially enjoyed the latter assignment: "Our expenses were paid, we stayed at a big hotel, had dinner at some club, were asked for interviews, talked with [the Pennsylvania Impressionist Edward] Redfield and Joe Pennell. We were young enough to be delighted with these glories, spread against the bareness of our year."[13] This was not just pleasure at living the high life for once but also at associating on an equal footing with the celebrated printmaker Pennell, who had influenced his early etchings and had long been one of his idols.[14]

Milne often saved his most challenging pictures for the Philadelphia annual.[15] In late 1914, for example, he showed four watercolours that he once again labelled according to the formal elements governing the pictures: *Broken Color*, *Dots and Dashes* and so on. The reviewer for the *International Studio* objected: "[I was] considerably puzzled here [by] certain works by Mr. David B. Milne catalogued as *Dots and Dashes, Broken Color, Domes and Pinnacles, Brilliant Triangle*. They were arrangements of colour but apparently represented nothing that ever existed in nature . . ."[16] Whether or not Milne anticipated this cranky reception, he nonetheless felt sure enough of the venue to choose it, rather than New York, for the debut of his radical series of watercolours of trees. *Brilliant Triangle* (probably *Brilliant Pattern*, fig. 11) exhibits a kind of organic pointillism, built

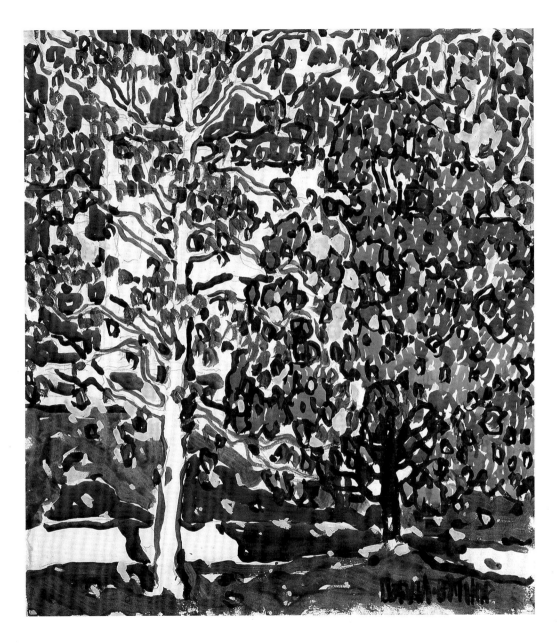

Fig. 11 David Milne, *Brilliant Pattern*, 1914, M&S 105.136, watercolour over graphite on wove paper, with watercoloured wove paper overlay, 50.9 × 46.0 cm, Milne Family Collection

45

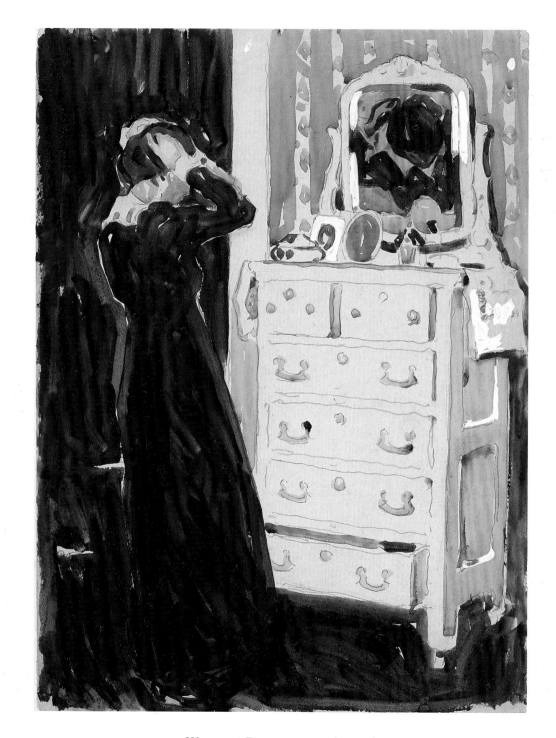

Woman at Dresser, c. 1912 (cat. 10)

watercolour over graphite on illustration board, 50.8 × 38.1 cm

Private Collection

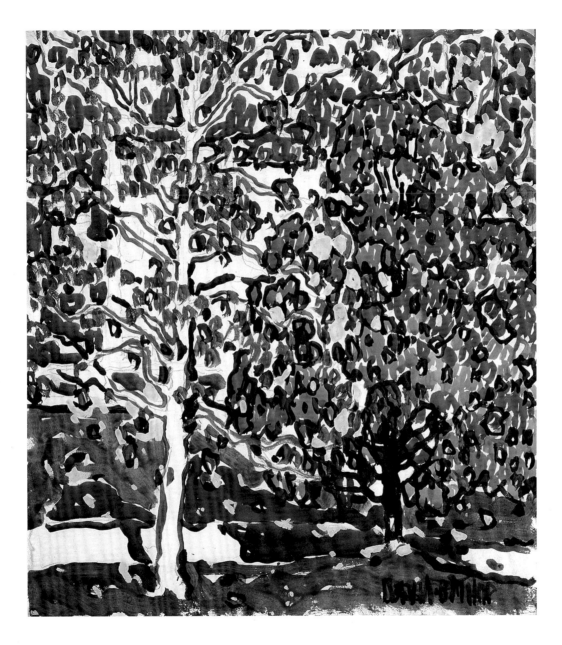

Fig. 11 David Milne, *Brilliant Pattern*, 1914, M&S 105.136, watercolour over graphite on wove paper, with watercoloured wove paper overlay, 50.9 × 46.0 cm, Milne Family Collection

45

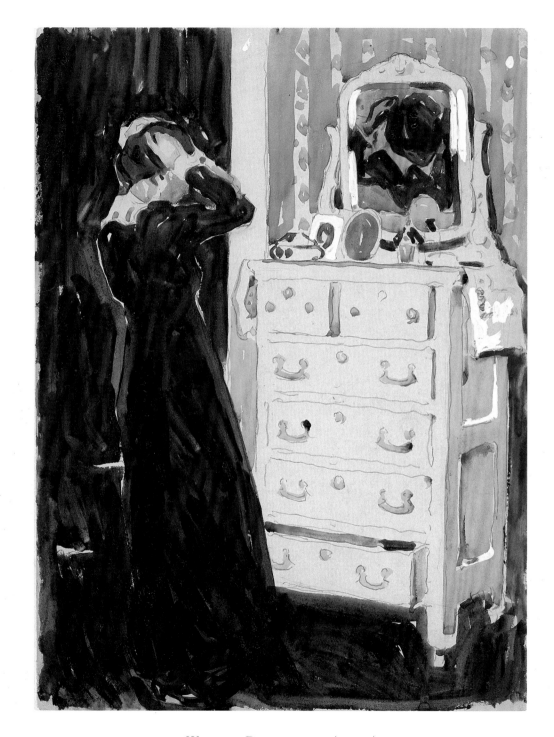

Woman at Dresser, c. 1912 (cat. 10)

watercolour over graphite on illustration board, 50.8 × 38.1 cm

Private Collection

46

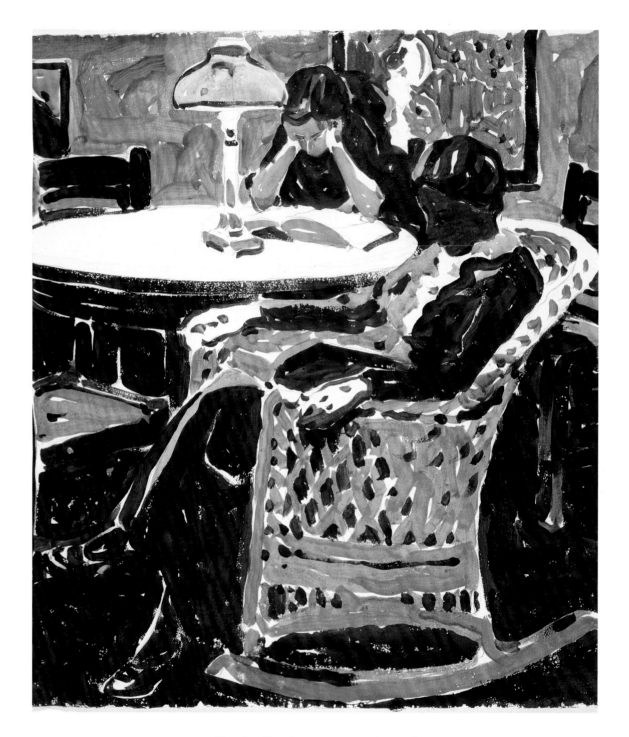

Evening Interior, c. 1913–14 (cat. 15)

watercolour over graphite on wove paper, 46.4 × 41.3 cm

Collection of Dr. Peter Chan and Mrs. Debbie MacKinnon-Chan

Fig. 12 David Milne, *Black Cores*, July 31, 1915, M&S 106.38,
watercolour over graphite on wove paper (watermark: "J Whatman"),
45.5 × 55.8 cm, The Thomson Collection (PC-959)

demands to be seen from a distance, at which point the stand of trees come into focus — revealing the *International Studio* reviewer to have been myopic indeed.

Milne's submissions to Philadelphia's show in 1915 were equally experimental. By this time he was painting almost exclusively in the Bronx. He rarely depicted interiors or urban views, and when he painted a residential neighbourhood, he nestled it in the trees. Of the two works shown, *Pointed and Full Forms* has not been identified; *Black Cores* (fig. 12) was sufficiently important to Milne that he showed it twice in New York during the next two years.

It did not sell, and remained with him. More important, it remained on his mind. In a commentary written about a watercolour painted a few years later, Milne reexamined the formal problem he set for himself in the work: "The black 'cores' of the trees, a convention started in a watercolor made in 1915 from near Gun Hill Road . . . This started from the need of a convention to represent trees looked at against the light where they showed a dark shadowed part surrounded by an illuminated part."[17]

The austerity and solemnity of *Black Cores* is astonishing, following so closely on the almost giddy "stippled pattern" series of less than a year earlier. It represents a complete about-face from those almost scientifically calibrated yet euphoric mosaics of secondary colours. Now Milne works with silhouetted graphic shapes and a stripped-down, weighty palette of black, grey, and green. Pigment is applied opaquely for the most part, except for the sky, where the cascading grey washes create a sense of heaviness perhaps signalling an impending storm. Milne once again uses large areas of unpainted

from intensely coloured parentheses-shaped strokes that had become Milne's shorthand for rustling leaves. The foliage fills the sheet, and trees are defined by staccato strokes that set up a swirling movement. The tension between surface energy and spatial recession, between positive and negative shapes (rendering one tree with vibrant commas of opaque pigment and the other with reserved paper), is as exhilarating as the lights of Luna Park. At the same time, *Brilliant Pattern* is remarkable for its strength and presence. It defies the traditional intimacy of watercolour, creating a powerful statement that

paper. Here it represents the immediate foreground and the hillside in the distance — his shorthand for a neutral space that also serves as an active element in the design.

Reviewers variously struggled to understand ("Mr. Milne builds color without line") and dismissed him ("David Milne may trifle well with 'Black Cores' and no one's feelings are hurt").[18] At this point, Milne began to withdraw. His exhibitions of 1916 with both New York watercolour associations would be his last. Montross seems to have lost interest; after the shows in the mid-teens, he would hang a few of Milne's watercolours in 1921 and then not again. His watercolours from late 1915, primarily landscapes and views of residential streets in the Bronx, are increasingly black in tonality and mood, with an almost claustrophobic surface density. He sent one of these, possibly *Jerome Avenue, the Bronx (Black Hill)* (1915, M&S 106.51, National Gallery of Canada), to Montross's "Fifty Pictures by Fifty Artists" show; otherwise, he did not exhibit them.

By early 1916 Milne was discouraged and dissatisfied. He later alluded to a "nervous heart" and characterized his work in negative terms: "My painting, before I left New York, had taken an unfortunate turn, maybe reflecting a troubled frame of mind. The pictures were mannered, heavy, spotty and lacking in sensitiveness or subtlety . . ."[19] The reasons for this can only be imagined. His career, which just six years before seemed so full of promise, had stalled. His work, earlier associated variously with establishment figures such as Prendergast and Hassam and with promising artists such as Marin, was now seen as puzzling, anomalous. Milne's sales had always been sporadic, and he had no regular dealer to encourage purchases and boost his morale. He may well have run out of ideas and energy for promoting his own work. In May 1916 he left New York City, his home for nearly thirteen years. Although he would return occasionally, he would never live there or be a part, however peripheral, of its art community again.

Milne left New York at the end of a brilliant season for watercolours. Paintings by two acknowledged American masters of the medium, Winslow Homer and John Singer Sargent, had been on view at the Metropolitan Museum of Art. Stieglitz showed Marin's watercolours of Maine. The Montross Gallery put on a Hassam retrospective that included sixty watercolours, followed by a show of Cézanne's watercolours and oils. And in March 1916 the "Forum Exhibition of Modern American Painters" proclaimed its intention "to put before the American public . . . the very best examples of the more modern American art."[20] The statement could well have continued, "without regard for medium," for a significant number of the works shown were on paper.

More and more, watercolour had come to be regarded as a medium for serious expression and not just for singing "the tune of joyous summer time."[21] In a pioneering essay published in 1916, the critic, collector, and painter A.E. Gallatin urged artists to take watercolour seriously and to develop the medium's inherent expressive potential. He dismissed tightly painted, highly finished compositions dominated by opaque pigment (the kind of work still plentiful at the watercolour annuals). Instead, he held up as models J.M.W. Turner, Homer, and Marin and argued that the "*true* method

Summer Night, Saugerties, 1914 (cat. 16)

watercolour over graphite on wove paper, 51.9 × 44.5 cm

Milne Family Collection

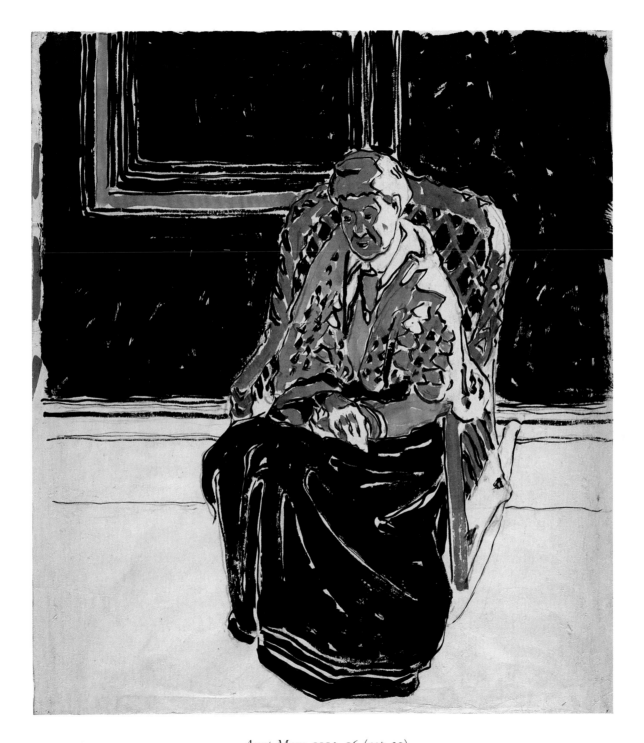

Aunt Mary, 1915–16 (cat. 21)

watercolour and ink over graphite on Japanese paper, 48.6 × 42.7 cm

Art Gallery of Ontario, Toronto, gift from the Douglas M. Duncan Collection, 1970 (70/87)

The Waterfall, 1916, August 12, 1916 (cat. 23)

watercolour over graphite on wove paper, 45.5 × 56.5 cm

Milne Family Collection

of painting in watercolor" depended on "broad and transparent washes, full of suggestion, in which simplification and spontaneity are necessary qualities."[22]

Although at that moment there was no room for Milne in Gallatin's pantheon—his watercolours of 1916 relied little on transparent washes and ephemeral effects—the paintings he produced over the next decade would conform to Gallatin's other criteria. Milne continued to work in both watercolour and oil (though the watercolours significantly outnumber the oils), regarding those media as equally valid. His writings are filled with observations about the effects of different techniques of paint application. The watercolours he made over the next decade were highly experimental, pushing the medium well beyond conventional practice, and were even more original than anything he had achieved in the feverish atmosphere of modernist New York.

In his autobiography, Milne describes his decision to move to Boston Corners, New York (some one hundred miles north of the city and at the Connecticut and Massachusetts borders), as the result of a systematic inquiry: he and his friend James Clarke scoured maps and railroad routes to determine the ideal place for him to restart his career. Nonetheless, his language suggests he felt Boston Corners was preordained: "Boston Corners was not a chance discovery. It was more like finding a star or an element."[23] In 1916 it was a hamlet of perhaps eight houses, a church, a school, a boarding house, and a store, but was on three railroad lines.[24] As Milne noted, "It was a good painting place because it was a good place for a painter to live, demands on him were fewer than in any other place I knew."[25]

With so few people in town, social life was limited; distance from New York precluded active participation in exhibitions. There was also little opportunity for part-time employment, which Milne had always found distracting. Rather, life in Boston Corners required inventiveness, self-sufficiency, and closeness to nature, and Milne delighted in the challenge.[26]

The seclusion Boston Corners afforded Milne suited him temperamentally, but it also conforms to a deeply ingrained belief about American artists: the true artist is ascetic, solitary, and driven only by artistic concerns. Just as Homer has been lionized as a hermit-genius, so Milne has been seen as heroic in his isolation, his austere life-style, and his unwavering dedication to his art.[27]

Milne didn't refute this myth. In his autobiography he downplayed his contact with the outside world (even though he travelled to New York, read New York newspapers, entertained visitors from the city, and would over the years welcome gifts and gourmet provisions from friends).[28] He treated his deprivations in an offhand manner, which made them seem more dire. But he *was* completely consumed by his art, and revelled in the process of art-making: "It was the effort [of painting] that brought . . . [enjoyment], not success or lack of it . . . Painting was almost entirely for the delight of doing it."[29]

For the next year and a half, he found all his watercolour subjects within a few miles of his house. They were painted on the spot, usually with graphite underpinnings, occasionally even more directly, and Milne claimed not to alter them once they were done. Since, as he said, he was the only audience intended for these pictures, rather than revising when something proved unsatisfactory, he

Reflected Forms, November 1, 1917 (cat. 28)

watercolour over graphite on wove paper, 38.8 × 56.6 cm

Art Gallery of Greater Victoria, Victoria, British Columbia, AGGV Women's Committee purchase, 1954 (54.17)

Massive Design, 1915 (cat. 19)

watercolour over graphite on wove paper (watermark: "J Whatman"), 45.7 × 56.4 cm

Milne Family Collection

55

would set the work aside and start again. He painted many pictures of the same subjects; they are both variations on a theme and an obsessive search for what he considered perfection.

Milne's landscapes are variously panoramic (e.g., *The Mountains [Catskills III]*, p. 58) and closely scrutinized.[30] As in many of the New York City watercolours, white paper is used to both suggest and deny spatial recession. Sometimes (e.g., *Village toward Evening [Afternoon Light I]*, November 10, 1917, M&S107.115, National Gallery of Canada), unpainted areas define bands of space that guide the eye back to the horizon. Sometimes the white elements push forward (for example, the post in *Back Porch, the White Post* (see fig. 34, p. 160), which creates an almost Japanese division of space). Sometimes Milne emphasizes the picturesqueness of the Christmas-card-pretty valley. Elsewhere, he focuses on the town's ordinary, blunt, unpicturesque side, as in *Boston Corners I* (p. 60), which depicts the boarding house, railroad station, and water tower.

In a number of the first Boston Corners watercolours (for instance, *Joe Lee's Hill [Green Masses]*, May 31, 1916, M&S107.15, National Gallery of Canada), Milne retained the austere black, white, and green colour scheme of *Black Cores*. He subsequently expanded his palette to include blue or teal and rust tones. The works remained dense, but colour functioned as a constant while he investigated problems of design. He applied his paint with new energy: wet, thick, juicy strokes in *Joe Lee's Hill*; in *Boston Corners I*, broad, finger-painty strokes, firm and assured. The paint is opaque, almost like tempera — there is nothing of the liquid, spontaneous character of watercolour here — to complement a plain subject.

In other watercolours, however, transparency is the point. Milne returns to the interest in reflections and atmosphere he addressed in *Reflected Spots*. In such watercolours as *Water Forms* (fig. 13) and especially the masterful *Bishop's Pond* (frontispiece), the first in a series of watercolours made at a nearby charcoal pit latterly a pond, he uses a technique that inverts the orthodox method of painting wet-on-wet. Rather than dampening the paper first and then applying colour, Milne laid in colour first and then washed over it. The result is a passage of shimmering colours with outlines only slightly blurred — as are reflections in a still pond — but with crisply defined boundaries not possible when painting wet-on-wet.

In these pictures he reaches far beyond Gallatin's prescription for the ideal modernist watercolour. His opaque passages are as evocative as his diaphanous washes. Some of his images are like jigsaw puzzles of interlocking shapes, at once completely legible as landscapes and brilliantly abstract. Often (in *Bishop's Pond*, for example) he wedged shapes densely layered with wash, line, and softly expanding squares of colour between large shapes created from blank paper. Milne titled another such watercolour *Half and Half*, June 7, 1917 (M&S107.87, Dinah Arthur, Toronto) — a coy acknowledgment of the daring combination of seemingly contradictory effects. There are few parallels for these watercolours. Even when — in such pictures as *The Mountains (Catskills III)* or *Sunburst over the Catskills* (p. 59) — he comes closest to Marin, who was celebrated for his use of transparent wash, Milne's unorthodox method of painting first dry then wet creates a magical richness of surface that is entirely original.

Fig. 13 David Milne, *Water Forms*, 1921, M&S107.61,
watercolour over graphite on wove paper, 46.9 × 39.0 cm, National Gallery of Canada,
Ottawa, gift from the Douglas M. Duncan Collection, 1970 (16127)

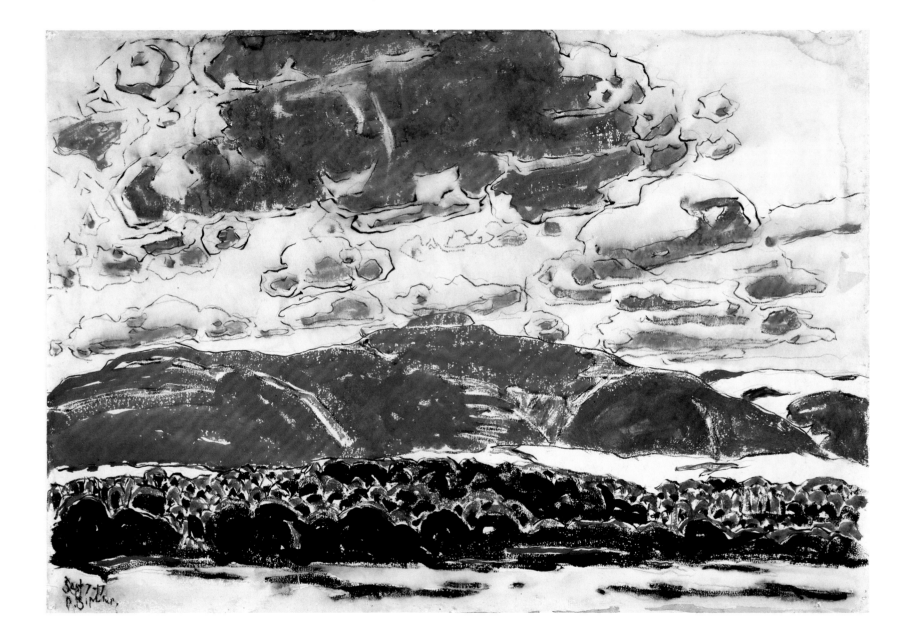

The Mountains (Catskills III), September 7, 1917 (cat. 26)

watercolour over graphite on wove paper, 39.4 × 55.9 cm

National Gallery of Canada, Ottawa, purchased 1924 (3019)

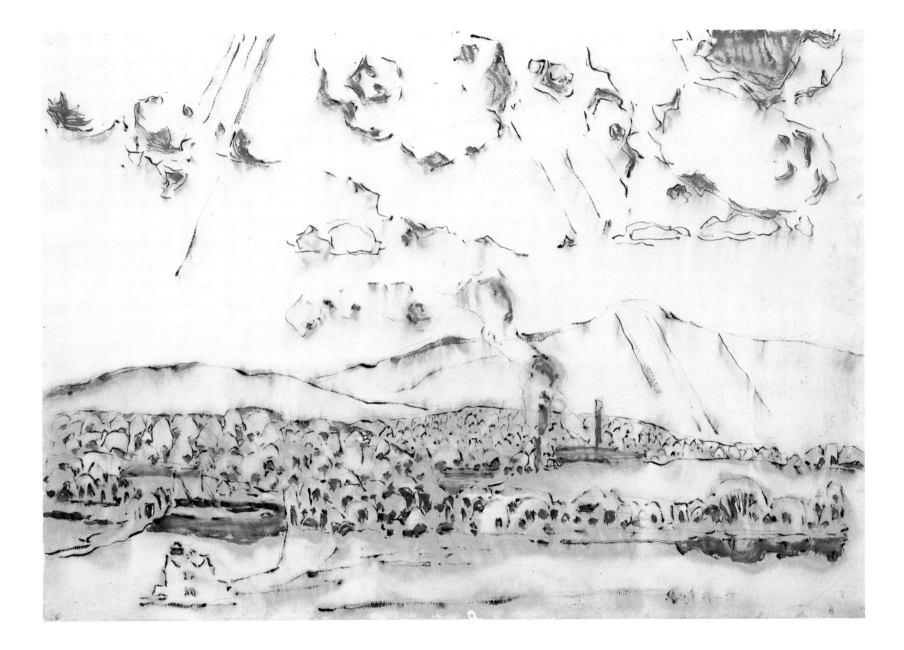

Sunburst over the Catskills, September 8, 1917 (cat. 27)

watercolour on wove paper, 38.5 × 55.3 cm

The Museum of Modern Art, New York, gift of Douglas Duncan, 1961 (384.61)

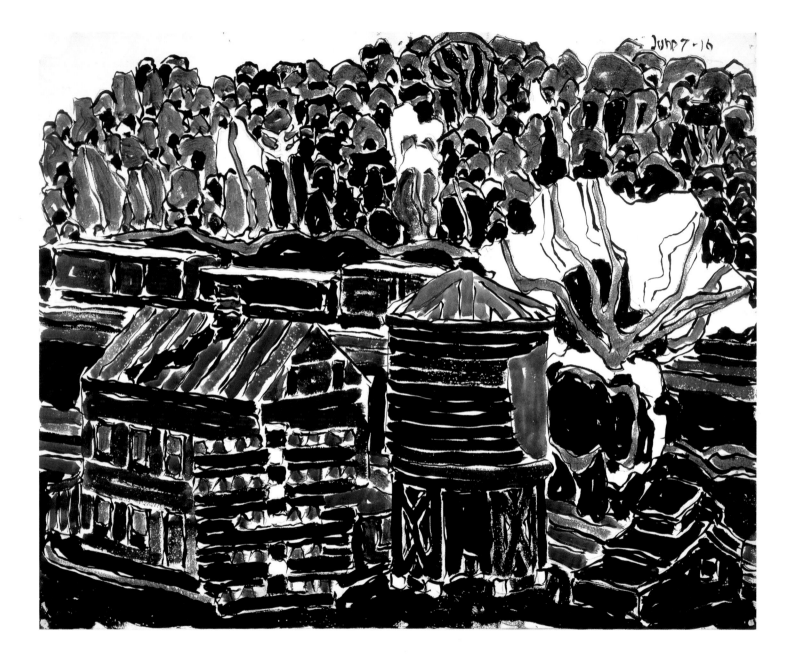

Boston Corners I, June 7, 1916 (cat. 22)

watercolour over black chalk on wove paper, 45.0 × 57.0 cm

The British Museum, London, England, purchased 1997 (1997-7-12-121)

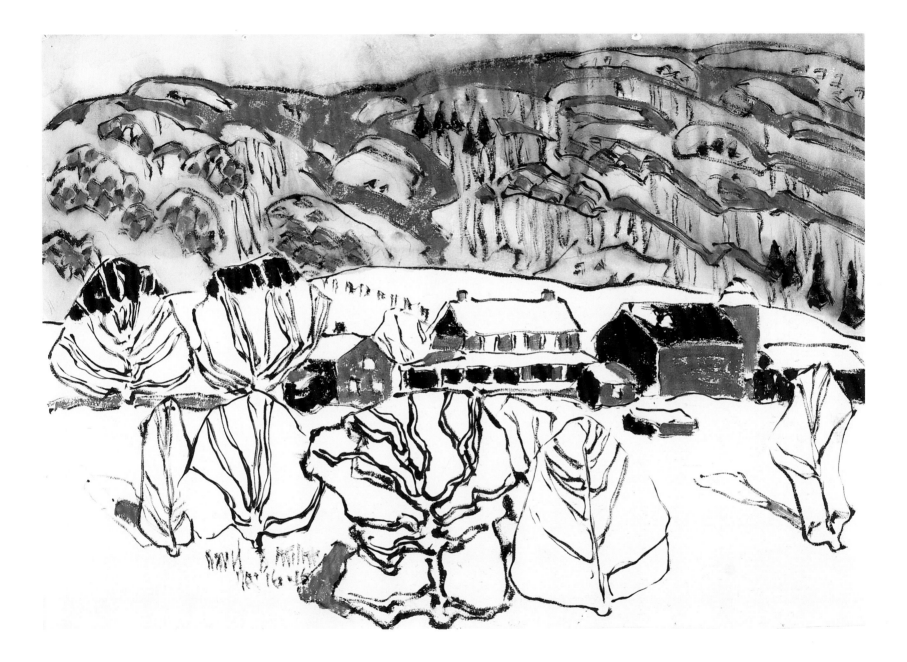

Lee's Farm, 1916 (cat. 25)

watercolour over graphite on wove paper, 38.5 × 54.9 cm

Private Collection, Toronto

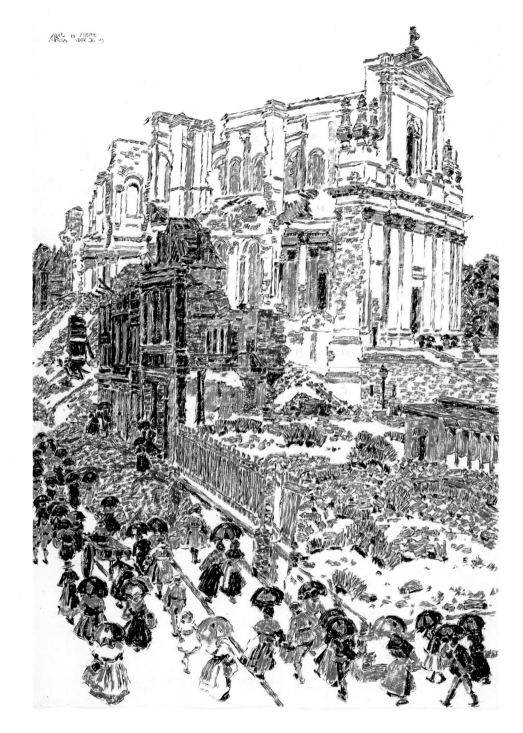

The Cathedral, Arras, July 1919 (cat. 42)

watercolour over graphite on wove paper, two sheets: 70.6 × 50.4 cm

National Gallery of Canada, Ottawa, transfer from the Canadian War Memorials, 1921 (8507.1-2)

"The Man Changes, and with That, the Painting"
The War Watercolours

ROSEMARIE L. TOVELL

David Milne joined the Canadian Army to fight, not to paint. He had been following the war's progress from the pastoral security of Boston Corners, but by 1917 circumstances changed to convert him from an observer to a participant. The war had taken on a "gloomy turn as Russia was out, but the United States was moving very slowly. Canada seemed to be losing some of its enthusiasm, [and] France was troubled. It looked as if everyone would be needed."[1] The passing of a conscription bill in Canada led Milne to believe that for him, army life might only be a matter of "waiting for instructions."[2] But it was the opening of the British Recruiting Office in New York that gave Milne the final incentive to enlist. To his surprise, at the age of thirty-six he was accepted, and on March 1, 1918, Pte. David Milne was in Toronto, enrolled in

the 2nd Depot Battalion (or B Company) of the Central Ontario Regiment, receiving his uniform and kit.

However, a set of unexpected circumstances kept Milne out of the war. The political tensions created by the Conscription Act came to a head with rioting in Quebec City, and on April 1 Milne's company was hurriedly sent there to restore order. By the time Milne arrived, the worst was over, and the company was subsequently deployed to the mining region in the Eastern Townships of Quebec. On September 13 Milne's company set sail for England and, on arrival, was immediately taken to Kinmel Park Camp in North Wales. It was a newly established segregation camp for quarantining incoming soldiers against the deadly pandemic known as the Spanish flu. Milne was still training at Kinmel Park when Armistice was declared.

Army life agreed with Milne, and as long as he was kept busy with training he apparently did not miss painting. Yet once the war was over, Milne's thoughts naturally returned to his future. He considered a scheme to stay in England for a year rather than return immediately to Boston Corners: "I felt that the decided change would stimulate picture making and had some hope that my pictures (rather stiff and dry) might line up with English temperament."[3] However, since the Canadian military allowed its soldiers to be discharged only in Canada, Milne had to abandon the idea. Yet it was likely this desire to remain and paint in England that gave Milne the incentive to press his case when an alternative suddenly presented itself.

On his last day of leave in London in early December, Milne saw a painting of a camouflage ship in the window of the Goupil Gallery bearing a label indicating it had been purchased by the Canadian War Memorials (CWM).[4] Inquiring within, Milne learned that Lord Beaverbrook had established the CWM to record Canada's war effort and that it had a program of commissioning leading British and Canadian artists — often the most avant-garde. Wasting no time, Milne raced to their offices and spoke with Capt. Harold Watkins. Watkins was at first reluctant: the war was over, and he was deeply involved in organizing a huge art exhibition of the Canadian War Memorials scheduled to open at the Royal Academy in Burlington House on January 4. But Milne pressed his case. Noting that the CWM did not have any images of Kinmel Park Camp, Watkins agreed to put him on probation to make pictures of the camp, with a possible commission to record the battlefields of the Western Front. Milne was also to arrange to have examples of his work sent from New York, along with letters of recommendation. It would then be up to Beaverbrook's art adviser, *The Observer*'s art critic P.G. Konody, to pass final judgment on Milne's worthiness for further commissions. Ecstatic, Milne quickly purchased some art supplies and was back at Kinmel Park Camp the next day, using the laundry room as his studio.

An air of dissatisfaction crept into Milne's own description of the Kinmel Park landscape subjects. Not having held a brush for almost ten months, Milne found he "had some difficulty at first in getting going, in adapting my way of working a year or before to the subjects I was now undertaking or to what I considered should be done with these subjects. All the early ones were done in great detail, with a suggestion of map making. Patient and leisurely, endless

rows of miniature huts, exactly alike, with toy hills and trees and toy figures . . . though colour was used, 'drawings' accurately describes them."[5] Indeed, among these first works are two that show Milne's uncertainty about what was required. *Kinmel Park Camp: Location Sketch Made from the Hills above Dyserth* (p. 68) is Milne's attempt to render a standard military topographical map, while *Kinmel Park Camp No. 13, Looking toward Rhyl and the Irish Sea* (p. 69) is his effort to demonstrate a similar panoramic view but done in his own Boston Corners landscape style. The most successful of these earliest watercolours are the ones depicting camp life. *Kinmel Park Camp: The Concert at the 'Y'* (p. 67) and *Kinmel Park Camp: Pte. Brown Writes a Christmas Letter* (p. 66) introduce the viewer to the camp's boisterous evening entertainment and to the peace and intimacy of Milne's studio as his best friend writes a letter home. The reason for the success of these two subjects was the evident lack of artistic struggle. Both were happily rendered in the style Milne had already developed for such works: the key was his uncanny eye for dramatic composition and strong draughtsmanship.

In mid-January Milne was back in London, delivering these first watercolours to Captain Watkins, who entered nine, including the four discussed above, in the Burlington House exhibition. With the arrival of his watercolours from New York, Milne met with Konody, who, without hesitation, not only recommended Milne's appointment as a war artist but also suggested a dealer in London to handle his work. (Milne quickly forgot the name of the dealer and never followed up.)[6] The problem now for Watkins was to find the means within the military bureaucracy to get Milne to the battlefields, with an officer's authority and benefits. Until a solution could be found, he was sent to more camps in Britain with Canadian personnel.

Throughout Milne's career, the landscape imposed a style and methodology on his painting. From January to May 1919, he painted watercolours in Kinmel Park Camp, as already discussed, followed by Ripon in Yorkshire, Bramshott in Hampshire, and finally Seaford in East Sussex, working for about a month in each camp as winter turned to spring. Each location offered Milne a different geography and climate, thereby demanding from him, in quick succession, a constantly evolving set of æsthetic solutions.

At Ripon, Milne was using a new way to paint. Employing Winsor & Newton watercolour sketching blocks, he had several sketches on the go at the same time. He also altered his style of brushing on paint, eschewing transparent washes for thickly applied impastos of pigment scratched onto the paper with a hard-bristled brush. One wonders if this was not an æsthetic as well as a physical response to working out of doors in the cold and damp January–February weather of Yorkshire when washes would take time to dry. Milne himself discerned an improvement in his style: "still panoramic but less map like and with greater use of color."[7] This is quite apparent in *Ripon: High Street* (p. 70), in which reddish brown and vivid blue brighten the dominant grey blue and khaki green, reflecting the animated life on the street. However, his use of colour was more subtle and complicated in *Ripon: South Camp from General Headquarters* (p. 74), as he responded to the misty, silvery light of a winter's day in northern England. Of this watercolour he wrote:

Kinmel Park Camp: Pte. Brown Writes a Christmas Letter, December 23, 1918 (cat. 31)

watercolour over graphite on wove paper, 28.8 × 29.9 cm

National Gallery of Canada, Ottawa, transfer from the Canadian War Memorials, 1921 (8499)

Kinmel Park Camp: The Concert at the 'Y,' December 21, 1918 (cat. 30)

watercolour over graphite on wove paper, 29.1 × 42.9 cm

National Gallery of Canada, Ottawa, transfer from the Canadian War Memorials, 1921 (8513)

Bodelwyddan Church Kinmel Kinmel Park Camp Welsh Mountains - This Range includes Snowdon Colwyn Bay Llandudno
Abergele The Irish Sea

River Clwyd - The flat land on either side of Rhuddlan Castle and Town River Clwyd
the river was once the famous
Rhuddlan Marsh Dyserth Village

Kinmel Park Camp: Location Sketch Made from the Hills above Dyserth, December 26, 1918 (cat. 32)

watercolour over graphite on wove paper, 29.1 × 45.7 cm

National Gallery of Canada, Ottawa, transfer from the Canadian War Memorials, 1921 (8515)

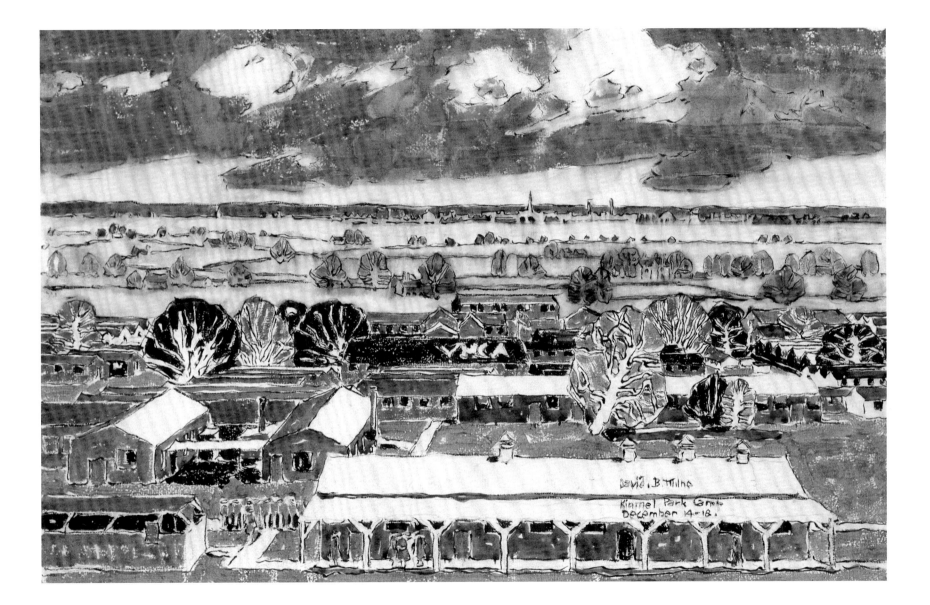

Kinmel Park Camp No. 13, Looking toward Rhyl and the Irish Sea, December 14, 1918 (cat. 29)

watercolour over graphite on wove paper, 29.1 × 45.7 cm

National Gallery of Canada, Ottawa, transfer from the Canadian War Memorials, 1921 (8517)

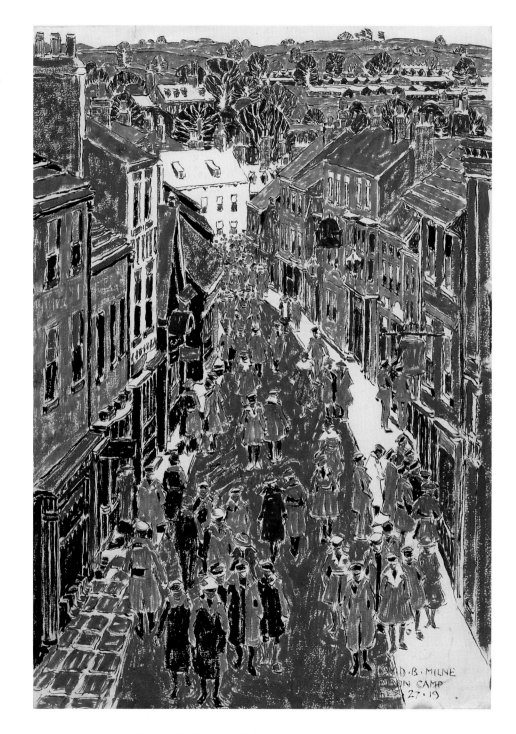

Ripon: High Street, February 27, 1919 (cat. 33)

watercolour over graphite on wove paper, 50.8 × 35.6 cm, Art Gallery of Ontario, Toronto,
bequest of Mrs. J.P. Barwick (from the Douglas M. Duncan Collection), 1985 (85/127)

"took all day until dark and long after tea time. It is rather interesting, something I have had in mind several times but never put across before. It is quite vigorous but colors are all subdivided—more or less greys—a brownish grey (cerulean and orange vermillion), a blue grey (cerulean and neutral tint), a grey green (cerulean and viridian), a yellowish grey (cerulean and yellow ochre) and a bluish grey (cerulean and vermillion, cerulean predominating) a very slight bit of purple and a little pure cerulean, and of course the white paper—also a little purer green. Up to today I have been using rather more brilliant color than usual. The trees in today's program were particularly interesting."[8]

Because Bramshott was located at the highest point, panoramic views of the camp were impossible. Instead Milne concentrated on its details, forcing him to focus on more explicit painting problems. While at Bramshott, he sent a selection of twelve watercolours—six each from Ripon and Bramshott—to join his Kinmel Park watercolours already in the Canadian War Memorial Exhibition. The expanded exhibition was leaving for the Anderson Galleries in New York. Knowing that his friend, patron, and principal art correspondent, James Clarke, would see them there, Milne discussed these Ripon and Bramshott watercolours in a letter dated April 9, 1919. To start with, he remarked on his surprise at the "use of very dry color and various things arising from the limitation and possibilities of this . . ." With *Ripon: South Camp from General Headquarters*, Milne was interested in the way he had created a strong, clear pattern by using the white untouched paper with the dull greys: "The whole thing (scratching on the color in this dry way and making it do the

work without lightening it or darkening it is a Scotch motive, getting the result with the slightest possible means . . . The development doesn't necessarily need white paper—the drawing may be quite detailed and over the whole sheet." *Bramshott: Interior of the Wesleyan Hut* (p. 75) pushed this idea along. The greys, reddish browns, purples, green and bronze yellows were held together as closely as possible in dark and light tonality, yet pushed as far apart as possible in terms of colour. The white paper in the upper half of the composition played only a very slight part in this, and Milne admitted to using the bright colours in the flags to reduce the monotonous structure of the ceiling.

Tellingly, Milne confessed that "all this theorizing is post mortem—not a plan." Yet he did go on to outline his plan for *Bramshott: The London—Portsmouth Road* (p. 72). The problem he had to resolve with this composition was looking against the light. His plan was to distinguish the black forms from each other by subtly edging them with brilliant colours to differentiate the types of uniforms and plaids of the kilts. He followed his plan precisely. Perhaps analyzing his work in writing had aided Milne's ability to clarify and solve his problems in advance of painting. The April 9 letter marks an important turning point in Milne's artistic evolution. As the replacement for what would have been the usual verbal discussions Milne and Clarke enjoyed, the letter, with its detailed parsing of specific paintings, is the germ of his practice of keeping a painting journal—something he began on his return to Boston Corners in December 1919—and that would help him develop and refine a personal, cogent æsthetic vocabulary.

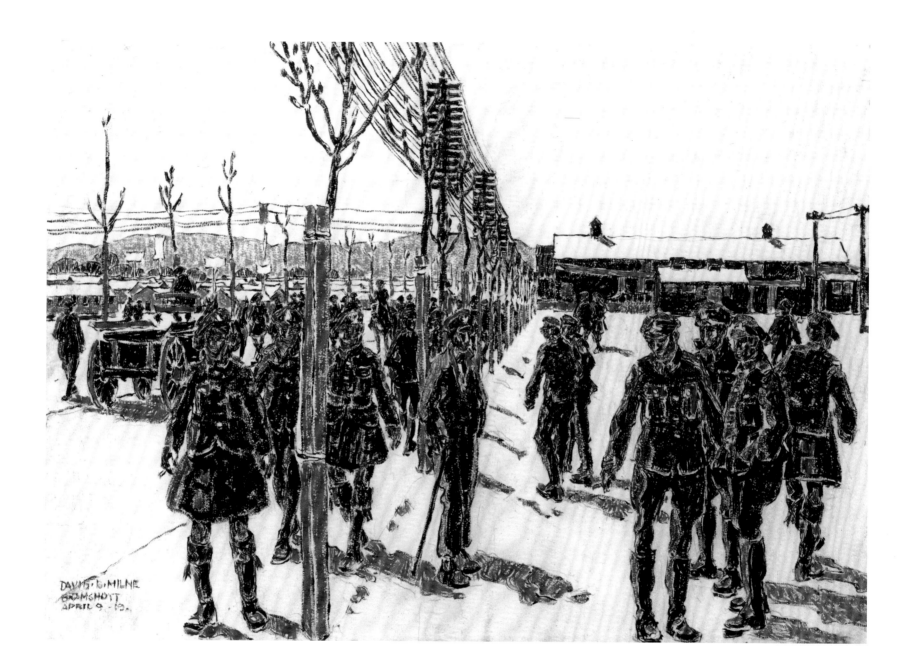

Bramshott: The London–Portsmouth Road, April 9, 1919 (cat. 36)

watercolour over graphite on wove paper, 35.4 × 50.7 cm

National Gallery of Canada, Ottawa, transfer from the Canadian War Memorials, 1921 (8546)

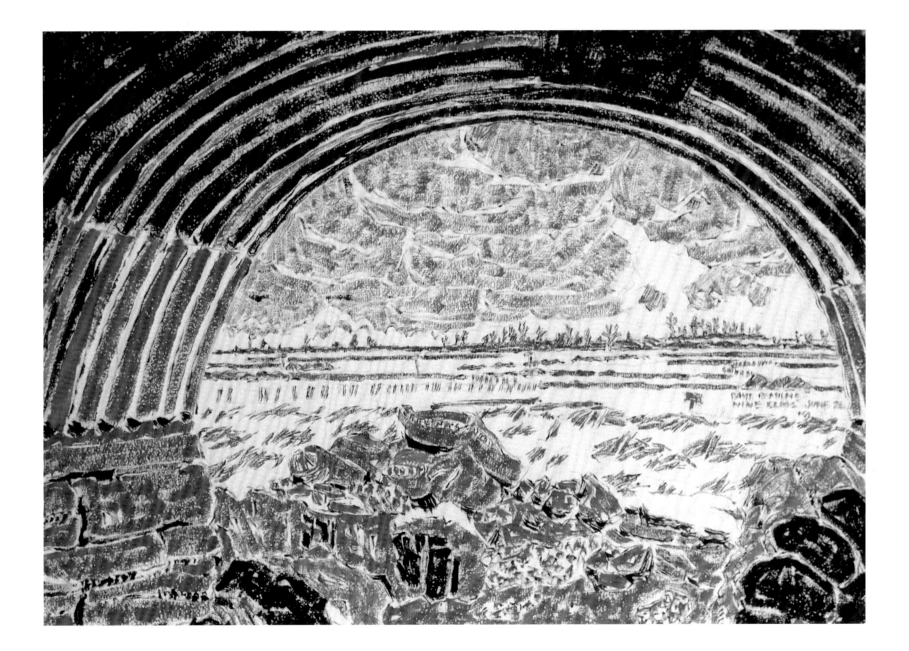

Looking towards Thélus and Thélus Wood from a Nissen Hut under the Nine Elms, June 26, 1919 (cat. 41)

watercolour over graphite on wove paper, 35.4 × 50.5 cm

National Gallery of Canada, Ottawa, transfer from the Canadian War Memorials, 1921 (8463)

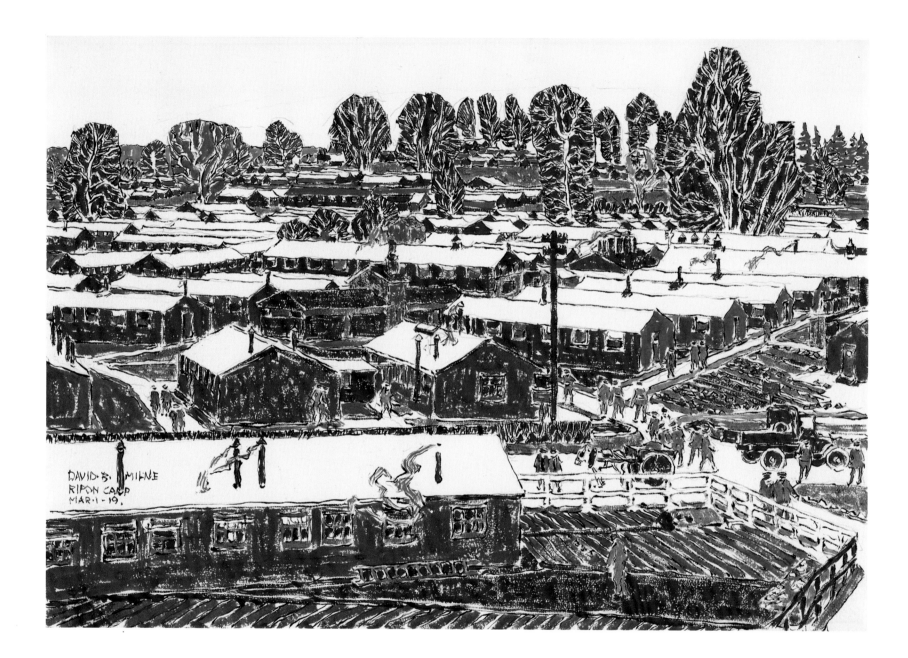

Ripon: South Camp from General Headquarters, March 1, 1919 (cat. 34)

watercolour on wove paper, 35.3 × 50.7 cm

National Gallery of Canada, Ottawa, transfer from the Canadian War Memorials, 1921 (8535)

74

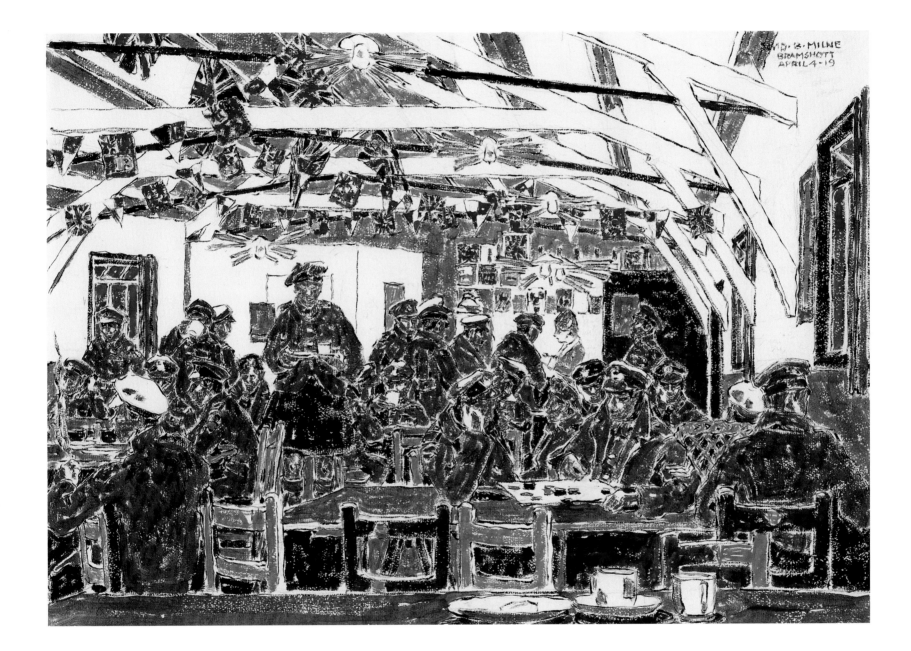

Bramshott: Interior of the Wesleyan Hut, April 4, 1919 (cat. 35)

watercolour over graphite on wove paper, 38.5 × 50.6 cm

National Gallery of Canada, Ottawa, transfer from the Canadian War Memorials, 1921 (8541)

In May, Watkins had found a solution to getting the appropriate military classification that would allow Milne to proceed to the Continent. With instructions and military maps in hand, he left for France on May 17, 1919. He was to concentrate his work at the battlefields of Vimy Ridge and the Somme areas, both near Arras, and the Ypres/Passchendaele region in Belgium. He was assigned a car and a driver, which proved to be an unreliable means of transport.[9] Many of Milne's subjects were found in long walks over the battle-scarred landscape.

Describing the landscape as a "wilderness of war wreckage," Milne recalled that

the earth had been torn up and torn up and torn up again and from it at every step, rifles and bayonets and twisted iron posts and wire projected. Shell hole merged with or overlapped shell hole, and everywhere was a litter of shell fragments, cartridges, shell cases and dud shells big and little, web equipment, helmets, German, British and . . . French, water bottles of three nations, boots and uniforms, the boots often with socks and feet in them . . . and, over all, the sweet sickish, but not offensive, smell of death . . . There were no civilians in the forward areas . . . and no soldiers except for the men engaged in three tasks. First was the Canadian graves detachment . . . They were searching all the ground that Canadians had fought over for bodies known and unknown . . . [The second were] German prisoners of war under British soldiers. They too were searching and collecting, gathering unexploded shells of all sizes . . . the larger ones were dangerous to move and were exploded

in shell holes . . . There [were] also Chinese labour battalions doing salvage work collecting reusable war material."[10]

Milne's task was to record as accurately as possible the visible aftermath on the land of Canada's war effort. To do so, he had to exercise heightened concentration of mind and eye to make visual order out of visual chaos. It was nature rendered grotesque and incomprehensible. Today, looking at photographs of the battlefields, we find it difficult to differentiate or understand the contours and details of these scenes (fig. 14). Milne was forced to develop the ability to extract those essential details and arrange them into readable compositions. Over the four months he spent on the fields of battle, he developed an increasingly pared down method of painting. He used fewer colours and reduced the detail. Compositions were simplified, allowing for an empty receding road or a tank in a barren landscape to convey the scale of war and the desolation it engendered. His greater use of drybrush created a texture sympathetic to the subjects such as churned-up ground, broken buildings, barbed wire and splintered trees.

The progress made in England to understand and control the dramatic changes in his style had laid a solid foundation to anchor, but not restrain, the further changes that occurred in France and Belgium. However, we can only surmise his thoughts on the æsthetic progress of the battlefield subjects by examining the watercolours themselves. It is Milne's emotional response to this alien, violent subject matter that is most evident in the few letters he sent from the front and his recollections in his unpublished autobiography.

Gone was the detailed analysis of his paintings, and in its place were moving descriptions of his subjects—the horror of finding a charred, rotting corpse in a wrecked tank, the size of the Montreal Crater at Vimy, so large that it could hold a church, or the poignant letter written by a soldier who took shelter in a Nissen hut under the Nine Elms. Throughout his time on the battlefields, Milne "was reminded in the hot sunshine of beautiful summer [that] countless other men had struggled in agony through darkness and cold and mud."[11]

No experience stayed in his heart more than the one that occurred while painting the watercolour *Courcelette from the Cemetery* (p. 87). Three years previously, Courcelette had been the site of Canada's participation in the first days of the Battle of the Somme, where the twenty-four thousand casualties represented a tenth of all Canadian casualties sustained in the war. The work is the best known of Milne's war watercolours and fittingly stands as his memorial to Canada's war dead. He wrote:

> The sunshine of the morning was gone and a fog was closing down before I got to Courcelette, but I could see across a shallow valley the red brick ruins of the village, dead apple trees and beyond, the wreckage of the sugar refinery. I came to a small Canadian cemetery. New, muddy, with weeds growing in the earth and row on row of wooden crosses. A single wire on short posts surrounded it. The white fog was now close to earth and covered me like a white tent with only a small area visible before me. The bowl in which was the ruin of Courcelette showed mistily beyond the crosses of the cemetery. I set to work, no sounds reached me. I was cut off from the world, only this little bit of the past concerned me.

Fig. 14 *Montreal Crater, Vimy Ridge, No. 24*, undated, Canadian War Museum, Ottawa, George Metcalf Archival Collection (AN19660047-024)

> I had been working for a while when I became aware that I wasn't alone. A detachment of Canadian soldiers was entering the cemetery, a chaplain, and an officer with a firing party. They formed up opposite me. Whether they beckoned me or whether I joined them of my own accord I don't remember, but I stood at attention with them. The burial service was read, volleys were fired and the bugle sounded. The detachment consulted maps and hurried off . . . for another such service I suppose.

> It is less than ten minutes since they first appeared. The artist is again at his drawing, adding more crosses, trying to find some

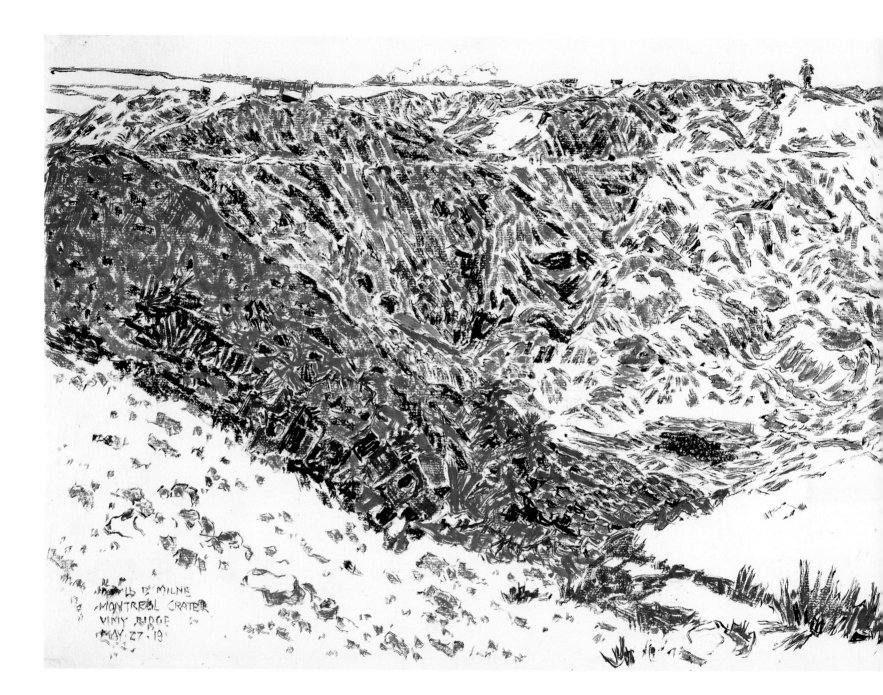

DAVID B. MILNE
MONTREAL CRATER
VIMY RIDGE
MAY. 27. 19

Montreal Crater, Vimy Ridge, May 27, 1919 (cat. 39)

watercolour over graphite on wove paper, two sheets: 35.3 × 101.3 cm

National Gallery of Canada, Ottawa, transfer from the Canadian War Memorials, 1921 (8440.1-2)

order in the tumbled flatness . . . The Canadians have gone from France, all but a handful, less than a hundred left . . . to care for Canadian Graves. This ceremony, with its one spectator drafted as participant is Canada's official farewell to the men who won, and lie beside, Courcelette.[12]

Completing his task at the end of August, Milne turned over the remainder of his watercolours to the CWM. All 111 are of an astonishingly high quality, rendered in a style totally his own and unlike any First World War subjects painted by any artist from any country.[13] Where others had painted the action of war, be the subjects figurative or landscape, Milne painted the stillness of war's aftermath on the denuded and convulsed landscape. The war watercolours are pivotal to his art, profoundly changing his style by eliminating all vestiges of his Impressionist roots — particularly light's transient effects. They also made him conscious of his need to first understand and then define his own æsthetic language, which would soon make him one of Canada's most thoughtful art theorists. The security and support he was given to undertake the project certainly played a part in his unquestionable achievement.[14] Yet one must also consider Milne's ability to make the most out of the emotional intensity of the experience and the constantly changing æsthetic demands he had to meet. David Milne tersely summed up his war experience: "The man changes, and with that, the painting."[15]

Zillebeke: Maple Copse and Observatory Ridge from Dormy House, August 14, 1919 (cat. 44)

watercolour on wove paper, 35.4 × 50.5 cm

National Gallery of Canada, Ottawa, transfer from the Canadian War Memorials, 1921 (8485)

Wancourt, August 30, 1919 (cat. 46)

watercolour over graphite on wove paper, 35.3 × 50.6 cm

National Gallery of Canada, Ottawa, transfer from the Canadian War Memorials, 1921 (8496)

Wrecked Tanks outside Monchy-le-Preux, May 24, 1919 (cat. 38)

watercolour over graphite on wove paper, 35.4 × 50.7 cm

National Gallery of Canada, Ottawa, transfer from the Canadian War Memorials, 1921 (8438)

Loos from the Trenches on Hill 70, August 23, 1919 (cat. 45)

watercolour over graphite on wove paper, 38.4 × 55.9 cm

National Gallery of Canada, Ottawa, transfer from the Canadian War Memorials, 1921 (8493)

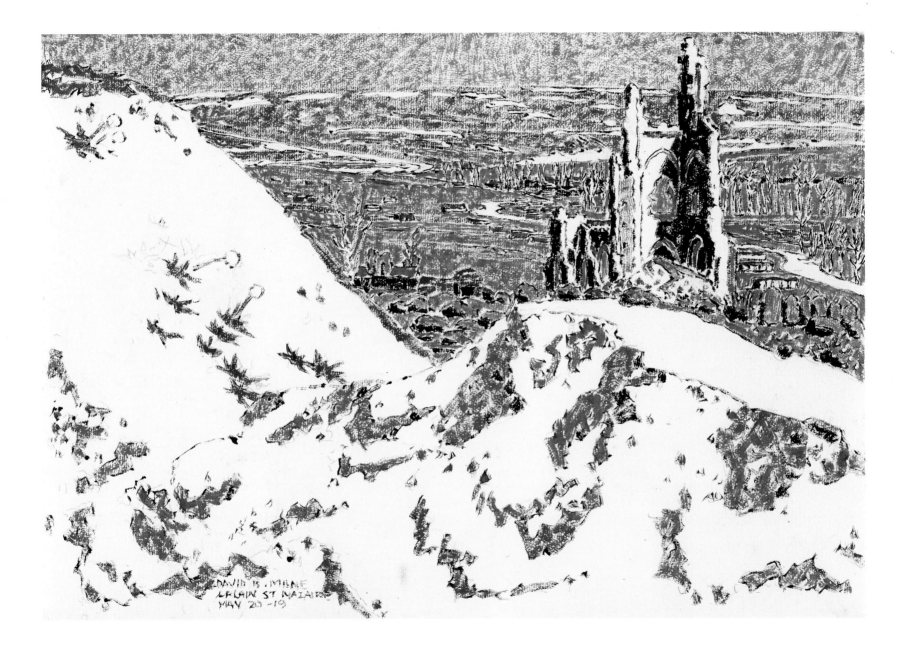

Ablain-Saint-Nazaire Church from Lorette Ridge, May 20, 1919 (cat. 37)

watercolour over graphite on wove paper, 35.4 × 50.6 cm

National Gallery of Canada, Ottawa, transfer from the Canadian War Memorials, 1921 (8434)

From a German Gun Pit at Bailleul, East of Vimy, June 3, 1919 (cat. 40)

watercolour over graphite on wove paper, 25.1 × 35.3 cm

National Gallery of Canada, Ottawa, transfer from the Canadian War Memorials, 1921 (8446)

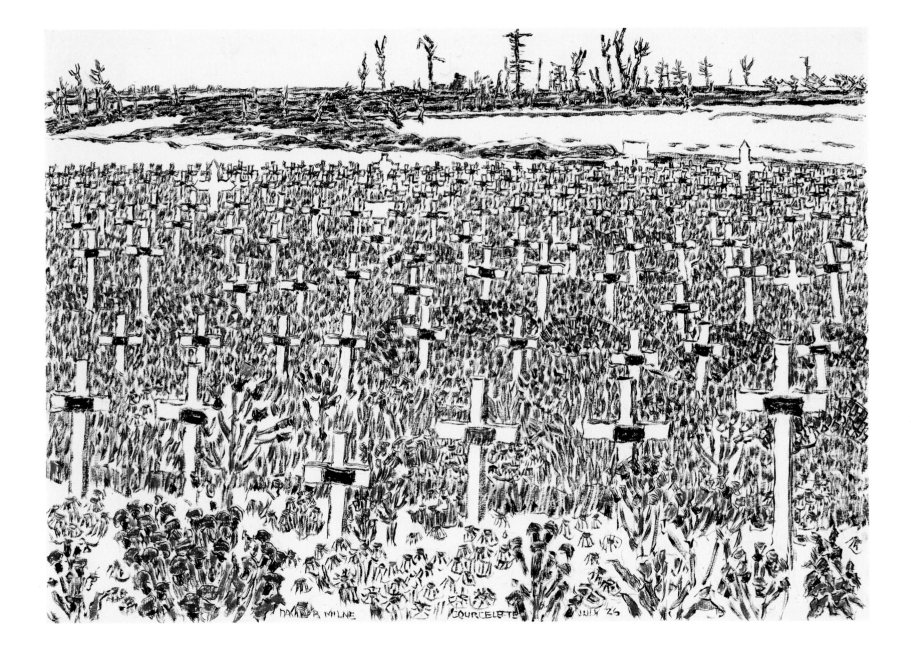

Courcellette from the Cemetery, July 26, 1919 (cat. 43)

watercolour over graphite on wove paper, 35.4 × 50.6 cm

National Gallery of Canada, Ottawa, transfer from the Canadian War Memorials, 1921 (8478)

Lanterns and Snowshoes (Interior of Tea-House), September 4, 1923 (cat. 56)

watercolour over graphite on wove paper (watermark: "J Whatman"), 38.5 × 55.0 cm

Milne Family Collection

"Decision, Strength, and Brilliant Colour"
The Post-War Watercolours

CAROL TROYEN

Milne left Europe in the fall of 1919. He was demobilized in Toronto, visited New York City briefly in November, and by December was back in Boston Corners. His next ten years in New York State, when he was based in or near Boston Corners and then at Lake Placid, were not nearly as idyllic as the pre-war years had been. In part, Milne was restless; in part, he was driven by the need for income and was frustrated by the lack of response to his work. Periods of isolation (especially the winter of 1920–21, when he was alone in a "painting cabin" he constructed for himself on Alander Mountain), were restorative; summers, when he worked as a handyman while Patsy ran a tea room or worked as a bookkeeper at various camps and resorts, were sometimes productive (in his first summer at Dart's Lake, he painted nearly forty pictures), sometimes

not (the next year he produced only one watercolour between April and October).

During these years he occasionally sent watercolours to the familiar venues, with indifferent success.[1] On the positive side, a few new opportunities emerged. While at Dart's Lake in the summer of 1921, he met Christian Midjo, a professor of painting at Cornell University, who arranged an exhibition of some fifty watercolours at the College of Architecture the following spring. The show presented a survey of Milne's recent work. Prices were low; pictures were offered at $20 or $30.[2] Milne was nonetheless gratified that some pictures sold, and he gained the support of two new patrons, Robert North and Maulsby Kimball of Buffalo. North also acted as Milne's agent, arranging the sale of at least a half-dozen works.[3] The Toronto artist and designer J.E.H. MacDonald provided similar support, arranging to have one of Milne's watercolours (*Camp Porch*, p. 94) reproduced in the publication *Canadian Forum*, for which Milne was paid a $15 fee.

During Milne's years in New York State, his greatest friend and benefactor was James Clarke. Like Milne, Clarke began his career as a commercial artist in New York City but remained in that field, eventually becoming the vice chairman of Calkins and Holden, a leading New York advertising agency. It is not certain when the two met — possibly in connection with Milne's 1915 exhibition in his apartment.[4] Clarke visited Milne frequently in Boston Corners; provided timely financial support through loans, housing, and agreeable employment; and sent him packages of delicacies every Christmas for some thirty years.

Clarke, in many respects, was Milne's Stieglitz — champion, protector, agent, and confessor. He promoted Milne's paintings through his network, the advertising world, hanging pictures in his company offices and urging colleagues to buy them.[5] He stored paintings for Milne. He kept Milne abreast of exhibition opportunities in New York. And, by writing letters to Milne and welcoming his replies, Clarke provided encouragement, moral support, and an outlet for Milne's thoughts on personal and especially artistic matters.

Milne's letters to Clarke are like a diary, recording his daily activities in extraordinary detail. He worked out painting problems in them, included sketches and diagrams of the painting house he was constructing, and shared even the most mundane episodes: "besides tea I had a lettuce and mayonnaise sandwich, a cheese sandwich, and strawberry jam for supper."[6] Such letters are at once self-absorbed — stemming from Milne's conviction that he would be recognized someday and that even such commonplace facts might be found significant — and generous. They allowed Clarke, who had given up his fine arts career, to imagine himself painting alongside Milne, and so to continue living vicariously as a painter in the heroic American tradition.

Clarke, for his part, was often quite perceptive about Milne and his work. He noted, for example, that Milne was not a passionate painter but an almost scientific one ("There was nothing emotional or impulsive about him. [Painting] was a process of thought and logic").[7] This is borne out by Milne's painting journal, kept between December 18, 1919, and September 14, 1920, and again between November 15, 1920, and January 14, 1921. Those journals contain a

Fig. 15 David Milne, *Woman Reading*, 1920, M&S201.88,
watercolour over graphite on wove paper, 38.3 × 55.8 cm, National Gallery of Canada,
Ottawa, gift from the Douglas M. Duncan Collection, 1970 (16460)

Verandah at Night IV, August or December 1923 (cat. 55)

watercolour over graphite on wove paper, 39.6 × 56.5 cm

Art Gallery of Hamilton, Hamilton, Ontario, gift from the Douglas M. Duncan Collection, 1970 (70.86.29B)

Ice Box and Shelves, March 7, 1920 (cat. 47)

watercolour over graphite on wove paper, 44.5 × 55.3 cm

Museum London, London, Ontario, Bequest of Mrs. Frances Barwick, Ottawa, Ontario, 1985 (85.A.17)

Camp Porch, September 7, 1921 (cat. 52)

watercolour over graphite on wove paper, 39.4 × 41.6 cm

Art Gallery of Ontario, Toronto, gift from the McLean Foundation, 1960 (59/36.1)

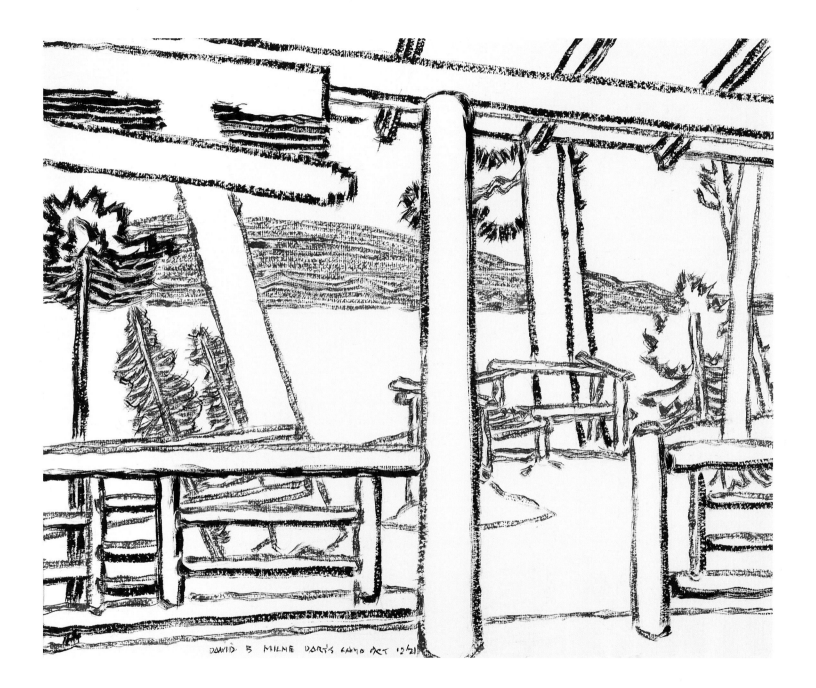

Porch by the Lake, October 12, 1921 (cat. 54)

watercolour over graphite on wove paper, 38.8 × 48.6 cm

Milne Family Collection

Fig. 16 David Milne, *Tribute to Spring*, May–June, 1925, M&S207.40, water-colour over graphite on wove paper, 28.2 × 38.5 cm, National Gallery of Canada, Ottawa, gift from the Douglas M. Duncan Collection, 1970 (16126)

precise, factual recording of time, place, and weather for each picture, the specifics of his practice ("Color on figure is literal except that black is left out") and the results of the undertaking ("This is the first successful treatment of scattered trees on hillside"), all analyzed dispassionately.[8] Glimpses of emotional engagement with his subject matter (which in fact was great) are rare. In his writings, Milne often shifts to the passive voice when talking about the processes of picture making, and his language becomes terse and dry.[9] But occasionally there is a flash of poetry: "Came past Trinity Church

[his name for a massive dead hemlock] and carried over slab of bark in as far as the stove. The stove with its rusty vermilions, grays, blues and purples is as brilliant as an orchid."[10]

Similarly, although few of Milne's watercolours display any obvious outpouring of emotion, a number are personally revealing. *Woman Reading* (fig. 15), a descendant of the New York City interiors from 1912, and one of a number of single figure studies painted in early April 1920, is a cozy, intimate picture. Patsy sits bent over a book, unaware of the viewer's presence. Her foot is turned over at an awkward angle, which gives the picture an affectionate, humorous charm. Yet the space is cramped. Her head is nearly cut off at the top of the sheet. And she is hemmed in by two of her husband's paintings, a landscape with a black background at right and a similar landscape with a white background at left, next to which is a bust of Milne with its head turned away from her. It is an image dense with unspoken tensions.

The watercolours Milne painted in his New York State years are extraordinarily experimental. Such experiments were part of the modernist program, and like Marin, O'Keeffe, Demuth, and others,[11] Milne adopted unconventional methods and materials for his watercolours: he cut out parts from one to use as a corrective on another (*Bishop's Pond*, frontispiece); he flung paint to produce a spattered effect (*Tribute to Spring*, fig. 16). He undoubtedly used a stiff-bristled brush (probably one designed for oil paints) rather than a soft, sable watercolour brush for his drybrush technique, whose raspy, angular linearity flies in the face of conventional watercolour's spontaneous, flowing quality (Milne referred to such works as "line drawings in

Glenmore from under the Porch, September 26, 1923 (cat. 57)

watercolour over graphite on wove paper, 38.1 × 55.6 cm

Private Collection

color"). And his remarkable reflections paintings from 1920, about which he says little even though he must have recognized their radical nature, take the convention of painting wet-on-wet and stand it on its head.[12]

In several pictures, notably *In the Cabin on the Mountain I* (p. 118; second version, April 1923, M&S204.117, National Gallery of Canada) and *Verandah at Night IV* (p. 92), Milne defies watercolour's inherent transparency and the contribution usually made by the white paper to suggest light and atmosphere. He instead experimented with building his images out of opaque blackness. The objects in these watercolours, whether inanimate or human, are defined — almost perversely — by white outlines that are actually reserved paper and that are sometimes coloured with dense pigments, either rusty brown or blue. As a result, the space is read clearly as three-dimensional and just as clearly as patterns of spidery lines on the surface. Milne had played before with the push-pull spatial effects created by relationships between black and white, but never so boldly as here.

About six months after he painted the first version of *In the Cabin on the Mountain*, he painted an equally radical image that is seemingly as empty as that work is dense. In 1912 he had been dubbed "the brilliant and subtracting Mr. Milne;"[13] by 1920 reduction and elimination had become his mantras: "Starting with a clean sheet of paper . . . cover the paper as slightly as possible . . . remove it as slightly as possible from its original smooth whiteness . . . put just enough labor and color on the paper to tell what is to be told."[14]

In *Across the Lake I* (p. 116), painted at the end of the 1921 season at Dart's Lake, Milne pushes the shoreline — a horizontal band of

dry brush strokes — to the upper third of the sheet. He first used these spare, scratchy strokes — made by dragging a stiff brush loaded with dry pigment over textured paper — when working as a war artist in Belgium, where they were particularly suited to rendering denuded landscapes and shattered trees. Here they cause the trees and houses to seem to vibrate; the contour of the mountain looks like barbed wire. The bottom two-thirds of the sheet, magically leading the eye across the lake's broad expanse while simultaneously reading as a strong, abstract design element, is unpainted paper. This area is white, but not blank, smooth but not textureless, empty but not insubstantial. Milne surely recognized his achievement, for he chose this watercolour for the show at Cornell and, along with *In the Cabin on the Mountain*, to represent him at the British Empire Exhibition in London in 1924.

Milne visited Canada in 1923–24.[15] It was an often frustrating trip during which he produced little and sold even less — until just before he returned to the United States, when the National Gallery of Canada purchased six watercolours for $25 each. Although the price was low, the honour was significant — museums in the United States and Canada had just begun to collect contemporary watercolours[16] — and the Gallery's acquisitions represented a strong selection of Milne's mature work (although, oddly, there were no interiors and only one of the spectacular reflections pictures of 1920; these would come to the Gallery later). The more than one hundred watercolours done in the aftermath of the First World War had been transferred in 1921 from the Canadian War Memorials office to the Gallery, which made it the largest repository of Milne's work.[17] In

contrast, the first Milne watercolour did not enter a museum in the United States until 1961, when Douglas Duncan, a great patron of Milne's in his later years, gave *Sunburst over the Catskills* to the Museum of Modern Art.

After Milne returned from Canada, his watercolour production slowed dramatically. He was distracted by the construction of a cottage at Big Moose Lake, and, in the winters, by running a tea room at Lake Placid. He painted several watercolours in early 1925, but these are generally scattered, unsatisfactory, without the toughness or elegance of design of the earlier works. He experimented with spatters of colour (*Tribute to Spring*, fig. 16, p. 96) and with laying down his drybrush strokes in a circular, scrubby manner (*Clouds and Mountains I*, March 1925, M&S207.14, National Gallery of Canada) or in freer, more gestural strokes (as in the *Ski Jump Hills with Radiating Clouds* group, 1925 [M&S207.17, Milne Family Collection; M&S207.18, Vancouver Art Gallery; M&S207.19 and M&S207.20, National Gallery of Canada]), but these innovations did not engage him fully. Sometime in early summer he stopped making watercolours altogether and—absorbed by his oil painting and by his exciting new printmaking technique,[18] the color drypoint—didn't return to the medium until 1937.

Yet—as it had with so many talented artists of his generation—watercolour had become Milne's principal vehicle for modernist expression. As a medium, it had the potential to challenge the expected, the conventional, the academic. It allowed a tremendous variety of effects. It appealed to Milne's intense individualism and his seemingly insatiable interest in the technical problems of art making. Modernism's press for new, untraditional subject matter—the skyscrapers and bridges and machines that had been embraced by many of his contemporaries from the time he arrived in New York—held little attraction for him. He preferred old-fashioned picturesque landscapes, quiet interiors. Milne's modernism was bound up in how he painted, not what. And the excitement of how he painted, and the radical nature of his style, is best found in his watercolours. As he wrote in his autobiography, "I liked the medium. It was favorable to decision, strength and brilliant color."[19]

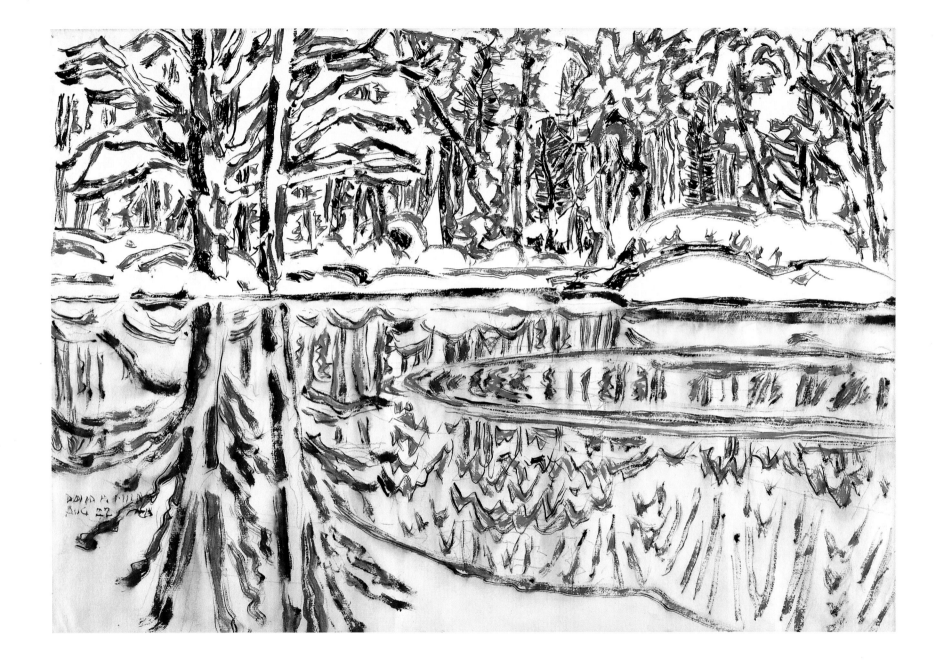

Reflections, Bishop's Pond, August 22, 1920 (cat. 48)

watercolour over graphite on wove paper (watermark: "J Whatman"), 38.4 × 56.1 cm, Art Gallery of Ontario, Toronto,

gift from the J.S. McLean Collection, Toronto, 1969, donated by the Ontario Heritage Foundation, 1988 (L69.45)

Reflections on
Turner, Whistler, Monet,
and Milne

KATHARINE LOCHNAN

Come said the Muse,
Sing me a song no poet yet has chanted,
Sing me the universal.

In this broad earth of ours,
Amid the measureless grossness and the slag,
Enclosed and safe within its central heart,
Nestles the seed perfection

— Walt Whitman, "Birds of Passage:
Song of the Universal"

The brilliant series of reflections of landscapes in bodies of water, executed at Boston Corners, Dart's Lake, and Big Moose Lake between 1916 and 1923, are among David Milne's finest achievements in any medium. These watercolours are so startlingly original that their genesis is difficult to trace. Milne, however, encouraged this investigation, writing some years later that "painters feel when they paint and only understand later . . . viewers need to understand first in order to feel."[1] In order for us to understand them and appreciate their place in the history of art, we need to follow the clues provided in Milne's unpublished writings. These lead straight to the nineteenth- and early-twentieth-century British and French landscape tradition, to the works of three artists whom Milne greatly admired: Joseph Mallord William Turner (1775–1851), James McNeill Whistler (1834–1903), and Claude Monet (1840–1926).

The three artists worked from nature and established landscape as a subject category worthy of serious artistic endeavour. They did this by going beyond a recording of topographical detail and exploring the relationship between art and poetry. They painted the emotions they experienced in the presence of nature with the intention of evoking a subjective response in the viewer. Inspired by Romantic and Symbolist poets,[2] they discerned a poetic element in fugitive natural phenomena such as light, atmosphere, and reflections. Whistler created variations on themes inaugurated by Turner, and Monet created variations on themes inaugurated by both Turner and Whistler. Impressionism and Symbolism owe much to this fascinating artistic dialogue that helped to set the stage for twentieth-century modernism.[3]

In "Art: Monet" (1940s), the only essay Milne ever wrote about another artist, he astutely pointed out the relationship between the works of Turner, Whistler, and Monet, demonstrating both his powers of perception and first-hand knowledge of their works. He observed that "Monet was closer to Turner, very close to the Turner of the sea pictures . . . and perhaps Whistler in his night scenes, than to the impressionists or any others." Milne's insights into their work transcended mere formalist analysis: he saw "æsthetic unity," which he considered central to art, as "the driving force" not only behind the painting of Turner and Monet but also of "Whistler's evening and night pictures of the Thames." He ended with the statement "the great effect Monet had on me would be hard to trace. No one has ever noticed it."[4] When Milne completed a questionnaire for his artist's file in the reference library of the Art Gallery of Toronto (Art Gallery of Ontario) in 1942, he noted that "for a while they [Monet's paintings] influenced my painting, directly; perhaps they still do very indirectly . . . I soon found that Monet's way of achieving unity was Monet's way, and impossible for anyone else to follow directly. I still look for unity in painting, for singleness of purpose in painters above all things, but whatever efforts I have made in this direction have been along other lines than Monet's."[5] Monet was the only artist whose influence he acknowledged, and only "in early years."[6]

Milne claimed that he left Canada "to get away from influences."[7] The belief that to acknowledge artistic influence was tantamount to acknowledging weakness was widespread by the 1890s (fig. 17). Whistler had categorically denied all influence; his pupil Walter Sickert wrote, "It was Whistler's incessant preoccupation to present

himself as having sprung completely armed from nowhere,"[8] which makes Whistler's personal and professional alliance with Monet in the mid-1880s all the more significant. Milne presented himself to Massey as virtually free of influence, writing that "for most of my painting life I have been cut off from other painters."[9] Aligning himself with the modernist position,[10] he maintained that he belonged to "no school."[11] When interviewed by Stockton Kimball, a patron, and asked if he was a member of Canada's Group of Seven, he replied, "I wouldn't like to be more than 1 of 1."[12] His good friend James Clarke provided insight into Milne's position, saying, "Of course a person that is imitating some other artist's methods and techniques, that's a reflection also on his own character. He is too weak to make his own methods. That wasn't true of Milne."[13]

Milne maintained that early impressions have the greatest impact on an artist's development.[14] His most vivid memories were childhood hikes up the hill behind the log cabin in Burgoyne, Bruce County, Ontario, where he was born. From the top of the hill, he looked down over fields rolling away in three parallel waves toward the blue band of Lake Huron with its glorious sunsets, a view that brought him "face to face with infinity where anything might be and anything might happen."[15]

There has been a tendency to assume that small towns in rural Ontario were intellectual and cultural backwaters in the nineteenth and early twentieth centuries. By 1903, when Milne left the picturesque town of Paisley for New York, it was one of the most prosperous in Bruce County.[16] When he returned for a visit in 1906 he observed that its citizens "probably have much better ideas of

OUR ART STUDENTS

THE ONE WITH THE PALETTE. "*I'm afraid—just a little afraid—that I've followed Sargent too closely.*"
THE ADMIRING FRIEND. "*Oh, it shows the influence of Sargent slightly, dear, but don't worry — there's enough of yourself in it to save it!*"

Fig. 17 "Our Art Students," *Harpers Monthly Magazine* (New York) 103 (June – November 1901): 161, courtesy Library and Archives Canada, Ottawa (A-17614)

life than even the better class of New Yorkers."[17] Bruce County schools graduated some of the province's leading scholars, among them Milne.[18] It had more public libraries than any other county in Ontario, and Milne was a great reader. While he was teaching school, studying commercial illustration, and making the decision to go to New York, the Paisley Public Library was an invaluable resource.[19] Milne must have spent a considerable amount of time there, as he and the librarian became close friends.[20]

There Milne could have seen the latest numbers of *Scribner's Magazine*, *Harpers Monthly*, and *The Century Illustrated Monthly*,

Fig. 18 J.M. Whistler (American, 1834–1903), *Nocturne* from *The First Venice Set*, K.184, 1879–80, etching and drypoint printed in warm brown ink with plate tone on old laid paper, 24.0 × 29.5 cm, Art Gallery of Ontario, Toronto, gift of Touche Ross, 1978 (77/190)

The death of James McNeill Whistler in London on July 17, 1903, a week after Milne's announced departure for New York, precipitated an outpouring of publications and exhibitions devoted to America's most celebrated expatriate artist. His fame had spread around the world in the wake of the 1878 court case that he had fought and won against the great Victorian art critic, John Ruskin, on the subject of the right of the artist to decide when a work of art is "finished." Milne would have been exposed to Ruskin's ideas before leaving for New York, as his popular writings were among the first acquisitions made by the Bruce County libraries and by the library in the nearest large town, Owen Sound.[26]

Milne probably read *The Gentle Art of Making Enemies* by Whistler (published in London in 1890 and New York in 1892) soon after his arrival in New York, in 1903, and it may have contributed to his decision to abandon a career in illustration for one in fine art. This compilation of Whistler's writings became a veritable quarry for Milne's æsthetic theories. Milne adopted the "art for art's sake" position advocated in Whistler's "Ten O'Clock" lecture (reproduced in the book), stating unequivocally that "art is useless, it has no objective."[27] He echoed Whistler's analogy of art to music and poetry in his own statement that "painting, music and poetry are pretty much pure art mediums—the æsthetic dominates."[28] Like Whistler, Milne resigned himself to the fact that his work would appeal only to the cognoscenti, saying that "many can feel a purely æsthetic emotion in music, few can get it from painting. So my audience, even when I reach it, is limited."[29] By 1906 he so fully identified with Whistler's æsthetic that he described his girlfriend, Patsy Hegarty, as "a certain

with their outstanding illustrations and articles about the British, French, and American art scenes.[21] In 1902 these included articles on the ambitious building boom in the "new New York" (which aspired to rival Paris),[22] the extraordinary number of exhibitions and art galleries,[23] and pointed out that "artists of the United States—those whose head-quarters are in New York especially—are more loyally supported than the artists of any other country."[24] This probably contributed to his decision to study in New York rather than take the shorter and more obvious route to the Ontario School of Art in Toronto.[25]

little colour scheme of red-gold and navy blue" whose lips touched his "like a butterfly."[30]

Milne was especially interested in Whistler's concept of "finish" and called his "Ten O'Clock" an "essay on economy of means."[31] The debate over finish was central to the Whistler versus Ruskin court case, and Milne puzzled endlessly over what Whistler had really meant by "a picture was finished when all trace of the means used to bring about the end has disappeared."[32] As late as 1931 Milne paraphrased Whistler's statement in a letter to Clarke as "a picture was finished when all evidence of labor was eliminated, something of the kind. I don't remember whether he said so or why, but he knew, and Ruskin was wrong—though the greatest of art critics just the same."[33]

To gain further insight into Whistler's ideas, Milne sought out those who had known the artist. He attended a lecture on Whistler by William Merritt Chase embroidered with inspiring, if colourful, reminiscences.[34] The New York dealer Frederick Keppel, who handled Whistler's work and encouraged Milne's initial forays into etching, was another source of Whistler reminiscences.[35] Milne studied the etchings of Whistler and those of his "pupils" and "followers" Joseph Pennell, Theodore Roussel, and Walter Sickert,[36] and his experimental etchings of 1909 bear the unmistakable stamp of Whistler and his circle. Elizabeth Robbins Pennell and Joseph Pennell's indispensable two-volume *Life of James McNeill Whistler* was published in October 1909 and was so popular that it was reprinted twice in the months that followed. Milne wrote to Patsy that month, saying that Pennell's etchings, on view at Keppel's, "were much like

Fig. 19 J.M. Whistler (American, 1834–1903), *Nocturne*, c. 1883, watercolour on beige wove paper, 227.0 × 284.0 cm, The British Museum, London, England, purchased 1982 (1982-2-27-4)

my own except better and more expensive."[37] In 1915 Milne sat with Pennell on a jury in Philadelphia and was thrilled to have an opportunity to discuss Whistler with the man who had been both his friend and biographer.[38]

In 1910 two important exhibitions of Whistler's etchings took place in New York, one at the Grolier Club in February and the other at the Keppel Gallery in December.[39] In July and August Milne made four visits to the New York Public Library[40] (then housed in the Lenox Library)[41] to look through the superb collection

Fig. 20 J.M. Whistler (American, 1834–1903), *Troop Ships*, July 27, 1887, K.319, etching, 12.7 × 17.7 cm, Hunterian Art Gallery, University of Glasgow, Scotland, Rosalind Birnie Philip Bequest, 1958 (GLAHA 46924)

of Whistler etchings donated by Samuel P. Avery.[42] On the first two visits he requested Otto Bacher's recent publication, *With Whistler in Venice* (New York, 1908), which describes the revolutionary tonal printing methods used by Whistler for his *Nocturne* etchings. On the second, third, and fourth visits he looked at the etchings themselves. On his last visit he also requested volume three of the newly published catalogue raisonné by Edward G. Kennedy, *The Etched Work of Whistler* (New York, Grolier Club, 1910), which contains some of the Venice etchings,[43] among them *Nocturne*, 1879–80 (fig. 18), a tour de force of "artistic printing." By consulting Kennedy's

descriptions of "states" and the reproductions in this catalogue, Milne would have been able to reconstruct the stages in the evolution of Whistler's most ambitious copper plate.[44]

Milne was impressed by Ruskin's statement that "the less sufficient the means appear to the end, the greater will be the sensation of power."[45] This concept was fundamental to Whistler's set of artistic "Propositions," one of which stated that "in Art it is criminal to go beyond the means used in its exercise," and "the space to be covered should always be in proper relation to the means used for covering it."[46] After studying Whistler's etchings, Milne concluded that "the vital part of any picture . . . is very small and can be quickly noted or easily remembered."[47] By comparing Milne's plate *Ellis Island, July 8, 1911* (fig. 21), to Whistler's *Troop Ships*, 1887 (fig. 20), it is possible to see how, following Whistler's example, Milne selected only the essential details of the composition, juxtaposed areas of pattern with areas of void, and strove to master Whistler's Oriental sense of balance and placement.

He had his first opportunity to see a critical mass of Whistler's paintings between March 15 and May 31, 1910, when the Whistler memorial exhibition, "Paintings in Oil and Pastel by J.A.M. Whistler," took place at the Metropolitan Museum of Art. It included three of Whistler's famous painted *Nocturnes* from the collection of Charles Lang Freer of Detroit, among them the controversial *Nocturne in Black and Gold: The Falling Rocket* (see fig. 8, p. 36), which gave rise to the Whistler versus Ruskin court case.[48] By the late nineteenth century Oriental perspective and compositional devices had revolutionized commercial illustration, and Milne would already have

been familiar with them.[49] He appears to have looked closely at how Whistler adapted Japanese perspective to the construction of his picture space. A pioneer *japoniste*,[50] with a large collection of ukiyo-e woodcuts, Whistler had employed a "bidimensional" picture space in the 1860s, "flattening" his compositions, and creating a sense of recession by raising the horizon line and incorporating *repoussoir* devices into the foreground. Milne not only adopted the bidimensional picture space, he renounced the third dimension, saying that "any picture that depends on 3 dimens[ional] form just goes thru my sieve and is lost there."[51] Despite the fact that his work owes at least as great a debt to Japan as Whistler's,[52] Milne told Stockton Kimball that Whistler was "not a first rate artist. Too imitative. Got a lot from the Jap[anese], but I get a thrill every time I see him."[53] In an attempt to defuse allegations of influence, Whistler had made similarly dismissive comments about Turner, which were dutifully recorded by the Pennells.[54]

By the time that Whistler's posthumous reputation had reached its zenith, Monet was at the height of his power and working on the water-lily series. His ongoing interest in the works of Turner and Whistler did not end with Whistler's death: on a trip to Venice in 1908 Monet made variations on themes inaugurated by both of them.[55] From the time of Milne's arrival in New York, Monet's works were on display almost every year at commercial galleries, and many found homes in New York private collections. Although Milne saw works from all of Monet's series, it was the sight of several grainstacks (haystacks) at the Durand-Ruel Gallery shortly after his arrival in New York that left an indelible impression.[56] "It was

Fig. 21 David Milne, *Ellis Island*, July 8, 1911, T.17, etching with plate tone on beige wove paper, 10.0 × 15.0 cm (imp.), Ed. 1/1, Milne Family Collection

the amazing unity of the pictures that impressed me," wrote Milne, "a unity gained by compressing [by pressing detail into], by forcing all detail to work to the one end. In all other pictures I was conscious of parts, in these I felt only the whole."[57] Seeing beneath Monet's surfaces he concluded that "of all modern painters of our time Claude Monet seems to me the most difficult."[58]

In his letter of August 20, 1934, to Alice and Vincent Massey, Milne wrote that "pictures in series are no novelty. The views of Yeddo, the Fuji-yama and other series of Japanese prints are familiar. These, however, are united merely by subject, title. Claude Monet's pictures in series, haystacks, cliffs, cathedrals, water lilies, have, in

Fig. 22 J.M.W. Turner (English, 1775–1851), *Lake Lucerne: The Bay of Uri from Brunnen; Sample Study*, c. 1841–42, TB CCCLXIV 354, watercolour and bodycolour on paper, 24.2 × 29.7 cm, Tate, London, accepted as part of the Turner Bequest 1856 (D36216)

Fig. 23 J.M. Whistler (American, 1834–1903), *Nocturne in Blue and Silver — Cremorne Lights*, 1872, YMSM 115, oil on canvas, 50.2 × 74.3 cm, Tate, London, bequeathed by Arthur Studd, 1919 (N03420)

addition, a distinct æsthetic group relation, each grows out of the ones preceding it in the series." He greatly regretted the fact that Monet's paintings had not all been shown in series, saying that "it would have been particularly interesting if each group could have been seen together. I don't believe they ever were shown that way, and it is too late now, except in reproduction."[59]

After moving to Boston Corners in 1916,[60] Milne began work on a series of reflections on Bishop's Pond. His use of liquid wash on wet paper reveals a debt to the watercolour technique of Turner and Whistler. While it is unclear whether he had seen Turner water-colours in the original by this time, he could have seen Whistler's *Nocturne*, c. 1883 (fig. 19) at the Keppel Gallery. The choice of subject recalls Monet's paintings of his pond at Giverny, with a significant difference: one was artificial, the other natural.

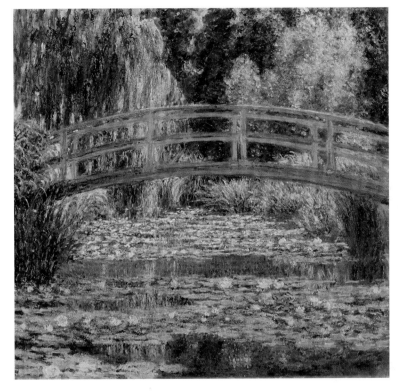

Bishop's Pond of 1916 (frontispiece) is one of Milne's first variations on this theme.[61] Its subject, compositional structure, synthetic forms, and blue palette recall Monet's series of mornings on the Seine at Giverny (fig. 24),[62] which were in turn indebted to Whistler's *Nocturnes* on the Thames (fig. 23), and Turner's watercolours of Swiss lakes (fig. 22). Milne transposed to watercolour the alternating areas of pattern and void that he had found in Whistler's etchings. He was justly pleased with the startlingly effective results and commented later to Alice and Vincent Massey: "blank areas . . . I believe no one else has knowingly used it."[63]

Fig. 24 Claude Monet (French, 1840–1926), *Morning on the Seine near Giverny*, 1897, W1482, oil on canvas, 81.6 × 93.0 cm, The Metropolitan Museum of Art, New York, bequest of Julia W. Emmons, 1956 (56.135.4)

Fig. 25 Claude Monet (French, 1840–1926), *The Japanese Footbridge and Water Lily Pool, Giverny*, 1899, W.1512, oil on canvas, 89.2 × 93.3 cm, Philadelphia Museum of Art, The Mr. and Mrs. Carroll S. Tyson Jr. Collection, 1963 (1963-116-11)

Milne would have seen the two great Turner oils *Staffa, Fingall's Cave*, and *Fort Vimieux*,[64] which were given by Col. James Lenox to the New York Public Library; these hung in the Lenox Library from 1908 to 1910, before their transfer to the new building in 1911.[65] His first opportunity to look at Turner in depth took place when he visited London between December 1918 and September 1919.[66] He made repeat visits to the National Gallery, where the famous Turners[67] hung in three redecorated galleries devoted to British painting.[68] The Tate Gallery (officially called the National Gallery of British Art) was a mecca for contemporary artists. Here oils from the Turner Bequest were on display upstairs in the magnificent suite of Duveen galleries specially built for that purpose, while a good selection of watercolours were hung in rooms downstairs.[69] These would have included examples of the Venetian and Swiss watercolours with their extraordinary blues and unrivalled reflections, which Ruskin considered Turner's greatest works.

Whistler and Monet would have been on Milne's mind in London. At the Tate Gallery Milne had the unparalleled opportunity to look at Whistler's Thames *Nocturnes* in conjunction with Turner's marine subjects.[70] His hotel in Villiers Street[71] was around the corner from the Savoy Hotel, where Whistler and Monet had stayed on separate occasions, and from whose windows they had worked.[72] It must have been thrilling to walk along the Thames Embankment and see the sites that had inspired their London views. As if looking at London through Monet's eyes,[73] Milne wrote to Clarke, saying, "Now about the sun—London gets its light and shade entirely from the more somber side of the weather. The smoke, rain, fog and wind act on the buildings and simplify and emphasize their main features in a remarkable way."[74]

It was not until summer 1920, after Milne had come back from Europe and was settled once again in Boston Corners, that he returned to his reflections series. Between August and October 1920 he made variations on the theme of Bishop's Pond. Like Monet's grainstacks, Milne's reflections constitute a non-identical series of motifs painted from different points of view to emphasize the changing seasons. While *Reflections, Bishop's Pond* (p. 100) is a variation on *Bishop's Pond* painted four years earlier, *Pink Reflections, Bishop's Pond* (p. 112) and *Dark Shore Reflected, Bishop's Pond* (p. 113) were made from different points of view. The mirror-like *Reflections, Bishop's Pond* recalls the hallucinatory effect found in some of Monet's water-lily paintings (fig. 25).[75]

Milne had read the first volume of Ruskin's *Modern Painters*, in which the author pointed out that Turner had employed the "crumbling touches of a dry brush" to give "a peculiar texture . . . to the most delicate tints of the surface, when there is little reflection from anything except sky and atmosphere." Ruskin maintained that "as a piece of mechanical excellence, it is one of the most remarkable things in the works of the master; and it brings the truth of his watercolour painting up to the last degree of perfection."[76] Although Milne's drybrush experiments do not resemble Turner's, the concept may have originated with this passage. Milne sketched the bare bones of his image with watercolour pigment on dry paper, then washed over the reflections with clear water to widen and soften the lines.[77] This brilliant innovation may owe something to Whistler's

etched Venice *Nocturnes*, in which the artist dragged ink from the lines with his palm and created reflections by spreading it around on his copper plates (see fig. 18).

One weekend Patsy arrived from New York with what Milne referred to as "a bomb in the shape of Thoreau's *Walden*."[78] Thoreau's passage "the poem of creation is uninterrupted; but few are the ears that hear it"[79] was echoed by Whistler in the "Ten O'Clock": "Nature, who, for once, has sung in tune, sings her exquisite song to the artist alone, her son and her master—her son in that he loves her, her master in that he knows her."[80] *Walden* and *The Gentle Art of Making Enemies* were Milne's two favourite books and exercised an enormous influence on him.[81] Seeking communion with nature, he decided to duplicate Thoreau's experiment and built a cabin on Alander Mountain. There, during the winter of 1920–21, he passed a hermetic existence in solitude, simplicity, and silence. Preoccupied with techniques for painting reflections in watercolour, he carried the first volume of Ruskin's *Modern Painters* up the snow-covered hillside in early January.[82] He would have found the chapter "Of Water as Painted by Turner" especially relevant.[83] Although irritated by Ruskin's style, Milne continued to dip into his famous defence of Turner over the course of the next month while "flirting with dark reflections on scraps of paper."[84]

When summer came, Milne left the cabin and moved with Patsy to Dart's Lake in the Adirondacks, where, at "the mirror time" of day, as he called it, he continued to paint reflections. In *Across the Lake I* (p. 116), he depicted the rustic lodge, whose sentinel form recalls Monet's grainstacks, sitting beside the lake. Made soon after

Fig. 26 David Milne, *Across the Lake (Second Version)*, 1929–30, T.56, colour drypoint, oil paint on wove watercolour paper, 20.0 × 28.9 cm (imp.), Art Gallery of Ontario, Toronto, gift from the Douglas M. Duncan Collection, 1970 (70/97)

the death of Milne's father, it is remarkable for its spareness and complete absence of reflection. In it Milne used a dry brush and played off areas of pattern against areas of void.[85] While eliminating unnecessary detail,[86] Milne continued to puzzle over what Whistler had really meant by "finish." Clarke, who ran into Pennell at this time, sought further clarification, without success. He wrote to Milne saying that Pennell "did not give me a satisfactory explanation of what he thought Whistler was getting at in the much

Pink Reflections, Bishop's Pond, August 24, 1920 (cat. 49)

watercolour over graphite on wove paper (watermark: "J Whatman"), 37.7 × 54.7 cm

National Gallery of Canada, Ottawa, gift from the Douglas M. Duncan Collection, 1970 (16128)

Dark Shore Reflected, Bishop's Pond, c. October 1920 (cat. 50)

watercolour over graphite on wove paper, 36.8 × 54.5 cm

The Thomson Collection (PC-265)

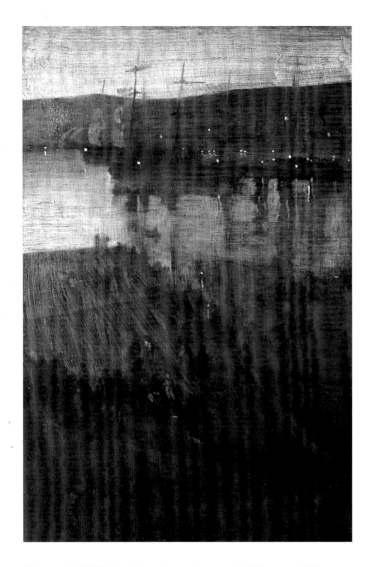

Fig. 27 J.M. Whistler (American, 1834–1903), *Nocturne in Blue and Gold: Valparaiso*, 1866/c. 1874, YMSM 76, oil on canvas, 76.4 × 50.7 cm, Freer Gallery of Art, Smithsonian Institution, Washington, D.C., gift of Charles Lang Freer, 1909 (F1909.127)

talked of 'Picture is finished' sentence. This from the biographer of Whistler."[87]

That fall Clarke encouraged Milne to write a book about his watercolour technique, explaining how he did it, adding that Whistler's "Ten O'Clock" "came closest to what he had in mind," and asking rhetorically "where is Monet's Impressionism?"[88] But Milne was more interested in forging ahead with his own work: the drybrush style, with its textured line, led to his first experiments in colour drypoint (fig. 26) employing a process invented by Whistler's pupil Theodore Roussel, known as the Roussel Medium,[89] which required a separate copper plate for each colour. Milne may have seen some of these on his visit to the Goupil Gallery in London in 1919, for Goupil was the first to show Roussel's coloured drypoints in 1899.[90]

The summer of 1923 was spent on Big Moose Lake in the Western Adirondacks. There Milne made a spectacular variation on *Across the Lake I* titled *Reflections, Glenmore Hotel* (p. 117). He created a dramatic sense of recession by incorporating the type of *repoussoir* device inspired by Japanese woodcuts first employed in Western art by Whistler (fig. 27).[91] Here Milne reached a pinnacle of achievement in watercolour.

He hoped that Prof. Christian Midjo would show some of his work in series at the exhibition he organized of Milne's watercolours at Cornell University in 1922. Unfortunately, this did not happen. In 1934, in his letter to the Masseys, Milne underlined the importance of viewing his work in series: "[T]heme, or motive, is difficult to define. The theme reveals itself to you as you go along, from day to day, like a film being developed in a dark-room" and "each

[work] is complete in itself, yet has a place in a larger development. They are easier to grasp and so to feel, when this development can be traced." He pointed out that his painting "has been so much, and for so long, influenced by these motives, these developments of themes, that it can be most readily approached by tracing some of them."[92] Comparing his series to Monet's, he observed that "many of my pictures are even more closely bound together than his. In some cases a dozen or more have to do with the development of an æsthetic theme."

Like Turner, Whistler, and Monet, Milne set out to capture the light, colour, and atmospheric effects that characterized the places where he worked. In the reflections series he focused on the New England landscape, with its white light, vivid fall foliage, and heavy snowfalls. However, as in the case of Turner, Whistler, and Monet, the physical appearance of nature was of secondary importance to the artist's poetic vision. To Milne, nature, spirituality, and art were inseparable. Raised in the Presbyterian Church, he did not, as an adult, subscribe to organized religion; however, he never forgot the biblical passages he had memorized as a child, and the Bible was the one book he always had with him.[93] He maintained that "heaven is not far away and shadowy and unreal, but here, now, and very real," and that "we build our own small heavens in our own small gardens or on our own thin canvas, we accept the imperfect world around us, we must, but within it we build our own perfect world."[94] Milne stated in his unpublished essay "Æsthetic Agents" (1940s) that "art is a way of life that in the very highest sense is a "labor to the glory of God."[95]

These ideas echo those of the American Transcendentalists whose works Milne greatly admired. He called Ralph Waldo Emerson "an early philosopher," Walt Whitman "the father of modern poetry," and Henry David Thoreau, his "favorite American author."[96] Their writings were readily available, and Milne probably knew them before leaving Paisley. [97] In May 1903, articles appeared in leading American periodicals to mark the centenary of Emerson's birth, discussing his importance and drawing attention to his essay "Nature" (1836), the seminal text of the movement.[98]

Here Emerson pointed out that nature is in a continual state of "metamorphosis" and that those who are in touch with nature participate in the Creation and "see God every day, face to face."[99] Nature exists in part to satisfy the soul's craving for beauty, and may be "trans-figured" by an act of the intellect into new creations such as poems or works of art.[100] He espoused a theory of "correspondences" in which all things in nature are seen as "emblematic" and "the whole of nature is a metaphor of the human condition."[101] In his essay "The Poet," he expanded on these ideas, stating that "the Universe is the externalization of the soul"[102] and that the end of nature is "ascension, or the passage of the soul into higher forms."[103] The poet and artist, who are able to see "analogues" to human emotion in language and nature, play a pivotal role in the transcendental process.

The word *reflections* perfectly embodies Emerson's concept of language as "fossil poetry"[104] as it encapsulates physical phenomena, thought processes, and spiritual meditations. Milne would have realized, as had Turner, Whistler, and Monet, that the theme of reflec-

Across the Lake I, October 4, 1921 (cat. 53)

watercolour over graphite on wove paper, 39.6 × 56.9 cm

National Gallery of Canada, Ottawa, gift from the Douglas M. Duncan Collection, 1970 (16427)

Reflections, Glenmore Hotel, October 1923 (cat. 58)

watercolour over graphite on wove paper (watermark: "J Whatman"), 28.0 × 39.2 cm

The British Museum, London, England, purchased 1990 (1990-3-3-42)

In the Cabin on the Mountain I, c. March 26, 1921 (cat. 51)

watercolour over graphite on wove paper, 38.5 × 56.3 cm

Collection of Greg Latremoille, Toronto

tions can be employed to explore the distinction between vision and reality, reason and imagination, fact and fantasy. His reflections, like theirs, embody an emotional and spiritual element that transcends the purely formalist exercise of themes and variations. It is because of the layers of metaphor that these works are so compelling.

Milne maintained that art was the product of "æsthetic emotion," which has an intellectual beginning and a spiritual end. He described the process as follows: "The painter gets an impression from some phase of nature . . . he simplifies and eliminates until he knows exactly what stirred him, sets this down in colour and line and so translates his impression into æsthetic emotion." The ultimate goal of true art is that the image arouse æsthetic emotion in the "appreciator."[105] Milne illustrated this point with reference to Turner: "people see gorgeous sunsets, but only in the last hundred years or so since Turner [taught them] to see them."[106]

If Milne's reflections owe a debt to Turner, Whistler, and Monet, his work can be read both as a homage and a challenge. Although he made variations on themes inaugurated in Europe, he set them in the physical and intellectual context of New England. Through a close study of their works, he created a succession of remarkably original styles, adopted the method of working in series, and realized that it is the poetry of nature that speaks to viewers on the deepest level. In the reflections series, arguably Milne's most refined artistic statements, his voice rings out with crystal clarity. These extraordinary watercolours could not have been made by anyone else, before or since, in the history of art.

Parliament Hill from Hull, December 1923 (cat. 60)

watercolour over graphite on wove paper, 36.9 × 54.6 cm, Art Gallery of Ontario, Toronto,
gift from the J.S. McLean Collection, Toronto, 1969, donated by the Ontario Heritage Foundation, 1988 (L69.42)

The Canadian Watercolours

DENNIS REID

The idea of moving back to Canada doubtless formed in Milne's mind over a period of years, but was acted on only when an appropriate confluence of inducements—some practical, some simply expedient, and perhaps even some emotional—had been effected. Certainly his time as a Canadian war artist must have stirred such thoughts, and when he heard late in 1920 that his 101 wartime watercolours were being transferred from the Canadian War Memorials to the National Gallery of Canada in Ottawa he began to form a scheme. This "Canadian venture," as he described it the following May to his long-time New York friend and steady correspondent, James Clarke, was to write to a number of Canadian "national" corporations, "such enterprises as the great pulp, resort and mining companies as well as the railways," suggesting that he

House of Commons, November 7, 1923 (cat. 59)

watercolour over graphite on wove paper, 39.0 × 55.7 cm

National Gallery of Canada, Ottawa, gift from the Douglas M. Duncan Collection, 1970 (16438)

Old R.C.M.P. Barracks II, January 1924 (cat. 61)

watercolour over graphite on wove paper, 39.1 × 56.4 cm

National Gallery of Canada, Ottawa, purchased 1924 (3017r)

Black House I, April 1925 (cat. 62)

watercolour over graphite on wove paper, mounted on paper card, 38.5 × 56.3 cm

Art Gallery of Ontario, Toronto, gift from the Douglas M. Duncan Collection, 1970 (70/88)

Still Life with Black Bottle, April 1925 (cat. 63)
watercolour over graphite on wove paper, 26.7 × 37.5 cm
Victoria University in the University of Toronto, gift from the Douglas M. Duncan Collection, 1970 (VUC1987.100.12)

Vinegar Bottle I, 1937 (cat. 64)

watercolour over graphite on laid paper, 40.7 × 53.3 cm

Collection of Greg Latremoille, Toronto

Over the Rock I, 1937 (cat. 65)

watercolour on wove paper, 35.4 × 50.7 cm

Milne Family Collection

be commissioned to work up "pictures" from his war watercolours that could be used in corporate advertising with what he termed a "Memorial feature."[1] There is no evidence he ever sent any such letters.

He and his wife, Patsy, did move closer to Canada in the summer of 1921, when they took jobs at a resort on Dart's Lake in the western Adirondacks, and the next two summers were passed in the same region, running a tea house at Big Moose Lake. Then, in a letter to Clarke in September 1923, Milne laid out a plan "to go up to Ottawa early in October to see what prospects are, and try to get a start," with the goal of raising enough money to build their own tea house at Big Moose the following spring.[2]

Milne arrived in Ottawa before the middle of the month and connected with the National Gallery right away. In a letter to Clarke sent off at the end of the month, however, he confessed to "a little stage fright at being all alone in a foreign country—Canada,"[3] but he soon met up with local artists, three of whom, Graham Norwell, Harold Beament, and Yoshida Sekido, had studios in the Butterworth Building on downtown Sparks Street where Milne had found space. Along with Paul Alfred, Frank Hennessey, and Florence McGillivray, they formed the Ottawa Group of Artists, and at the end of the year they welcomed Milne to their ranks. Milne also started looking farther afield, arranging a large exhibition at the Art Association of Montreal in early January, and contributing six works to an exhibition of the Ottawa Group at Hart House in the University of Toronto in early February. And with the support of the director of the National Gallery, Eric Brown, he applied for a government job as an illustrator. Plans for a sale of a representative group of his oil paintings and watercolours to the Gallery, however, were disappointed. They bought only six watercolours. Then he heard the government job had fallen through, and his Montreal and Toronto exhibitions had resulted in not a single sale. He returned to Big Moose at the end of March, ready to begin building the new tea house with Clarke's financial support.

The six months Milne spent in Canada that winter resulted in only sixteen known works. "Ottawa developed nothing," he recollected years later, describing the watercolours of that winter as "in the manner of the Dart's pictures. Perhaps I felt too insecure, too much disturbed in mind. Then, when cold weather came I didn't have clothes warm enough for working outside and painting fell away."[4] Back at Big Moose he was soon caught up in the construction of a cottage in which to operate the new tea room, and although he continued to paint in oils, and became deeply involved two years later with a colour drypoint printmaking technique of his own invention, his watercolour production tailed off, then stopped entirely the late spring of 1925.[5] He did not return to watercolour painting for twelve years.

They were years of significant change in Milne's life. He sold the Big Moose Lake cottage late in 1928 and returned to Canada early the following May, settling for the summer alone in a tent in the bush near the village of Temagami some five hundred kilometres northwest of Ottawa. In the fall he moved on to Toronto, renting a small space in Weston, then a village seven kilometres to the northwest, where Patsy joined him. In March 1930 they moved to Palgrave,

an even smaller village fifty-five kilometres farther north and west. While Milne found the rural lifestyle attractive, and certainly practical during the depths of the Depression, it is clear he also appreciated the relative ease of access to Toronto and its vital art community. He wrote to H.O. McCurry, one of his friends at the National Gallery, of his interest in the Group of Seven, for instance, and of his pleasure in seeing "two thrilling Pissarros and an almost equally thrilling Tom Thomson, The West Wind," at the Art Gallery of Toronto.[6] He began to exhibit with the various artists' societies and at all the other annual exhibitions, and though there were effectively no sales, because of the state of the economy, his work in oils and his brilliant colour drypoints flourished. His relationship with Patsy, however, was deteriorating rapidly, and in April 1933 they legally separated. She remained in Palgrave, and he, by late summer, was settled in almost complete isolation on Six Mile Lake, part of the Severn River system, near where it empties into Georgian Bay. He built a small cabin on a point of land accessible only by boat.

Milne kept up connections with the larger world by letter and the occasional journey to Toronto, though he stopped contributing to the annual shows. The summer of 1934, however, he wrote to Alice and Vincent Massey, wealthy patrons of the arts to whom he had been introduced by his friends at the National Gallery, establishing a relationship that led, in part, to a contractual agreement with a Toronto gallery that, while it benefited Milne little financially and saddled him with an expensive dealer he didn't want, did result in five exhibitions at the Mellors Galleries between November 1934 and January 1938 (four with catalogues).[7] Covering a wide spectrum of Milne's career, the shows helped raise his profile in Toronto and elsewhere in Canada, and brought him into contact with an expanding circle of artists, critics, and collectors. That included Douglas Duncan, who in 1936 helped found the Picture Loan Society, a non-profit organization offering contemporary art for lease and sale at terms beneficial to both artists and collectors. Duncan became his dealer and trusted financial agent late in 1938, and in December Milne had the first of what would be annual exhibitions at Picture Loan.[8] Duncan also made sure Milne contributed to all the annual exhibitions and joined two of the key artists' societies in 1939.

In the early fall of 1938 he had met a young nurse from Toronto vacationing at Six Mile Lake. Kathleen Pavey was half his age, but the two bonded immediately, and after a whirlwind courtship involving numerous visits back and forth, in July 1939 Milne moved to Toronto and in with Kathleen.[9] They remained in the city a bit more than a year, moving to the small town of Uxbridge, sixty-five kilometres to the northeast, in October 1940, shortly after discovering Kathleen was pregnant.

Milne had begun painting with watercolour again early in the summer of 1937. He did not, of course, pick up where he had left off in 1925. In place of the dense, elegantly ornate drybrush handling of *Still Life with Black Bottle* of that year (p. 125), we see comparatively spare, wet, though still elegant, brushwork when he returned to the medium in works like *Vinegar Bottle I* (p. 126). His palette had changed as well, with an emphasis now almost exclusively on a range of reds with black and white, and only the occasional bright touch of other hues. And the way he structured his composition

Goodbye to a Teacher III, 1938 (cat. 66)

watercolour over charcoal on wove paper (watermark: "J Whatman"), 38.2 × 56.3 cm

Milne Family Collection

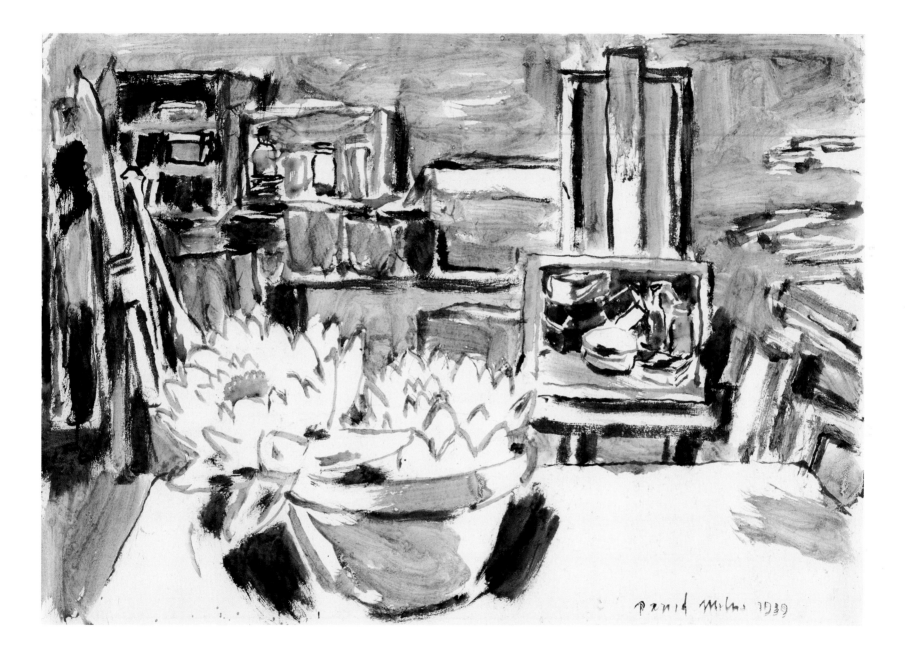

Waterlilies in the Cabin, 1939 (cat. 67)

watercolour over graphite on wove paper, 35.5 × 50.8 cm

National Gallery of Canada, Ottawa, gift from the Douglas M. Duncan Collection, 1970 (16431)

around a particular "painting problem," as he termed it, was more deeply ingrained. Writing to Alice Massey about one of the still lifes in the *Vinegar Bottle* series (three survive), he described the choice and formal arrangement of objects as arising from the desire to engage the viewer with "a progression, a progression in red—deep red, almost black, a full deep red, almost purple, a pink, nearly white, a full warm red, then a series of light warm reds ranging from yellow to rose, more small speckles of bright red and white or almost white. The idea seems to be a definite progress from black to white by way of red." [10]

Milne had also been discovering a wider range of subjects. Working directly in the landscape still attracted him, but painting during long hours alone in the cabin engaged his imagination even more actively in the process of composition. Still lifes became a regular part of his repertoire, and the largely solitary nature of his life on Six Mile Lake also increased his long-standing interest in interiors. We can see in *Waterlilies in the Cabin* (p. 131) of 1939 how the confines of his humble dwelling brought a sense of charged compression to these scenes. But as much as they are highly formal compositions of judiciously positioned line, balanced form and considered colour and texture, they are also lovingly rendered depictions of meaningfully arranged objects, each signifying a specific deep connection to Milne's sense of being. To the left, by the door, are his overcoat, his cross-country skis, his canoe paddles, then a case of books and his battery-powered radio, then neat cases, jars, cans and boxes of foodstuffs, his easel, holding a work in progress, and to the extreme right tidy stacks of his completed paintings. It presents a

progression, like his still life with the vinegar bottle, but one that causes us to reflect in turn on Milne's means of communicating with the outside world, of sustaining intellectual vigour, of supporting the material body, his field of creativity, and its outcome in his art. Dominating the foreground is what he called "the Massey bowl," a gift from his patrons, shown holding the almost immeasurably pleasurable, delicately odiferous water lilies that are the ostensible subject of his painting.

A more novel subject began to engage him early in the summer of 1938 when he started thinking about a picture that would embody the affection and gratitude he felt for the young teacher and students of a nearby rural school that had been an important point of human contact for him during the past five years, and, as he put it to Douglas Duncan, "the source of a lot of inspiration." [11] Based loosely on a photograph of Elizabeth Cowan and her eleven charges, the emerging image of *Goodbye to a Teacher*, as he called the series (see p. 130), absorbed Milne. "I have enjoyed doing it," he wrote to Carl Schaefer, a Toronto painter friend, "even doing it over so often." [12] (He was on the fourth of five versions.) "It is mostly a painting problem," he wrote to another friend, Alan Jarvis. "All the way along this picture has been interesting to me, in composition, in detail, way it developed, everything. No attempt at realism is made in it. I had no thought of character in the faces or figures of the children or teacher. Whatever character they suggest was the result of the way the lines fell in drawing the thing in charcoal." [13] A work that embraces the limitless promise of innocence, it avoids virtually all trace of sentimentality. Charged with feeling, it delights the eye with

its endless play of red, black, and white, arranged, as he described it to Schaefer, as "an alternation of vague shapes in opaque color and sharply defined shapes in transparent color."[14] Milne understood its radical nature. "Nobody will like it," he assured Jarvis, "not even the teacher."[15] The innovative direction it set nonetheless increasingly engaged him in the years to follow, years effectively devoted entirely to watercolour painting.

Why this sudden, all-consuming involvement in watercolour after having abandoned it for twelve years? His son reports that he felt watercolour was quicker than oil, and would make it easier to work outdoors and relieve the eye strain that was then bothering him.[16] Once he had taken up the medium again, its relative cleanliness and portability would have appealed, particularly following his meeting Kathleen Pavey and before settling in Uxbridge, a period during which he often moved. His approach to painting was also changing, as we have seen, and watercolour probably offered a greater sense of latitude when working in series, and certainly was conducive to the increasingly gestural nature of his brushwork. But there must have been a catalyst, and that almost certainly was the fact that he had re-engaged with working artists again in Toronto in the early thirties. The one watercolourist who particularly caught his eye was Carl Schaefer, from Hanover in Bruce County, not far from Paisley, Milne's birthplace, who was thirty-three when Duncan arranged for Milne to meet him and see his work in the fall of 1936 (see fig. 28). Milne later wrote to friends of viewing Schaefer's "splendid watercolors" and "his fine this year's watercolors."[17] He clearly did not reveal to the younger man his own current uninterest

Fig. 28 Carl Schaefer (Canadian, 1903–1995), *Before Rain, Parry Sound*, 1935, watercolour on paper, 39.4 × 55.9 cm, Art Gallery of Ontario, Toronto, gift from Friends of Canadian Art Fund, 1937 (2423)
© 2005 Estate of Carl Schaefer

in using the medium because the following February Schaefer wrote to inquire if he would like to participate in the upcoming annual exhibition of the Canadian Society of Painters in Water Colour.[18] He reported in April that the watercolours shown "are the best we have had for years."[19] Milne, as we know, was back at it that summer.

He was tentative about his initial progress, reporting to James Clarke, only in November, that he "had tried a few watercolors. At first I was completely lost, but after spoiling a lot of paper I have got some freedom in it, but still without much to show."[20] A year later he was forging boldly into new territory with *Goodbye to a*

Eggs and Milk, March 24, 1940 (cat. 68)

watercolour over graphite on wove paper (watermark: "RMFabriano"), 38.0 × 51.0 cm

Milne Family Collection

Window on Main Street, November – December 1940 (cat. 69)

watercolour over graphite on wove paper (watermark: "RMFabriano"), 37.9 × 50.8 cm

National Gallery of Canada, Ottawa, gift from the Douglas M. Duncan Collection, 1970 (16518)

Teacher, and a year and a half after that, in Toronto in the spring of 1940, he began again to use broad washes of the sort he had last employed twenty years before in the Boston Corners reflection pictures. As David Milne Jr. has remarked, these wet washes would dominate Milne's watercolour technique for the rest of his life.[21] Milne first reported to Clarke about this newest development in December 1940, describing a watercolour he was then working on in his Uxbridge studio, *Window on Main Street* (p. 135). "The interior part is drawn directly on the white paper and has a harsh, clear cut look. The part through the glass is drawn with thin lines mostly of black or red. Then it is washed over with clear water and before it is dry is worked into slightly and freely with red and black in larger areas and a few other colors in small quantities. This gives a soft texture, yet fairly well defined shapes because of the thin outline underneath." He was at that point cautious of embracing the wet-paper technique fully. "Sometimes I have omitted the underneath outline and done the whole thing on wet paper, but this is difficult to control and doesn't give much definition to any shape anywhere."[22] He soon mastered that concern, as we can see in the magnificent *Bay Street at Night* (p. 138), a Toronto subject painted in Uxbridge in November 1941. As he wrote to Clarke a year earlier, however, he still kept "enough of the old Boston Corners method to like a clear cut line to start with even though it is confused or lost (intentionally) in places afterward." As we can see in *Bay Street at Night* some of these clear lines were cut in after the washes.

Years later he described the intense preparation required for the execution of these works. "The planning has to be done before-hand in great detail; the order in which the colors are to be applied, what brushes are to be fully charged and what with only the slightest amount of paint on them, what effects of the diffusion, spreading and overlapping, due to the wetness of the paper."[23] Then, with the image already worked out in drawings and often numerous earlier versions, the practised hand and focused mind moved together in rapid execution. It is a process remarkably akin to one form of traditional Asian brush painting, where measured preparation of every detail culminates suddenly in a seemingly spontaneous creation. Could Milne have developed this technique himself? Perhaps. There certainly was no painter in Toronto at that time who could have offered an example. He did, however, spend at least two months in close proximity to a skilled practitioner of the Asian wet-paper technique in Ottawa, a decade and a half before beginning to explore such possibilities himself. This was Yoshida Sekido, one of the members of the Ottawa Group, with a studio in the same building then as Milne.

Although he does not name him, Milne writes of Sekido at some length in his autobiography, describing him making large brush paintings on silk.[24] This was one of a number of traditional and Western-influenced practices Sekido followed, including painting landscapes on wet paper. Born in Tokyo in 1894, he travelled to North America in February 1921, reaching Toronto by July 1923. He moved on to Ottawa in late September, was resident in the Butterworth Building by mid-November, was in Montreal by the end of January, and living in New York City in April.[25] His Ottawa stay coincides almost exactly with Milne's, and Milne certainly

would have recalled him when he returned to watercolour painting in 1937 because Sekido had forged strong links with a small group of Toronto artists and patrons that included J.E.H. MacDonald and his son, Thoreau, their friends Doris and Gordon Mills, and Carl Schaefer. He corresponded with them all until his return to Japan in September 1928, and they kept his letters, as well as paintings, drawings, and other mementoes, including a fine, carefully mounted photograph of one of his wet-paper landscapes (see fig. 29).[26] The great Toronto literary critic Northrop Frye, who then also wrote regularly on art, remarked in 1948 that Milne "has painted what must surely be some of the wettest water colours, both in technique and in subject-matter, ever done."[27] Frye could not have known the work of Yoshida Sekido or he surely would have noted the connection.

Landscape remained an interest of Milne's to the end of his life, but from the late 1930s he developed an increasing fascination with what he called "subject pictures" and others have described as "fantasy paintings." *Goodbye to a Teacher* was the first. Although inspired by its subject teacher and class, the idea actually developed through the early months of Milne's relationship with Kathleen Pavey, and other early subject pictures were even more closely linked to this significant new force in his life. In a long letter to her in June 1939 he described in great detail and in the most familiar terms his ideas for a painting of Noah and the ark, a subject that clearly already had been the cause of much affectionate discussion between them.[28] He later wrote to Alice Massey that Kathleen was "supposed to pose for the long contemplated Noah—for Noah, and Mrs. Noah and

Fig. 29 Mounted presentation photograph by Soichi Sunami of an untitled watercolour by Yoshida Sekido, c. 1920, Speirs Collection, The Thomas Fisher Rare Book Library, University of Toronto

maybe all the animals. Also for St. Francis."[29] Lora Carney has pointed out that while he was joking, the little fantasy about Kathleen's role does "bring the subject pictures into the context of emotional warmth that was in such contrast to Milne's life at Six Mile Lake, a warmth reflected in the gentle humour of the visual details of the pictures."[30]

The St. Francis subject was realized in the series of delightfully whimsical pictures known as *The Saint* (p. 142), and there were a number of other religious subjects, such as *Resurrection* (p. 148), and the long-favoured *Ascension* (p. 149), it alone known by thirty-three

Bay Street at Night, November 4, 1941 (cat. 71)

watercolour over charcoal on wove paper, 38.8 × 53.7 cm

Collection of the Art Gallery of York University, Toronto, gift of the Frances Barwick Estate, Toronto, 1985 (85.2)

Prints, c. March – April 1942 (cat. 72)

watercolour over graphite on wove paper (watermark: "J Whatman"), 37.5 × 55.9 cm

Milne Family Collection

139

surviving versions. Another religious subject, *Snow in Bethlehem* (p. 145), and a secular theme, *King, Queen, and Jokers*, were inspired by illustrations in books Milne was perusing in the Toronto Public Library in May 1941 while, at age fifty-nine, he awaited the birth of his first, and only, child, another significant new force in his life.[31] *King, Queen, and Jokers* went through seventeen versions over a five-year period. The last one, *King, Queen, and Jokers V: It's a Democratic Age* (p. 150), completed in April 1944, was his largest watercolour to date, "my masterpiece as far as size goes," as he wrote to Schaefer. "Douglas has seen it round for the last three years in various versions, more or less finished, but has shown no enthusiasm."[32] To Duncan he wrote, "My attitude is about the same as yours in regard to subject—no particular point to it. However I like the color and arrangement and invention."[33] When he first wrote to James Clarke about this new direction he summarized a detailed, but similarly objective, description of the subjects with "not much to look at but interesting to do."[34] Clarke responded, "I can't make out from the descriptions of the pictures whether you have gone surrealist or if you have finally taken to drink or what. I sure would like to see some of those things you describe."[35]

Northrop Frye had no difficulty taking the subject pictures at face value, seeing them as "a pictorial handwriting, so to speak, of a genuinely simple but highly civilized mind. This has enabled [Milne] to detach himself further than ever from the picturesque object and develop a free fantasy which may remind some of Chagall."[36] Later writers perhaps have understood Milne's position with the subject pictures to be more complex. Two in particular have carefully considered the later work in relation to the earlier. John O'Brian asserts a dichotomy in the apparent need in his later years to persistently express commitment to formal values and antipathy to narrative content while giving his paintings "explicitly allusive" titles that underline the symbolic nature of the image. He argues that Milne's need "to continue to affirm the beliefs he had held since the early years of his career in New York" creates a "tension between form and content" that is present in the work of many artists of Milne's generation, "one of the chafing points in the history of modern art."[37] Lora Carney sees a gradual but steady broadening of Milne's attitude toward content in his writing and painting from the twenties and thirties on. This, in concert with his evolving painting practice and changing domestic life, led naturally to the subject playing a greater role in the experience of his art. "The central content of the subject pictures is the figure," Carney observes, "which stands not as a formal model, but rather as a vehicle for the imagination, a way to express, or at least hint at, profound human meaning." She notes that at the time "[t]here was a general impulse in this direction among artists and critics, related at least in some instances to the Second World War and preceding events."[38]

Milne, always focused on process, comes the closest to explaining, in a long letter to Carl Schaefer in October 1943, how, in the broadest sense, the subject pictures worked for him. He noted that they evolved "probably" as a result of working from sketches rather than always directly from nature as he used to do. He sometimes would do a "borderline" picture over again at home, trying to improve something that was pretty good but not quite there.

Once in a while they came across but usually they lost whatever kick they had in the first place. The reason was that there was nothing in the picture to stir feeling as deeply as it had been stirred in front of the subject. It took me years to reconcile myself to that. After that I got into the habit of seeing the thing as vividly as possible and making a slight pencil sketch and then doing the picture entirely away from the subject. That didn't get rid of doing pictures over but it seemed to make it easier to do them over and hold the original feeling. In the subject pictures I go one stage farther (maybe that is the reason for doing them). I get the idea from something or another but not from any complete picture in nature. The idea is fairly complete before a very rough pencil sketch is tried mostly for arrangement. Then it is drawn in detail and painted—and usually painted and painted. But anyway the original feeling is kept.[39]

Fig. 30 David Milne, *Sketch related to "Petunias and Candy Box,"* c. 1938, graphite on laid paper, 18.0 × 22.9 cm, Art Gallery of Ontario, Toronto, gift of Gordon MacNamara, Toronto, 2001 (2001/191.1)

These little-known drawings, which he started to use in the early thirties, are freely exploratory in nature and are indeed full of vital "feeling." (See fig. 30, from nature, and fig. 31, an imaginary subject.)[40]

Subject pictures were a consuming, though not exclusive, interest of Milne's until late 1946. Then he put them aside. His painting activity diminished generally in the later forties, although he found a renewed interest in painting flowers (see pp. 146 and 147), the subject of his 1947 exhibition at the Picture Loan Society. He also was spending more time writing, and completed nine chapters of his autobiography during the late winter and spring of 1947. That summer he found a spot on Baptiste Lake, in the bush just west of

Bancroft, two hundred kilometres northeast of Toronto, where the following summer and fall he built a cottage that became his new, and final, painting place. He lived there alone through the winter, with periodic visits to Kathleen and David Jr. in Uxbridge, and they joined him at Baptiste Lake for the summer. Work was falling off as well, because, as he discovered early in 1951, he was fighting bowel cancer. Following an operation in Toronto in April and a period of recuperation, he was by the fall easing back into his painting routine

The Saint IV, June–September 1942 (cat. 73)
watercolour over graphite on wove paper, 38.3 × 55.2 cm
National Gallery of Canada, Ottawa, purchased 1948 (4878)

Picture on the Wall, c. November 1945 (cat. 77)

watercolour over graphite on wove paper, 36.5 × 54.6 cm

Collection of Mr. and Mrs. J. Hill, Vancouver

Fig. 31 David Milne, *Sketch perhaps related to "Mary and Martha,"* c. 1945, pen and ink on wove paper, 20.0 × 24.5 cm, Art Gallery of Ontario, Toronto, gift of Gordon MacNamara, 2001 (2001/192)

remarkably fluid sequence of shifting, sonorous skies is in that regard a virtuoso performance. Then in December he returned to subject pictures, starting first on a theme of angels with lipstick he called "The Salesman." By April 1952 he was trying it on his largest sheet of paper, the size of *King, Queen, and Jokers V*, and by early November was still working on *Tempter with Cosmetics V* (p. 151), as it is now known.[41]

Milne suffered the first of a series of strokes later that month and was no longer able to paint. Confined to his bed early in the new year, he was unable to write by March. He died December 26, 1953, in the hospital in Bancroft. *Tempter with Cosmetics V* was still sitting on his easel. There is much to admire in this last work, with its sly, yet deeply moving observations of the antic but somehow ingenuous and still worldly response of innocent angels to the blandishments of a purveyed beauty product, described with the most sensitive, light, yet deft exercise of Milne's brush. We might imagine that he would have been pleased with Northrop Frye's assessments of his achievement some five years earlier as, on the one hand, "the expansion of meaning from the desire to paint, rather than from a desire to say something with paint" and on the other, the understanding of the discipline of painting as "a training of the intelligence to see the world in a spirit of leisure and urbanity."[42] It seems like faint praise, until you think about it.

at Baptiste Lake, still at the top of his form, as we can see in the four magnificent versions of *Storm over the Islands* he painted that November (see pp. 152–53). He had for some time been using the series format to play meaningful variations on a theme rather than as a way to improve an image, and *Storm over the Islands*, with its

Snow in Bethlehem II, August 11, 1941 (cat. 70)

watercolour and ink over charcoal on wove paper (watermark: "J Whatman"), 39.1 × 55.9 cm

Art Gallery of Ontario, Toronto, purchased 1942 (2595)

Glass Candlestick, June 1946 (cat. 78)

watercolour over charcoal on wove paper (watermark: "J Whatman"), 37.2 × 54.9 cm

Collection of Mira Godard

146

Flowers and Candlesticks, July 1947 (cat. 79)

watercolour over charcoal on wove paper (watermark: "J Whatman"), 36.3 × 54.7 cm

Collection of Mucie and Ron Kaplansky

Resurrection III, 1943 (cat. 74)

watercolour over charcoal on wove paper (watermark: "J Whatman"), 38.1 × 55.9 cm

Art Gallery of Ontario, Toronto, gift from the Douglas M. Duncan Collection, 1970 (70/94)

Ascension XV, c. January – March 1944 (cat. 75)

watercolour over charcoal and graphite on wove paper (watermark: "J Whatman"), 56.0 × 37.9 cm

Collection of Jim Coutts

King, Queen, and Jokers V: It's a Democratic Age, 1943–44 (cat. 76)

watercolour over charcoal and graphite on wove paper (watermark: "J Whatman"), 55.6 × 76.7 cm

Art Gallery of Ontario, Toronto, purchased 1945 (2781)

Tempter with Cosmetics V, 1952 (cat. 84)
watercolour over graphite and charcoal on wove paper, 55.8 × 75.2 cm. Collection of Agnes Etherington
Art Centre, Kingston, gift of the Douglas M. Duncan Collection, 1970 (AE 13-079)

Storm over the Islands I, November 10–20, 1951 (cat. 80)

Storm over the Islands II, November 10–20, 1951 (cat. 81)

watercolour over graphite on wove paper, 27.6 × 37.2 cm / 27.3 × 37.2 cm

Collection of the Art Gallery of Windsor, bequest of Frances Duncan Barwick, 1985 (85.64.1 / 85.64.2)

Storm over the Islands III, November 10–20, 1951 (cat. 82)

Storm over the Islands IV, November 10–20, 1951 (cat. 83)

watercolour over graphite on wove paper, 28.0 × 36.9 cm / 28.0 × 36.9 cm

Collection of the Art Gallery of Windsor, bequest of Frances Duncan Barwick, 1985 (85.64.3 / 85.64.4)

Round Tree, c. 1912 (cat. 4)

watercolour over graphite on illustration board, 50.8 × 38.1 cm

The Thomson Collection (PC-625)

Domesticated Modernism?

JOHN O'BRIAN

The small book *An Art Museum: Its Concept and Conduct* was in David Milne's possession when war broke out in Europe in 1914. Published by the Hackley Gallery of Fine Arts in Muskegon, Michigan, it was a catalogue of the Hackley's permanent collection, dedicated to the improvement of American taste and "the development of the perceptive faculty in the general public."[1] In this respect it was a typical instrument of the era, intended to encourage readers to become modern viewing subjects attentive to their affective, interior lives at a time of rapidly changing industrial capitalism.[2] Art and nature could play an important role, so it was suggested, in coming to terms with the new technological imperatives of urban life and modernity.[3] They could furnish access to the truth and unite what was otherwise fragmented. Concern about technological

intrusions into the natural landscape, and about the violence visited by those intrusions, had been a recurring theme in American writing, art, and popular culture since colonial times. By the second half of the 1800s, the concern was widespread.[4] The Hackley collection consisted of American and European paintings, including a number of landscapes (none picturing machinery), mostly from the nineteenth century. Among the American artists represented were Ralph Blakelock, Frederick S. Church, Charles H. Davis, George Inness, Willard Metcalf, Dwight Tryon and James McNeill Whistler; among the Europeans were John Constable, Jean-Baptiste Corot, Thomas Gainsborough, Francisco Goya, William Hogarth, Henry Raeburn and Henri Le Sidaner.[5]

Between late 1914 and early 1918, when he enlisted in the Canadian army, Milne methodically defaced *An Art Museum*. Page by page, he pasted over the book with First World War newspaper maps of battle lines and fronts, transforming it into a war album (fig. 32).[6] The process of disfigurement can be construed as a response to the human costs of technological progress, particularly as embodied by the war, which was unrelenting in its entrenched brutality, or as a bloody-minded rejection of the artists and æsthetic ideas of preceding generations. Perhaps it was both. New York modern artists of Milne's generation often disowned their American predecessors as a source of embarrassment.[7] When it came to the business of artistic patricide, however, Milne's writings show him to have been a moderate, at least compared with the artists he encountered when he lived in New York from 1903 to 1916. He tended to write favourably about artists he admired, and to ignore those he did not.[8] "In those

little rooms, under the skylights," he wrote of Stieglitz's 291 gallery, "we met Cézanne, Van Gogh, Gauguin, Matisse, Picasso, Brancusi. For the first time we saw courage and imagination bare, not sweetened by sentiment and smothered in technical skill."[9] As a Canadian, whose country was immediately involved in the war, Milne must have felt considerable ambivalence living in the cultural capital of a country refusing military engagement. Both the artistic and social milieux surprised and challenged him. After all, Milne had come to New York from rural Ontario knowing "no more about my destination," as he said, "than if I had been plunging into the sun."[10]

In this essay, I want to investigate Milne's version of modernism, toward which he seems to have had a similarly complicated relationship. His work falls on the ordered side of the modernist scale. Nothing about the paintings can be described as unruly or fractious, notwithstanding the opinion of the British periodical *The Studio*, following the outbreak of war, that Milne was a "revolutionary" who contrived to make the faces of his figures "not out of roses, but out of dreary pigment, red or black, as the case may be."[11] The work is rarely given to extremes, and I am inclined to categorize it, cautiously, as an expression of domesticated modernism. (The term *domesticated modernism* comes from Frank Stella, who used it to describe a certain kind of second-generation Abstract Expressionism.)[12] Milne's paintings are invariably modest in scale—a work of 61.0 × 76.2 cm counts as large—and they generally traffic in the commonplace—street scenes, parklands, ponds, interiors, flowers, jam jars. What prevents them from becoming housebroken as opposed to domesticated—I am drawing a fine distinction here—is the artist's implacable

Fig. 32 Two-page spread from Milne's War Album, *An Art Museum:*
Its Concept and Conduct, c. 1915, book with newspaper clippings inserted
and laid over text to create an album, Milne Family Collection

157

self-reflexivity about his artistic procedures, combined with his fierce economy of execution. The paintings reject excess with a vengeance.

Although making scrapbooks out of unwanted books was common practice in the early twentieth century, the force of obliterating *An Art Museum* cannot have been unpremeditated by Milne. As the historian Modris Eksteins argues in *Rites of Spring: The Great War and the Birth of the Modern Age*, a large part of modern consciousness, especially artistic consciousness, emerged in response to the violence of the First World War. The transformation of the book therefore raises several additional questions. Why, it may be asked, did Milne acquire the book in the first place? Was it because it proposed the valorization of nature as an antidote to urbanization and technological change, and that this idea appealed to Milne, as it did also to John Marin, Georgia O'Keeffe, and other painters of Milne's generation in New York? It is worth observing that Milne was painting city parks and open spaces, as in *Cobalt Trees* (p. 42) and *Brilliant Pattern* (see fig. 11, p. 45), at the same time he was painting city buildings, streets and billboards, as in *New York Roofs* (p. 30) and *White Matrix* (p. 26). Or was it because the volume mentioned Charles H. Davis and Willard Metcalf? Davis was a painter "in the galleries" when Milne was a student, he later recalled, and Metcalf was a member of the American Ten, whose work attracted Milne's attention in the years around 1910.[13] The subject matter, if not the flattened two-dimensional handling, of *Dreamland Tower, Coney Island* (p. 31), with its Coney Island imagery and its watery sheen of electric lights flashing across the washed surface of the paper, may owe something to the example of the Ten.

Before Milne left New York for Boston Corners in the Berkshires in 1916, he wrote that his painting "had taken an unfortunate turn, maybe reflecting a troubled frame of mind."[14] It seems that his dissatisfaction with his painting in late 1914 and 1915, never mind his probable disgust with the direction of the war, caused him deep anxiety. In trying to deal with the anxiety, I think, he may also have dealt with the book. By burying the pages of *An Art Museum* under war maps, he was preparing himself to paint what it did not represent and to write what it did not say. During all the years he lived in New York, Milne wrote little, but from the close of the war until his death in 1953, long stretches of which were lived in Thoreauvian isolation, he spent nearly as much time writing as he did painting. He kept detailed journals, wrote essays, published articles, and maintained a voluminous correspondence. (This, too, was Thoreauvian.) The bulk of the correspondence was with James Clarke, his principal benefactor and a commercial illustrator with artistic ambitions employed by a successful New York advertising agency, Calkins and Holden. Milne frequently provided Clarke with day-to-day summaries of his thoughts and painting activities. "One is rather inclined to feel a little stage-fright with oil, to yield to its slowness and work in a soggy, painstaking way," he wrote after having worked only in watercolour for two years in Europe. "I seem to do better when I use it more rapidly and freely," he added, "call it by its first name and slap it on the back."[15]

Milne's style of writing is deceptively simple, corresponding in its spare verbal vocabulary to the spare visual vocabulary of the paintings. The dominance of his voice in accounts of his work has

not always served the artist well, however, for it has tended to stifle speculative inquiry. In *Anatomy of Criticism*, Northrop Frye, one of Milne's most perceptive observers during the 1940s, notes that a poet (or an artist) writing about his work is just one more of that poet's critics.[16] Milne might have agreed with Frye. He once warned another critic never to "believe what an artist says, except on canvas."[17]

It would be a mistake to disregard Milne's warning. He sent a long letter in 1932 to H.O. McCurry, assistant director of the National Gallery of Canada, about some paintings the artist had recently dispatched for exhibition; it is helpful to deliberate as much on what the letter leaves out as on what it puts in. A good deal depended on the persuasiveness of Milne's rhetoric in the communication, on his ability to flatter McCurry's grasp of modernism's disinterested gaze, if he was to secure future sales to the National Gallery.[18] The letter closely analyzed several paintings, including an oil, *Framed Etching (Lilies from the Bush)* (fig. 33), which Milne related to a series of watercolours he had produced fifteen years earlier, in 1916 (fig. 34, *Back Porch, the White Post*). "The title means nothing, explains nothing. It is merely a handle, a number would do as well only numbers are confusing . . . The subject — the real subject — is concerned with (1) line (2) the separation of colour into black and white hues and values (3) the arrangement — the use of blank space, light in value, on the right."[19]

The passage is indicative of the kind of formal scrutiny to which Milne habitually submitted his work. The ostensible subject matter of *Framed Etching*, he is insisting, wildflowers brought in from the

Fig. 33 David Milne, *Framed Etching (Lilies from the Bush)*, 1931, M&S302.43, oil on canvas, 66.1 × 71.1 cm, Collection of Foreign Affairs Canada, purchased 1935 (985)

Fig. 34 David Milne, *Back Porch, the White Post*, 1916, M&S 107.16, watercolour over graphite on wove paper, 38.8 × 48.0 cm, Milne Family Collection

bush and arranged in the studio in front of a framed drypoint etching and a blank canvas, is irrelevant. Meaning resides only in the spatial arrangements, scaffoldings of line, colour juxtapositions.[20]

Two years later, in 1934, Milne also wrote at length about his paintings to Alice and Vincent Massey, other potential patrons. The explanations were similar to those offered to McCurry, as was the appeal to the Masseys' cultural competence and æsthetic sophistication. "They don't aim to represent, and have no particular technical

excellence, whatever appeal they have is æsthetic. They are not pictures of flowers or fields or houses or jam jars, they have little sentimental appeal; they are simplifications of line and color, intended to produce a thrill, a kick. Many can feel a purely æsthetic emotion in music, few can get it from painting."[21] Milne's formalist convictions about his art, and by extension his convictions about what constitutes meaning in a modernist painting, echo the ideas of the British critics Roger Fry and Clive Bell. The ideas were present in Milne's earliest sustained writings on art, dating from 1919 to 1921, at a time when Fry and Bell were being widely read in the United States as well as in Britain. Milne also read them closely.[22] Fry and Bell argued for the importance of "plastic values," "significant form" and "æsthetic emotion" in art, while depreciating the importance of psychological values (what Milne called "sentimental" values).[23] Art neither imitated nature nor reproduced it. Associations of any kind connected to subject matter were beside the point.

Jonathan Crary, the art historian and theorist, has recently observed that "the ways in which we intently listen to, look at, or concentrate on anything have a deeply historical character."[24] Milne's artistic identity was formed in and around New York during the first two decades of the twentieth century, as well as by his involvement in the First World War. The formation of such an identity, Crary argues, necessarily requires the exclusion from consciousness of other forms of contemporary experience.

Because we no longer have direct access to Milne's experiences, we must instead bring our own experiences and questions to his work. Does the subject matter of his representations of the natural

and man-made worlds, we might want to ask, still seem as irrelevant as once claimed by the artist? Are we able to view lilies — not to mention cemeteries, studio interiors, Fifth Avenue street scenes, jam jars, ponds, fields, maple copses, buildings, battlefields, kings, queens, and jokers — as separable from their painted representations? It is not a simple task for contemporary viewers to isolate the symbolic connotations of lilies and battlefields from the pictorial language used to represent them, and Milne himself seems to have recognized the difficulties involved. Before setting up his easel and getting down to the activity of painting, we know that he selected his subjects with as much care as Cézanne and Matisse selected theirs, to mention only two artists of importance to him.[25] The obvious pleasure Milne took in his subject matter placed a strain on his formalist dicta. By the 1940s, when he was focusing on ascensions and saints, angels in bowler hats, and pictures of Bethlehem under snow (p. 145), the strain must have been intense.

A self-portrait photograph of Milne in army uniform, taken in Canada a few days before he was shipped overseas from Quebec in 1918, returns us to the war and *An Art Museum* (fig. 35). The setting of the photograph is in sharp contrast to the ordered settings of Milne's paintings.[26] "I snapped the camera with a forked stick as you can see in the picture," he wrote on the back of it, "sitting at the root of a burnt stump on the top of a rocky hill."[27] The description is precise and factual, not unlike Milne's reflections on his painting methods. But in a way also comparable to his reflections, it tells only part of the story. The rest of the story (that is, the story I am relating, for others could also be told) is obscured, like

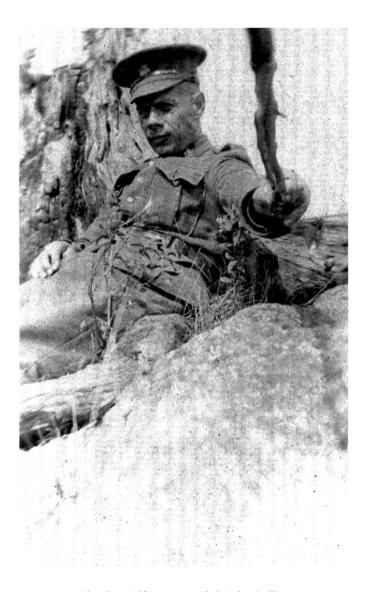

Fig. 35 David Milne, *Self-Portrait at Black Lake, Québec,* September 1918, gelatin silver photograph, Library and Archives Canada, Ottawa, David Brown Milne collection (C-057196)

the obliterated pages of *An Art Museum*. This is what seems striking: although the self-portrait is a before-leaving-to-go-overseas photograph, by some premonitory pictorial alchemy it has been transformed into an after-arrival-on-the-battlefield image. Milne depicts himself sitting on ground that has been broken and scorched, and thrusts his forked stick toward the viewer as if he is deploying a defensive weapon rather than a surrogate paintbrush. He is pushing the spectator away in the photograph, at the same time he is making himself a subject for viewing.[28]

The self-portrait photograph aligns itself with a recurring feature of Milne's work. In his tersely controlled paintings, he also seems to push his subject matter away, to distance himself and his spectators from the landscapes and verandas, the flowers and figures, the streets and ascensions he represents, while at the same time making them material for painting.[29] His cool, laconic means of execution intensifies this sense of removal. Northrop Frye called the paintings "reflective, observant and pastoral," a categorization that in important ways parallels the domesticated modernism I have chosen to identify with them.[30] The paintings are reflective, and participate in a modernist pastoral tradition. They register a suppressed anxiety about the continuing appetites of industrial capitalism and the technological changes introduced by it. Milne's transformation of *An Art Museum* into a war album is a pronounced expression of this anxiety.

Chronology

DAVID P. SILCOX

January 8, 1882 David Brown Milne is born in a log cabin on the stage road between Burgoyne and Port Elgin in Bruce County on the Bruce Peninsula, Ontario, the last and tenth child of Scottish farming folk, staunch Presbyterians, who had immigrated twelve years earlier. There is no birth record; the census of 1881, however, records him as having been born a year earlier than the date he always gave.

1892–93 The Milne family moves to nearby Paisley. Milne had been taught to read and write at home, and to memorize passages from the Bible; when he attends school, at about age ten and just before the move to Paisley, he excels.

1897 Milne goes to high school in Walkerton (only the second in his large family), where he proves to be a brilliant student, especially in botany.

1899 He qualifies as a teacher at the Model School in Walkerton.

January 1900–July 1903 He teaches forty-odd students in a one-room school just north of Paisley. During this time he develops a passion for drawing, subscribes in 1902 to a New York correspondence course in art, sketches avidly around the town, has illustrations (including cover designs) accepted for a local and short-lived boys' magazine, and dabbles in photography. He takes summer trips on bicycle to Niagara and visits Toronto several times.

September 1903 Milne goes to New York to become an illustrator.

November 18, 1903 He enrols in the Art Students League for two years and does a third year at night; his teachers are Frank DuMond, Henry Reuterdahl, and George Bridgeman. He attends lectures by William Merritt Chase and Robert Henri and exhibitions of Monet at Durand-Ruel in 1903. Milne makes a living painting showcards, or window signs, for shops.

1905 Rockwell Kent's exhibition makes a big impression on him and other students at the League.

1906 With fellow artist Amos Engle, a Quaker, he establishes a studio at 8 (now 20) East Forty-second Street, an enterprise that is a focal point for artists, such as William and Marguerite Zorach, and that lasts ten years. He meets Frances May (Patsy) Hegarty (c. 1889/90–1968).

1907–08 Milne and Engle take painting holidays near Ashley in the Wilkes-Barre region of Pennsylvania. His attempts to become

an illustrator for magazines are frustrating and seldom successful; he sells five illustrations to *Cosmopolitan* magazine, but they are never used; some work is published in *Uncle Sam's Magazine*, but work for *Munsey's*, *Cavalier*, and *Pearson's* all come to nothing. Posters and showcards are a steady source of business. Kent has another exhibition across the street from Milne's studio; and the Eight (Robert Henri, Maurice Prendergast, George Luks, etc.) have their first exhibition at the Macbeth Gallery. Steiglitz opens his Little Galleries of the Photo Secession, known as the 291 gallery.

April 29, 1909 Milne's first publicly exhibited picture, a pastel, *Classon Point Road*, is in the American Water Color Society's spring exhibition. His pastel *The Defiant Maple* is in the New York Water Color Club's exhibition October 30.

1910 Milne shows *The Defiant Maple* again at the Philadelphia Water Color Club's exhibition and receives his first, short, critical notice: "*The Defiant Maple* of David Milne is clever, if bilious." A friend of Milne's buys it and another painting.

1910–12 Milne initially shows mostly pastels and etchings, with a few watercolours, in various society exhibitions in New York, Philadelphia, Chicago, and Buffalo. From the fall of 1912 onwards, however, he submits only watercolours and oil paintings.

1911 Milne attends exhibitions at Steiglitz's 291 gallery: John Marin's in February; the first North American showing of Paul Cézanne's watercolours in March; and later those of Henri Matisse and Constantin Brancusi.

1911–21 Milne shows in the annual exhibitions of the American Water Color Society, the New York Water Color Club, the Philadelphia Water Color Club, and the Pennsylvania Academy from 1911 to 1916 (except no entry in the Academy in 1914); in 1917, 1918, 1920, and 1921 in the Philadelphia Club; and in the Boston Society of Water Color Painters, 1921; the N.E. Montross Gallery shows his work from 1914 to 1916 and again in 1921.

May 23, 1912 The New York Public Library opens; Milne paints several paintings of the interior and of fellow Canadian Edward Potter's lions soon after they are installed at the entrance.

August 3, 1912 Milne and Patsy marry and honeymoon in Paisley, Ontario. Milne becomes a full member of the New York Water Color Club. He exhibits regularly in this and several other society exhibitions (the American Water Color Club and the Philadelphia Water Color Club) until 1920, and receives periodic attention in the press — the critic of *The New York Times* being particularly attentive and sympathetic.

1913 Milne has five paintings (two oils and three watercolours) shown in the International Exhibition of Modern Art, the notorious Armory Show, in February; the American artist Carl Zigrosser rates Milne among the dozen or so best artists in the exhibition. Milne and Patsy holiday at West Saugerties in the Catskills for three weeks that summer. Has his first (and only) work accepted by the National Academy of Design in December.

1914 In January, Milne organizes an exhibition with seven friends

who call themselves the Contemporaries; he shows ten works. Milne exhibits at the N.E. Montross Gallery and a work, *Red*, is reproduced in *The New York Times*, October 18; Montross represents the Eight, some, if not all, of whom Milne knows, and with whom he occasionally serves on juries for society exhibitions. In June–August he paints at West Saugerties, where he learns of the outbreak of war in Europe. Along with John Marin, Maurice Prendergast, and N.C. Wyeth, Milne is elected a member of the Philadelphia Water Color Club.

1915 Milne wins a silver medal for his seven watercolours at the Panama–Pacific International Exposition in San Francisco (Ernest Lawson won a gold). Serves as a juror with Edward Redfield and Joseph Pennell for the Philadelphia Water Color Club. Serves on the Executive Committee of the New York Water Color Club. Exhibits his work in his apartment, first painting the walls black. He meets James Clarke, who has seen his work at Montross and admired it greatly. Clarke is an advertising artist using the name Réné Clarke; he later becomes a top executive with the firm Calkins and Holden and is later the first inductee into the American Advertising Hall of Fame; he becomes Milne's close friend and confidant, as well as his financial supporter.

May 1916 The Milnes move to rural Boston Corners, a tiny village in upstate New York (where the New York, Connecticut, and Massachusetts state lines meet), on the west flank of the Taconics. Milne's intention is to paint full time, but he continues to make showcards monthly for some clients and tries gardening for profit (onions and celery) without much success. Anne and James Clarke

Fig. 36 Milne at Boston Corners, 1916, gelatin silver photograph, 12.8 × 7.5 cm, Library and Archives Canada, Ottawa, David Brown Milne collection (c-057190)

visit regularly. The Milnes holiday at nearby Tivoli in 1916 and 1917, where Patsy's aunt has an estate.

Late December 1917 Milne enlists in the Canadian Army at the British Recruiting Office in New York.

March 1, 1918 Arrives in Toronto for basic training; he is sent to Quebec City in April because of conscription riots there, continues training, and spends the summer rounding up deserters in the Eastern Townships of Quebec near Black Lake; finally embarks for Europe on September 10; quarantined (for the Spanish flu) at Kinmel Park Camp in Wales.

November 11, 1918 Armistice declared; Canadian soldiers await return home.

December 6, 1918 In London on leave, Milne discovers the Canadian War Records program and is engaged to paint locations where Canadian troops are billeted. He paints first at Kinmel Park Camp in Wales; on January 19 his first nine watercolours are added to the large Canadian War Memorials exhibition, then a sensation at the Royal Academy; he proceeds to Ripon in Yorkshire February 24, to Bramshott in Hampshire March 20, and in late April to Seaford in Surrey.

May 17, 1919–August 30, 1919 Milne spends three and a half months in France and Belgium painting the battlefields on which Canadian troops fought and many died: Amiens, Vimy Ridge, Courcelette, Lens, Monchy, Ypres, and Passchendaele among them. He paints forty-two works in the United Kingdom and sixty-seven on the Continent.

September 1919 Milne returns to London, then takes leave to travel to Scotland to visit the villages (Fyvie and Udney) in Aberdeen where his parents came from.

October 14, 1919 He is demobilized in Toronto.

November 20, 1919 Milne returns to Boston Corners and starts painting again December 13. He begins numbering and making notes (duly typed up and often illustrated) on each of his paintings. In four months, to mid-April, he produces nearly one hundred works, about half watercolours and half oils.

September–October 1920 He paints a series of reflection paintings at Weed Iron Mines, Kelly Ore Bed, and Bishop's Pond.

Winter 1920–21 In the fall, Patsy goes to work in New York when Milne decides to build a retreat for himself high above Boston Corners on Alander Mountain and to attempt more carefully considered work. However, only thirty paintings, most done quickly, are completed before the little hut is abandoned May 9, 1921.

May–October 1921 Milne and Patsy work at Dart's Camp in the western Adirondacks, where Milne advances his austere and original drybrush watercolour style, developed in France and Belgium. He meets Christian Midjo, a Norwegian artist teaching at Cornell University.

June 10, 1921 Milne's father dies.

Winter 1921–22 The Milnes live in Howard Sherman's summer house at Mount Riga, just south of Boston Corners. Milne's

submissions to the watercolour societies and to Montross are all rejected. He continues to make notes on his paintings.

1922 Midjo organizes an exhibition of Milne's work at Cornell University. This brings him the patronage of Robert North, Spencer Kellogg, and Stockton Kimball, all of whom buy work and try to arrange more exhibition opportunities for Milne.

May 29, 1922 Milne's mother dies.

Summer 1922 The Milnes run the Little Tea House at Big Moose Lake through the summer. Milne does no painting.

Winter 1922–23 The Milnes return to Sherman's house at Mount Riga, now owned by Clarke. Milne again keeps notes on his paintings.

Summer 1923 The Milnes again run the Little Tea House. Milne does little painting.

Early October 1923 Milne goes to Ottawa to try to earn some money by teaching or otherwise, and to become part of the Canadian art world. He also hopes that, based on his war paintings, the National Gallery of Canada will buy a large selection of his work. He sets up his studio and living quarters in a room at 197 Sparks Street, at Bank Street. Despite having two watercolours chosen for the British Empire Exhibition at Wembley in 1924 (and three more in 1925), and some money from Midjo, who has sold several paintings, Milne's painting languishes.

1924 A large exhibition of watercolours (112 sent, 95 hung) at the Art Association of Montreal opens January 1; not a single work is sold. In March, the National Gallery buys six watercolours for $25 each. Milne, dispirited, returns to Big Moose Lake.

April 1924 Clarke finances Milne to buy a lot and build a cottage at Big Moose Lake; Milne's intention is to run a tea house in the summers and paint in the winters. He expects construction to take the summer, but it stretches out over the next four years. During the first year (and again in 1928) he and Patsy run the tea house at the nearby Glenmore Hotel.

Winters 1924–29 The Milnes run the tea house at the foot of the ski jump at Lake Placid. Milne learns to ski.

Summers 1925–28 The Milnes run their own (unfinished) tea house at Big Moose in 1925–6–7. Milne's painting production drops significantly. He stops painting watercolours in the spring of 1925.

Winter 1927 Milne starts experimenting with colour drypoints at Lake Placid in 1927, after Clarke purchases a small etching press for him. Milne tries to sell the cottage in 1926 and 1927 and finally succeeds at the end of 1928.

May–September 1929 Milne leaves Lake Placid and returns permanently to Canada, alone. He camps near the village on Lake Temagami in northern Ontario and devotes his whole time to painting.

September 1929–March 1930 Milne moves to Weston, Ontario, a suburban community near Toronto; Patsy joins him, but their relationship is parlous. His studio is in the Longstaff Pump Works.

1930 Milne receives a commission, through the intercession of his

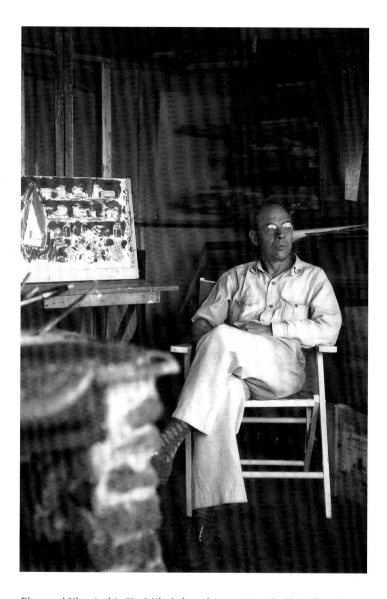

Fig. 37 Milne in his Six Mile Lake cabin, 1938, with *The Yellow Coat* on the easel, photo by Douglas Duncan, Milne Family Collection

friend James Clarke, from Elmer Adler, publisher of *The Colophon*, to make two thousand two-colour drypoint prints to be bound into this deluxe periodical for bookmen. The subject he chooses is *Hilltop*, now known as *Painting Place* after the painting it was based on; Milne misses the deadline, the print run is extended to three thousand, and the drypoint is bound into *The Colophon, Part V* (1931).

March 1930 – May 1933 The Milnes move to Palgrave, Ontario, a country village about sixty kilometres northwest of Toronto, and rent an unfurnished house. The effect of the Depression, a lack of sales of paintings, and only sporadic payments on the mortgage of the Big Moose cottage, which Milne and Clarke had assumed, add to the difficulties of his and Patsy's deteriorating relationship. Milne, nevertheless, paints more than two hundred canvases and writes many long letters (some up to fifty pages) and makes extensive notes on his art theories, devices, and ideas. He also produces a number of his finest drypoints.

1932 From Palgrave, Milne corresponds from time to time with H.O. McCurry at the National Gallery of Canada, who recommends, in 1932, the purchase for $175 of a major painting to Alice and Vincent Massey, leading art patrons.

April 24, 1933 Milne and Patsy sign a separation agreement.

1933–39 Milne leaves Palgrave in May 1933, travelling by canoe up Lake Couchiching and the Severn River to Severn Falls, finally settling, late in the summer, at Six Mile Lake, then uninhabited, in Baxter Township near the south end of Georgian Bay — a location

accessible only by boat or by foot in winter. He builds a 3.7 × 4.8 m cabin there late in 1933, his home for the next six years.

August 20, 1934 In a letter, Milne proposes to Alice and Vincent Massey that they buy all his paintings (about a thousand) for $5 each, an acquisition that would allow him to continue painting. They purchase three hundred canvases and two watercolours for $1500, those Milne had with him, most of them from Palgrave and Temagami. Contrary to Milne's wishes that these works be kept together, the Masseys arrange to exhibit and sell some at Mellors Galleries in Toronto (the terms are kept secret from Milne). The Masseys promise to share the profits with Milne after their $1500 and expenses are recouped, but with many expenses (including framing them for their home, shipping, and many other costs) and a hefty 50 per cent commission to Mellors, a "profit" is never realized.

Nevertheless, the exhibition (opening November 20, 1934) and subsequent exhibitions in Toronto (May 1935, November 1935, October 1936, and January 1938), Ottawa (January and December 1935), and Montreal (March 1935), push Milne into the spotlight and gave him national (and later international) exposure. Alan Jarvis, a student at the University of Toronto and later director of the National Gallery of Canada, writes a review of the first exhibition in 1934, and introduces Douglas Duncan to Milne's work. At his exhibition in 1938 he meets the artist Arthur Lismer, the curator Robert Hunter, and the art critics Pearl McCarthy and Graham McInnes, both of whom become strong supporters.

The Masseys move to England in 1935 and continue to acquire Milne's work of 1935 and 1936, paying even less than initially and ignoring his entreaties that the arrangement was not intended to cover current production.

1937 Milne begins painting in watercolour again, and this becomes the dominant medium of his last fifteen years' work. He is enchanted anew by children's paintings, and his fantasy pictures of biblical themes, playing card characters, and other amusing subjects develop from this point on. Milne sends for the boxes of paintings stored with Clarke and entrusts them to Duncan.

1938 Milne meets Kathleen (Wyb) Pavey, a woman half his age; they fall in love. The arrangement with the Masseys ends acrimoniously with respect to Mellors, in 1938. Duncan becomes Milne's agent and dealer, and thereafter organizes, almost annually, exhibitions at the Picture Loan Society in Toronto. Duncan and J.S. McLean buy a large number of the early watercolours. McLean buys twenty-two watercolours for $1600 and becomes Milne's most generous patron. Milne's work is part of a large Canadian art exhibition at the Tate Gallery, London.

June 1939 Milne moves to Toronto to live with Kathleen, who takes his name. Their plans to go to England are blocked by the outbreak of war.

September 1940 Milne and Kathleen make a six-week camping trip in Haliburton and, with the exception of 1941, do this every year until 1946.

October 31, 1940 Milne and Kathleen move, since she is pregnant, to Uxbridge, Ontario, a small town about sixty-five kilometres

Fig. 38 Milne in a tweed cap, c. 1942, in his Uxbridge studio, photo by Douglas Duncan, Milne Family Collection

northeast of Toronto. Their whereabouts are not disclosed except to a few close friends, partly because of the scandal (Milne is neither divorced from Patsy nor married to Kathleen) and partly because Milne does not want Patsy showing up, though he continues to provide for her support to the extent he can. All banking and correspondence are funnelled through Duncan at the Picture Loan Society in Toronto.

May 4, 1941 David Milne Jr. is born.

1943–47 Duncan promotes Milne's work and manages to increase his annual income to over $1000 for the first time during these years. He finally sells the oil painting *Boston Corners* (1917–18, M&S 107.126) to the National Gallery for $450, the most Milne sells a painting for during his lifetime.

1947 Milne writes nine chapters of his autobiography early in the new year but writes nothing about his life at Big Moose Lake, Lake Placid, Temagami, or Palgrave.

September 9, 1947 Milne entrains for Baptiste Lake, immediately south of central Algonquin Park, to find a new place to paint. He discovers a congenial spot and decides to build a cottage there, which he does the following summer and fall.

1948 He sees the local doctor about "indigestion, heartburn, and nervous heart."

Late May to mid-November 1948 Milne returns to Baptiste Lake and builds his 4.9 × 6.7 m log cabin. He cuts his own logs and builds

accessible only by boat or by foot in winter. He builds a 3.7 × 4.8 m cabin there late in 1933, his home for the next six years.

August 20, 1934 In a letter, Milne proposes to Alice and Vincent Massey that they buy all his paintings (about a thousand) for $5 each, an acquisition that would allow him to continue painting. They purchase three hundred canvases and two watercolours for $1500, those Milne had with him, most of them from Palgrave and Temagami. Contrary to Milne's wishes that these works be kept together, the Masseys arrange to exhibit and sell some at Mellors Galleries in Toronto (the terms are kept secret from Milne). The Masseys promise to share the profits with Milne after their $1500 and expenses are recouped, but with many expenses (including framing them for their home, shipping, and many other costs) and a hefty 50 per cent commission to Mellors, a "profit" is never realized.

Nevertheless, the exhibition (opening November 20, 1934) and subsequent exhibitions in Toronto (May 1935, November 1935, October 1936, and January 1938), Ottawa (January and December 1935), and Montreal (March 1935), push Milne into the spotlight and gave him national (and later international) exposure. Alan Jarvis, a student at the University of Toronto and later director of the National Gallery of Canada, writes a review of the first exhibition in 1934, and introduces Douglas Duncan to Milne's work. At his exhibition in 1938 he meets the artist Arthur Lismer, the curator Robert Hunter, and the art critics Pearl McCarthy and Graham McInnes, both of whom become strong supporters.

The Masseys move to England in 1935 and continue to acquire Milne's work of 1935 and 1936, paying even less than initially and ignoring his entreaties that the arrangement was not intended to cover current production.

1937 Milne begins painting in watercolour again, and this becomes the dominant medium of his last fifteen years' work. He is enchanted anew by children's paintings, and his fantasy pictures of biblical themes, playing card characters, and other amusing subjects develop from this point on. Milne sends for the boxes of paintings stored with Clarke and entrusts them to Duncan.

1938 Milne meets Kathleen (Wyb) Pavey, a woman half his age; they fall in love. The arrangement with the Masseys ends acrimoniously with respect to Mellors, in 1938. Duncan becomes Milne's agent and dealer, and thereafter organizes, almost annually, exhibitions at the Picture Loan Society in Toronto. Duncan and J.S. McLean buy a large number of the early watercolours. McLean buys twenty-two watercolours for $1600 and becomes Milne's most generous patron. Milne's work is part of a large Canadian art exhibition at the Tate Gallery, London.

June 1939 Milne moves to Toronto to live with Kathleen, who takes his name. Their plans to go to England are blocked by the outbreak of war.

September 1940 Milne and Kathleen make a six-week camping trip in Haliburton and, with the exception of 1941, do this every year until 1946.

October 31, 1940 Milne and Kathleen move, since she is pregnant, to Uxbridge, Ontario, a small town about sixty-five kilometres

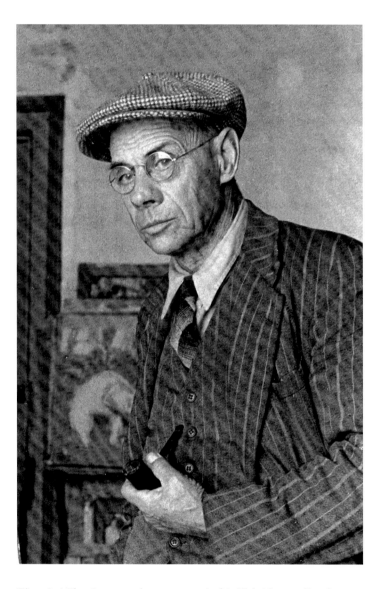

Fig. 38 Milne in a tweed cap, c. 1942, in his Uxbridge studio, photo by Douglas Duncan, Milne Family Collection

northeast of Toronto. Their whereabouts are not disclosed except to a few close friends, partly because of the scandal (Milne is neither divorced from Patsy nor married to Kathleen) and partly because Milne does not want Patsy showing up, though he continues to provide for her support to the extent he can. All banking and correspondence are funnelled through Duncan at the Picture Loan Society in Toronto.

May 4, 1941 David Milne Jr. is born.

1943–47 Duncan promotes Milne's work and manages to increase his annual income to over $1000 for the first time during these years. He finally sells the oil painting *Boston Corners* (1917–18, M&S 107.126) to the National Gallery for $450, the most Milne sells a painting for during his lifetime.

1947 Milne writes nine chapters of his autobiography early in the new year but writes nothing about his life at Big Moose Lake, Lake Placid, Temagami, or Palgrave.

September 9, 1947 Milne entrains for Baptiste Lake, immediately south of central Algonquin Park, to find a new place to paint. He discovers a congenial spot and decides to build a cottage there, which he does the following summer and fall.

1948 He sees the local doctor about "indigestion, heartburn, and nervous heart."

Late May to mid-November 1948 Milne returns to Baptiste Lake and builds his 4.9 × 6.7 m log cabin. He cuts his own logs and builds

the cabin single-handedly, and it is almost finished before he leaves.

February 1949 At the beginning of the month he is back, finished cabin or no, to continue his painting at the lake. Thereafter, he paints only at the lake, where he lives by himself, except in the summer months. The usual pattern for the next three years is to be at Uxbridge for Easter and until David Jr.'s birthday, and then back again for Christmas and New Year's.

April 12, 1951 After feeling unwell for some time, Milne is operated on at Toronto's Western Hospital for cancer of the lower intestine. He recuperates at the Ford Hotel in Toronto, where he sketches the subjects of many of his later paintings in pencil.

June–November 1952 Milne's work represents Canada at the Venice Biennale. Kathleen and David Jr. move to Bancroft in September. Milne has a stroke at Baptiste Lake on November 14 and is taken to hospital.

1953 He sustains another severe stroke on January 5 and is transferred to Sunnybrook Hospital in Toronto, where he suffers yet another in March, and one again in July at Baptiste Lake, where he wanted to be for the summer. He dies, aged seventy-one, in Bancroft, December 26. He is buried on December 28 in Mount Pleasant Cemetery in Toronto in a grave marked only by plot number.

1955–56 The National Gallery of Canada, under its new director, Alan Jarvis, sponsors a retrospective exhibition, organized by Duncan, which travels across Canada.

1962 A small retrospective exhibition of Milne's work is shown at Hart House, University of Toronto. The National Film Board makes a film, *The World of David Milne*, a somewhat incomplete and biased account, although beautifully produced, with the incomparable actor Douglas Rain reading from Milne's writings.

1967 The Agnes Etherington Art Centre at Queen's University, Kingston, Ontario, organizes a major retrospective exhibition for Canada's Centennial.

1968 Douglas Duncan and Patsy Milne die.

1969 James Clarke dies.

1979 Paul Caulfield makes *A Path of His Own*, a comprehensive film on Milne, with Les Carlson playing the part of the artist.

November 14, 1980–April 12, 1981 The National Gallery of Canada mounts a travelling exhibition of Milne's prints and drypoints.

1991 A major exhibition of Milne's work is organized by Ian Thom for the McMichael Canadian Art Collection, just north of Toronto.

1996–99 The biography of Milne, *Painting Place: The Life and Work of David B. Milne*, is published by the University of Toronto Press; the two-volume *Catalogue Raisonné of the Paintings* follows in 1998, and the accompanying CD-ROM in 1999.

December 25, 2000 Kathleen dies in Ottawa.

Notes

"A Welcome and Refreshing Note": Milne and the New York Art Scene, 1903–13

by Carol Troyen

1. Unidentified clipping, Milne Papers, Library and Archives Canada, Ottawa. The article carries no byline, nor is the newspaper identified. The show is not named; however, a handwritten date on the clipping, October 29, 1910, suggests it was the twenty-first annual exhibition of the New York Water Color Club, which opened on October 29 that year. To complicate matters further, the works discussed in the article do not tally with the pictures Milne and Engle actually exhibited.

2. The disparate group of painters who became known as the Eight after their Macbeth Gallery exhibition was assembled by the legendary teacher Robert Henri. They mounted the show to protest what they believed were the restrictive policies of the National Gallery of Design, and not incidentally to win attention for themselves.

3. J. Nilsen Laurvik, "The Fine Arts: The New York Water Color Club Exhibition," November 2, 1910, quoted in

David P. Silcox, *Painting Place: The Life and Work of David B. Milne* (Toronto: University of Toronto Press, 1996), 28.

4. David Milne, "Notes for an Autobiography," 1947, Milne Family Collection, 9.

5. "We early learned that the Academy wasn't open very wide to us. It didn't take many years of 'rejected,' 'accepted but not hung,' and of being hung behind the door in the morgue, to drive us to watercolor. Watercolor exhibitions were less rigid, the idea still prevailed that watercolor wasn't a serious medium." Milne to Alice and Vincent Massey, August 20, 1934, Massey Papers, Massey College, University of Toronto.

6. But see Katharine Lochnan, "Reflections on Turner, Whistler, Monet, and Milne," this volume, 103–104.

7. Milne, "Notes for an Autobiography," 1.

8. Marin's watercolours were described in *Camera Work* as having "the infectious charm of the natural," and as such quintessentially American. O'Keeffe, also proclaimed a uniquely American genius, obligingly claimed, "I am one of the intuitive ones." J. Nilsen Laurvik, "The Water-Colors of John Marin," *Camera Work* 39 (July 1912): 38, and O'Keeffe to Waldo Frank,

summer 1926, quoted in Jack Cowart, Juan Hamilton, and Sarah Greenough, *Georgia O'Keeffe: Art and Letters* (Washington, D.C.: National Gallery of Art, 1988), 184.

9. See Milne, "Notes for an Autobiography," 1–2.

10. See Marchel E. Landgren, *Years of Art: The Story of the Art Students League of New York* (New York: Robert M. McBride & Company, 1940), 64, 84; Milne, "Notes for an Autobiography," 12.

11. However, he met Amos Engle at the Art Students League.

12. Milne, "Notes for an Autobiography," 10.

13. Ibid., 7.

14. Silcox, *Painting Place*, 23.

15. "Water Color Club Excels All Former Exhibitions," *Public Ledger* (Philadelphia), November 12 [13?], 1910; Laurvik, "The Fine Arts."

16. Milne to Alice and Vincent Massey, August 20, 1934.

17. Stieglitz argued, "[I do] not see why photography, water colors, oils, sculptures, drawings, prints . . . are not of equal potential value. I cannot see why

one should differentiate between so-called 'major' and 'minor' media. I have refused so to differentiate in all the exhibitions that I have ever held." Dorothy Norman, ed., "Writings and Conversations of Alfred Stieglitz," *Twice a Year* 14–15 (1947), quoted in Barbara Rose, *Readings in American Art Since 1900: A Documentary Study* (New York: F.A. Praeger, 1968), 45.

18. The New York Water Color Club was founded in 1890 by Hassam and other artists in reaction to the increasing conservatism and restrictive admissions policies of the American Water Color Society, which had been in existence since 1866. The new organization was more broadly inclusive (as a result, many women participated in its annuals) and more tolerant of experimental approaches to watercolour, especially mixed-media effects. Although there was considerable crossover between the two groups, even by the time Milne began exhibiting, established artists were more likely to show with the American Water Color Society; younger artists more often found a welcome in the Water Color Club shows.

19. "'Hop' Smith at Knoedler's," *American Art News* 9, no. 10 (December 17, 1910): 2.

20. Milne, "Notes for an Autobiography," 171, and Milne to Carl Schaefer, February 16, 1938, Carl Schaefer Papers, Library and Archives Canada, Ottawa.

21. David Milne, "Art: Monet." Unpublished essay, 1940s, Milne Family Collection.

22. Milne to Alice and Vincent Massey, August 20, 1934. In fact, his memory of the 291 shows probably blurred with what he saw at the Armory Show, for neither Gauguin nor Van Gogh were exhibited at 291.

23. "Notes and Reviews," *The Craftsman* 1908: 8, quoted in John Cauman, "Henri Matisse, 1908, 1910, and 1912: New Evidence of Life," in Sarah Greenough et al., *Modern Art and America: Alfred Stieglitz and His New York Galleries* (Washington, D.C.: National Gallery of Art, 2001), 86.

24. "Annual Watercolor Show," *American Art News* 10, no. 3 (October 28, 1911): 3; "The Twenty-second Annual Exhibition of the New York Water-Color Club," *International Studio* 45, no. 178 (December 1911): xliii.

25. "Passing in the Art World. Opening of the Water Color Club Exhibition," October–November 1911. Undated, unidentified review, Milne Papers, Library and Archives Canada, Ottawa.

26. Gelett Burgess, "Wild Men of Paris," *Architectural Record* 27 (May 1910): 402.

27. This is the case even when he depicts new buildings, such as the New York Public Library, which opened in 1911.

28. John O'Brian, *David Milne and the Modern Tradition of Painting* (Toronto: The Coach House Press, 1983), 63–66. As O'Brian points out, the art press discussed Prendergast and Milne together on several occasions.

29. Robert A.M. Stern, Gregory Gilmartin, and John Massengale's *New York 1900* (New York: Rizzoli International Publications, Inc., 1983) provides a generously illustrated survey of the new buildings of this era.

30. On Coney Island, see Edo McCullough, *Good Old Coney Island* (New York: Charles Scribner's Sons, 1957) and Robert W. Snyder, "City in Transition," in Rebecca Zurier, *Metropolitan Lives: The Ashcan Artists and Their New York* (Washington, D.C.: National Museum of American Art in association with W.W. Norton & Company, New York and London, 1995), 29–57.

31. As O'Brian notes (*David Milne and the Modern Tradition of Painting*, 75), "Whistler's high reputation in America . . . reached its zenith in the decade following his death in 1903 . . . In the period from 1907 to 1914 . . . books on Whistler were published at the rate of two a year, and three large retrospectives of his work were mounted in New York — at the Metropolitan Museum of Art (1910), at the Grolier Club (1910), and at M. Knoedler & Co. (1914)." Works by Whistler were also prominent in group shows, including a 1910 exhibition at Montross Gallery, and his etchings and lithographs were shown regularly at Frederick Keppel & Co., New York's leading outpost for contemporary prints. See also Lochnan, "Reflections on Turner, Whistler, Monet, and Milne," 104–107.

32. Richard Dorment and Margaret F. MacDonald, *James McNeill Whistler* (Washington, D.C., and London: National Gallery of Art and Tate Gallery Publications, 1994), 133.

33. See O'Brian, *David Milne and the Modern Tradition of Painting*, 74.

34. Compared with Milne, who was motivated by an interest in abstract patterning, these artists emphasize the luxury of their interiors; the figure is just one more feature in a display of wealth and good taste.

35. See, for example, Whistler's *Princess from the Land of Porcelain* and *Caprice in Purple and Gold: The Golden Screen* (both Washington, D.C.: Freer Gallery of Art) for kimono-clad figures. The latter was included in the Whistler exhibition at the Metropolitan Museum in 1910. Whistler's tender, decorative watercolours of his lover, Maud, provide yet another compositional precedent.

36. See also *Yellow Room*, 1913 (M&S 104.72, Milne Family Collection), which includes his December 25, 1912, watercolour *Winter Shadow* (M&S 104.65, Milne Family Collection) and *Study*, 1912–13 (M&S 104.79, Milne Family Collection), which contains *Woman at Dresser*, 1912. This device was used by Whistler, among others, most famously in his *Arrangement in Grey and Black: Portrait of the Painter's Mother* (Musée du Louvre).

37. J.N.L. [J. Nilsen Laurvik], "New York Watercolor Club: A Motley Array of Inconsequential Work—Grace E. Hackett's Picture One of the Redeeming Features—Work by Mr. Milne and Mr. Shaw," *Boston Transcript*, November 6, 1912.

"The Best Essays in Modernism": New York and Boston Corners, 1913–17

by Carol Troyen

1. Although Milne was not asked to participate, his work was selected from a large roster of uninvited applicants by a committee chaired by Prendergast.

2. *New York Times*, March 2, 1913, 15; *Christian Science Monitor*, February 24, 1913, quoted in David P. Silcox, *Painting Place: The Life and Work of David B. Milne* (Toronto: University of Toronto Press, 1996), 56.

3. In comparison, the already popular Marin priced his watercolours at $250 and $300.

4. "Novel Hanging at Water Color Show: Best Essays in Modernism," *New York Sun*, November 1913, Milne Papers, Library and Archives Canada, Ottawa (quoted in Silcox, *Painting Place*, 56–57).

5. And not always admiringly. See, for example, *International Studio*'s review of the 1914 Philadelphia Water Color Club exhibition, in which Milne's submissions, along with Marin's, were deemed "quite too modern in technique to be intelligible." "Studio Talk," *International Studio* 54 (February 1915): 313.

6. Milne, "Notes for an Autobiography," Milne Family Collection, 136.

7. Milne, quoted by Alan Jarvis, *David Milne* (Toronto: McClelland and Stewart, 1962), 6.

8. Judith Zilczer, "'The World's New Art Center': Modern Art Exhibitions in New York City, 1913–1918," *Archives of American Art Journal* 14, no. 3 (1974): 4.

9. Montross was moved as much by expediency as by a crusading dedication to modernism. He believed his shows would "prove to be a natural sequel to the international exhibition of modern art which created so much interest . . . I consider it wiser to open the door from the inside rather to have it thrust in your face from outside." "American Pictures at the Lotos Club . . . Modernist Exhibition at Montross Galleries," *New York Times*, January 30, 1914, 8.

10. "The Montross Gallery Opens with an Interesting Display — Fifth Exhibition at Corcoran Gallery, Washington, to Open Dec. 15," *New York Times*, October 18, 1914, sec. 5, 11. The same theme recurred in response to Milne's entries to the New York Water Color Club Show: "David Milne invariably manages an effect of modernity. His subjects are just the same pleasant old subjects — men reading, women sewing or peeling apples or having tea. It is all just the same, except that the work is dressed in the fashion of the moment, and well dressed. The artist has a genius for fashion. Not one in a thousand [artists] can spot a piece of paper as cleverly as he. "New York Water Color Club's 25th Exhibition," *New York Times*, November 8, 1914, 11.

11. James Clarke, interview by Blodwen Davies, May 1961, reel 3, p. 9. David Milne Papers, Library and Archives Canada, Ottawa. Gold mats — which give watercolours the presence of oil paintings — were often used by artists of an earlier generation, such as John La Farge. Modernists preferred white or cream mats. And Milne's concern for the æsthetic character of the experience as a whole — the design of the exhibition space so that it becomes a work of art in itself — is of course Whistlerian.

12. "Art Notes: American Water Color Society Exhibition — J.A. Smith's Etchings," *New York Times*, February 20, 1914, 8.

13. Milne to Alice and Vincent Massey, August 20, 1934, Massey Papers, Massey College, University of Toronto.

14. He wrote to Patsy in 1909, "I saw some Etchings of Joseph Pennells this afternoon. There is an Exhibition of them at Keppells on 39th St. They are something like the ones I do, only of course a great deal better. I imagine he gets a great deal of money for them now. He is about the best living Etcher." Milne to Patsy Hegarty, October 6, 1909, Milne Family Collection.

15. "The Philadelphia Watercolor Exhibition was always our favorite. These exhibitions were better financed than the New York ones, and could do things that the New York societies couldn't attempt." Milne to Alice and Vincent Massey, August 20, 1934.

16. "Studio Talk," *International Studio* 54, 311–13.

17. Boston Corners Painting Note 118. August 27, 1920. Milne Papers, Library and Archives Canada, Ottawa, quoted in Silcox, *Painting Place*, 62.

18. "The Water Color and Other Art Exhibitions," *The New York Times Magazine*, November 14, 1915, sec. 4, p. 21; "Water Color Exhibition: American Society's Members Show Their Work at National Club," *New York Times*, February 5, 1916, 10.

19. Silcox, *Painting Place*, 67.

20. "In Explanation," *The Forum Exhibition of Modern American Painters* (New York, 1916), 5.

21. "'Hop' Smith at Knoedler's," *American Art News* 9, no. 10 (December 17, 1910): 2. See p. 21 for full quotation.

22. A.E. Gallatin, "Some Masters of the Water-Colour," *Certain Contemporaries: A Set of Notes in Art Criticism* (New York: John Lane Company, 1916), 35–36.

23. Milne, "Notes for an Autobiography," Boston Corners chapter, 1.

24. In fact, it is not much different today, although trains no longer run through the village, and residents can enjoy the local golf course. Milne's house still stands, tucked under the mountain, about a half-mile from the main crossroads at Boston Corners.

25. Milne, "Notes for an Autobiography," Boston Corners chapter, 7.

26. He wrote proudly in his autobiography, "If jobs were scarce, living was cheap and there were many ways of stretching our small resources." Milne, "Notes for an Autobiography," 9. When forced to resume his commercial art business, he was able to compress it into about ten days a month, leaving him free to paint the rest of the time.

27. Other artists of Milne's generation were subject to the same mythologizing. The mystique of O'Keeffe would be magnified by her departure from New York for the southwest; Dove's impoverished years living on a houseboat, in a former roller-skating rink, and in an abandoned post office are

seen as evidence of his willingness to suffer for his art.

28. In a letter to the Masseys, he wrote, "For most of my painting life I have been cut off from other painters." Milne to Alice and Vincent Massey, August 20, 1934.

29. Milne to Clarke, Boston Corners, December 18, 1919, Milne Papers, Library and Archives Canada, Ottawa.

30. Milne called this a "camouflage picture." Milne to Clarke, December 7–9, 1918, Milne Papers, Library and Archives Canada, Ottawa.

"The Man Changes, and with That, the Painting": The War Watercolours

by Rosemarie L. Tovell

1. Milne to Alice and Vincent Massey, August 20, 1934, Massey Papers, Massey College, University of Toronto.

2. Milne to James Clarke, May 19 or 26, 1917, Milne Papers, Library and Archives Canada, Ottawa.

3. Milne to Clarke, November 3 and 13, 1918, Milne Papers, Library and Archives Canada, Ottawa.

4. The work cannot be identified. There is no record of such a purchase among the CWM records at the Canadian War Museum, Ottawa, nor does any work of this subject in the CWM collection meet these criteria.

5. David Milne, "Notes for an Autobiography," 1947, Milne Family Collection, 63.

6. Draft letter, Milne to Clarke, January 23, 1919, Milne Family Collection.

7. Milne, "Notes for an Autobiography," 68.

8. Milne to Clarke, March 1, 1919, Milne Papers, Library and Archives Canada, Ottawa.

9. His cars were lost to accidents or breakdowns, and replacements could be had only by returning to London. The first trip is recorded and took place for a few days from July 18. Milne mentions a second trip that, judging from the absence of dated watercolours, could have taken place from August 10 to 13.

10. Milne, "Notes for an Autobiography," 78–79, 85.

11. Milne to Alice and Vincent Massey, August 20, 1934.

12. Milne, "Notes for an Autobiography," 96–97; and Milne, draft of letter to Clarke, c. July 26, 1919, or undated memoir of the War Memorials, Milne Family Collection.

13. One hundred seven were turned over to the CWM and are now housed at the National Gallery of Canada. For reasons unknown, Milne retained four, including *Ripon: High Street* (p. 70, cat. 33), now in the Art Gallery of Ontario's collection.

14. See David Milne Jr. and David P. Silcox, *David B. Milne: Catalogue Raisonné of the Paintings*, volume 1, 1882–1928 (Toronto: University of Toronto Press, 1998), 200.

15. Milne, "Notes for an Autobiography," 102.

"Decision, Strength, and Brilliant Colour": The Post-War Watercolours

by Carol Troyen

1. By 1918 critics were commenting only that "Mr. David B. Milne's drawings might have been interesting to other painters, but the man in the street would fail to find them so." Eugene Castello, "The Philadelphia Water Color Exhibition," *American Magazine of Art* 9, no. 3, (January 1918): 114. Reviewers of subsequent exhibitions failed to mention him at all. Yet Milne was far from alone in suffering from the apathy of the art world in the post-war years. The art market was depressed; the most avant-garde galleries were shutting down (291 closed in 1917; Marius de Zayas's gallery in 1921). Even some Stieglitz-circle artists were doing less well than previously, and artists without enthusiastic promoters were selling poorly, if at all. As Amos Engle wrote to console Milne, "But those miserable dealers—strange they can't see them [Milne's pictures]. The Zorachs said that the war seemed to have a

reactionary effect on the taste of buyers and dealers—they seemed to lack both discernment and courage. No doubt an improvement will be felt shortly along this line." Engle to Milne, about April 4, 1921, Milne Family Collection.

2. However, by this time works by Marin, probably the most popular watercolour painter in America, could bring as much as $1500; Demuth's watercolours sometimes sold for $1000. See Timothy Robert Rogers, "Alfred Stieglitz, Duncan Phillips, and the '$6000 Marin,'" *Oxford Art Journal* 15, no. 1 (1992): 54–66.

3. North to Milne, Buffalo, January 23, 1925. See Milne Papers, Library and Archives Canada, Ottawa.

4. David P. Silcox, *Painting Place: The Life and Work of David B. Milne* (Toronto: University of Toronto Press, 1996), 64.

5. Clarke's most ambitious project of this sort took place in the fall of 1916, when he hung a group of oils and watercolours at Calkins and Holden and sold as many as fifteen for a total of about $400. See David Milne Jr. and David P. Silcox, *David B. Milne: Catalogue Raisonné* (Toronto: University of Toronto Press, 1998), 1065, and Silcox, *Painting Place*, 393n27.

6. Milne to Clarke, Big Moose Lake, late June–July 1923, Milne Papers, Library and Archives Canada, Ottawa.

7. Clarke, interview by Blodwen Davies, May 1961, reel one, p. 8, Milne Papers,

Library and Archives Canada, Ottawa.

8. Painting note #28, January 21, 1920. Milne Papers, Library and Archives Canada, Ottawa.

9. For example, "Toward the end of the summer changes of texture began to be used, the softness of shapes in reflections on the still water against the harsher shapes of logs and trees." Milne, "Notes for an Autobiography," 1947, Milne Family Collection, Dart's Lake chapter, 120.

10. Alander Journal, Monday, November 29, 1920, in David Milne Jr. and Nick Johnson, eds., "David Milne: His Journals and Letters of 1920 and 1921: A Document of Survival," *artscanada* 30 (August 1973): 30.

11. Both Demuth and O'Keeffe deliberately chose thin, smooth, seemingly inhospitable papers for some of their watercolours—Demuth is known to have used hotel stationery—and Marin applied pigment with his fingers, matchsticks, even a syringe; he cut out shapes and pasted or, in at least one famous example, sewed them onto another sheet.

12. See Katharine Lochnan, "Reflections on Turner, Whistler, Monet, and Milne," in this volume.

13. J.N.L., "New York Watercolor Club," *Boston Transcript*, November 6, 1912.

14. Boston Corners painting note 78, March 30, 1920, quoted in Silcox, *Painting Place*, 134.

15. See Dennis Reid, "The Canadian Watercolours," in this volume, 128.

16. For example, no museum owned a Marin watercolour until 1921, when A.E. Gallatin gave *Landscape, Delaware County* (1912) to the Metropolitan Museum; two years later, the first Hopper (*Mansard Roofs*, bought by the Brooklyn Museum) entered a museum collection.

17. Rosemarie L. Tovell, "'The Man Changes, and with That, the Painting': The War Watercolours," in this volume, 80, 176n13.

18. See Lochnan, "Reflections on Turner, Whistler, Monet, and Milne," 114.

19. Milne, "Notes for an Autobiography," 171.

Reflections on Turner, Whistler, Monet, and Milne

by Katharine Lochnan

1. Milne to Alice and Vincent Massey, August 20, 1934, Massey Papers, Massey College, University of Toronto, 3.

2. Turner was known as the "Shelley of English painting," Whistler was inspired by Swinburne, Baudelaire, and Mallarmé, and Monet by Baudelaire and Mallarmé.

3. Katharine Lochnan, ed. *Turner, Whistler, Monet: Impressionist Visions* (London: Tate Publishing, 2004).

4. Milne, "Art: Monet" c. 1940s, typescript, Milne Family Collection.

5. Milne, March 20, 1942, "Question List," Art Gallery of Toronto. Milne Family Collection.

6. Ibid.

7. Milne, "Notes for an Autobiography," 1947, Milne Family Collection. Milne could have seen the caricature titled "Our Art Students" in *Harpers Monthly Magazine* 103 (June–November 1901): 161, to which the Paisley Public Library subscribed. The dialogue reads, "The One with the Palette: 'I'm afraid—just a little afraid—that I've followed Sargent too closely.' The Admiring Friend: 'Oh, it shows the influence of Sargent slightly, dear, but don't worry—there's enough of yourself in it to save it.'"

8. Walter Sickert, "Round and about Whistler: The New Life of Whistler," reprinted in *A Free House* (London: Macmillan & Co. Ltd., 1947), 9. This review of Joseph and Elizabeth Pennell's *Life of Whistler* first appeared in *The Fortnightly Review*, December 1908. Their *Life* was so popular that the first edition came out in October 1908, the second in December, and the third in February 1909.

9. Milne to Alice and Vincent Massey, August 20, 1934, 14.

10. See John House, "Tinted Steam," in Lochnan, ed., *Turner, Whistler, Monet*, 37.

11. Milne, 1942 AGT "Question List."

12. Stockton Kimball, September 9–18, 1935, "Unpublished Notes," typescript, 18, Milne Family Collection.

13. Blodwen Davies, "Interview with James Clarke," typescript, c. 1940s, 13, Milne Family Collection.

14. Milne to Alice and Vincent Massey, August 20, 1934.

15. K.M. (Kathleen Milne) typescript of "Notes for an Autobiography" corrected by D.B.M., April 13, 1947, 2, Milne Family Collection.

16. Norman Robertson, *The History of the County of Bruce* (first pub. 1906, repr. Owen Sound: Richardson, Bond, and Wright, 1971), 398.

17. Milne to Patsy Hegarty, September 1, typescript, Milne Family Collection.

18. Robertson, *History*, 176.

19. Ibid., 175.

20. David Milne Jr. was told by his mother that Milne had had a romantic involvement with an older woman while still living in Paisley. He believes that this was Miss Sarah MacCallum, appointed Librarian of the Paisley Mechanics Institute in November 1889. She remained Librarian for forty-seven years, until her death. He has seen a letter from Miss MacCallum to Milne c. 1919.

21. Account book, Paisley Mechanics Institute, Paisley Public Library. The first entry for *The Century* and *Harpers* subscriptions is dated January 31, 1895, and for *Scribners*, January 8, 1898. On March 12, 1895, Milne's brother James was paid for papering and painting the library.

22. Randall Blackshaw, "The New New

York," *The Century Magazine* 64, no. 4 (August 1902): 493–513. This building program included the New York Public Library at Fifth Avenue and Forty-second Street and a new wing at the Metropolitan Museum of Art.

23. William A. Coffin, "The Field of Art: Twenty-Five Years of American Art," *Scribner's Magazine* 32 (July–December 1902): 127.

24. Ibid.

25. Milne, 1942 AGT "Question List." Milne visited the Toronto Normal School c. 1899, which housed the Ontario School of Art, and was struck by a painting by George A. Reid (Canadian, 1860–1947) titled *The Berry Pickers*. He said that this was his "first real kick from an oil painting." Reid taught at the Ontario School of Art from 1890 to 1928.

26. All the standard works of Ruskin were available in the Mechanics Institute Libraries of Bruce and neighbouring Grey County by the 1890s. These included *Modern Painters* 5 vols. and *Fors Clavigera*. See *Owen Sound Public Library Catalogue of Books*, compiled January 1899 (Owen Sound: McCallum and Pratt, 1899). I would like to thank Judith Armstrong, Chief Librarian, Owen Sound Public Library, for drawing this publication to my attention. Although the library stock catalogues do not appear to have survived for the public libraries to

which Milne would have had access in Port Elgin, Southampton, Paisley, and Walkerton, the Library Stock Catalogue of the Cargill Mechanics Institute does survive. Cargill was on the railway line between Paisley and Walkerton and was smaller than both. The first group of entries is dated March 22, 1895, and includes M. Mather, "Life of John Ruskin" (B. 400), and Ruskin's *Two Paths in Art* (S. 713). The second group of entries was made on March 29, 1895, and includes Ruskin's *Seven Lamps of Architecture* (S. 729). I would like to thank Marzio Appoloni, Bruce County Librarian, and his staff for assisting in this research, and for drawing this catalogue to my attention. From this it can be safely assumed that Ruskin's works would have been available at the much larger libraries in Southampton, Paisley, and Walkerton.

27. Milne to Alan Jarvis, May 21, 1936, Milne Family Collection.

28. Ibid. This is a paraphrase of Whistler's statement in "The Red Rag," from *The Gentle Art of Making Enemies* (repr. New York: Dover Publications Inc., 1967), 127, "as music is the poetry of sound, so is painting the poetry of sight."

29. Milne to Alice and Vincent Massey, August 20, 1934, 1.

30. Milne to Miss May Hegarty, August 20, 1906, Milne Family Collection. He appears to have been thinking of Whistler's charming watercolours of his mistress, Maud. For examples, see

Margaret F. Macdonald, *James McNeill Whistler: Drawings, Pastels and Watercolours: A Catalogue Raisonné* (London/New Haven, Conn: The Paul Mellon Centre for Studies in British Art/Yale University Press, 1995), nos. 897 *Violet and Amber—Tea*, p. 339, and no. 900, *The Pink Note*, p. 341, both of which were purchased by Charles Freer in 1902.

31. Kimball, September 9–18, 1935, typescript, 17.

32. Whistler, *The Gentle Art of Making Enemies*, 115.

33. Milne to Clarke, October 3, 1931, quoted in Gwendolyn Owens, *The Watercolors of David Milne* (Ithaca, N.Y.: Cornell University, 1984), 103.

34. Milne, "Notes for an Autobiography," 1947, Milne Family Collection.

35. See Frederick Keppel, *One Day with Whistler* (New York: Keppel & Co., 1908). He relates an anecdote on the subject of "finish," pp. 10–11. Milne befriended Frederick Keppel, whose gallery moved in 1907 to Thirty-ninth Street and Fifth Avenue, close to Milne's studio at Forty-second Street and Fifth Avenue. Keppel lent Milne his personal copy of Maximi Lalanne's *Treatise on Etching*, originally published in Paris in 1866 as *Traité de la Gravure*; the second French edition (1878) was translated into English by Sylvester Rosa Koehler and published in Boston and London in 1880. See David Milne,

draft essay on colour drypoints, February 1942, Milne Family Collection, cited by Rosemarie L. Tovell, *Reflections in a Quiet Pool: The Prints of David Milne* (Ottawa: National Gallery of Canada, 1980), 15n35.

36. See Katharine Lochnan, *Whistler and His Circle: Etchings and Lithographs from the Collection of the Art Gallery of Ontario* (Toronto: Art Gallery of Ontario, 1986).

37. Milne to Miss May Hegarty, October 6, 1909, Milne Papers, Library and Archives Canada, Ottawa.

38. See Carol Troyen, "'The Best Essays in Modernism': New York and Boston Corners, 1913–17," in this volume, 44.

39. Keppel exhibited 107 etchings, drypoints, and lithographs. I would like to thank Nigel Thorp, Director of the Centre for Whistler Studies, Glasgow University Library, for this information.

40. Visitors' Book and Print Collection Readers Registers, Manuscript Department, New York Public Library. Milne visited the New York Public Library on June 17, July 2, July 5, and August 12, 1910. I would like to thank Roberta Waddell, Curator of Prints and Drawings, James Moske, Archivist, and Daniella Romano, Archival Intern, for providing me with this information.

41. Located on Fifth Avenue across from Central Park on the current site of the Frick Collection. I would like to thank Roberta Waddell for the information that the Lenox Library was

located on the present site of the Frick Gallery of Art.

42. The Whistler etchings were transferred to the Print Department of the new New York Public Library on Forty-second Street at Fifth Avenue, which opened in May 1912. Milne could have known of this resource before leaving Paisley, as Avery, his gifts, and student use of the collection were featured in "The Field of Art" column in *Scribner's Magazine* 31 (January–June 1902): 253–56, and *Scribner's Magazine* 33 (January–June 1903): 125–27.

43. Vol. 3 contains Kennedy numbers 165–97.

44. It is debatable whether these were true states—they are really a succession of monoprints or trial prints.

45. John Ruskin, *Modern Painters*, vol. 1, in 3d vol. of E.T. Cook and A. Wedderburn, eds., *The Works of John Ruskin*, library ed., 39 vols. (London/New York: G. Allen/Longmans, Green, and Co. 1903–12), 123.

46. Whistler, "Proposition X," *The Gentle Art of Making Enemies*, 76. The "Propositions" were originally published with the *Second Venice Set*, a group of etchings, but then incorporated into *The Gentle Art*.

47. Milne to Jarvis, May 21, 1936.

48. The other two were *Nocturne in Blue and Gold: Valparaiso Bay*, 76 in Andrew McLaren Young, Margaret Macdonald, Robin Spencer, and Hamish Miles,

The Paintings of James McNeill Whistler (New Haven, Conn.: Yale University Press, 1980), and *Nocturne: Blue and Silver, Battersea*, YMSM 119. In 1913 Milne would also have had the opportunity to see *Nocturne*, 1872, YMSM 153, at Knoedler's.

49. There was an article on this subject titled "A Study in Japanese Perspective" in "The Field of Art" column in *Scribner's Magazine* 28 (July–December 1900): 381–84. The influence of Japanese prints had revolutionized the art of illustration by the 1890s.

50. As early as 1864 Whistler applied the lessons learned from studying Japanese ukiyo-e to the reconstruction of the picture space. Two of his "kimono paintings" were included in the 1910 exhibition at the Metropolitan Museum, *Caprice in Purple and Gold: The Golden Screen*, YMSM 60, 1864, and *Purple and Rose: The Lange Leizen of the Six Marks*, YMSM 47.

51. Kimball, September 9–18, 1935, typescript, 3.

52. See Troyen, "'The Best Essays in Modernism,'" 37, and Dennis Reid, "The Canadian Watercolours," both in this volume.

53. Kimball, September 9–18, 1935, 17.

54. Pennell, *Life*, and *The Whistler Journal* (Philadelphia: J.B. Lippincott Company, 1921), 248.

55. Lochnan, ed., *Turner, Whistler, Monet*, 2.

56. Milne, "Art: Monet," 2.

57. Milne, 1942 AGT "Question List."

58. Milne, "Art: Monet," 1.

59. Milne to Alice and Vincent Massey, August 20, 1934, 1.

60. See Troyen, "'The Best Essays in Modernism,'" 49.

61. Ibid., 56.

62. Exhibited at Durand-Ruel in 1906.

63. Milne to Alice and Vincent Massey, August 20, 1934, 8.

64. Martin Butlin and Evelyn Joll, *The Paintings of J.M.W. Turner*, 2 vol. (New Haven, Conn.: Yale University Press, 1984), nos. 341 and 347.

65. I would like to thank Roberta Waddell for her research into the display of these works. The paintings were moved from the Lenox Library to the New York Public Library in March 1911. Harry Lydenberg, *History of the New York Public Library* (New York: New York Public Library, 1923), 395.

66. His first visit took place over a four-day period in the first week of December 1918. He visited the Tate Gallery, which remained open throughout the war, and the British Museum, whose galleries were closed during the war, to see the special exhibition installed partly to ensure that overseas troops saw something of the collections before returning home. He also made his first visit to the National Gallery, which was gradually putting more works on view as war offices

began to move out, on February 3 and April 22, 1919. He dropped in to the British Museum for a few minutes on February 3, 1919, perhaps to see what had recently gone back on display. See also Rosemarie L. Tovell, "'The Man Changes, and with That, the Painting': The War Watercolours" in this volume, 64.

67. These included *The Fighting Temeraire*, B&J 377, and *The Evening Star*, B&J 453, with their reflections.

68. *The Year's Art*, 1921, National Gallery Report for 1919, January 10, 1920, 11.

69. Ian Warrell e-mail to Katharine Lochnan, March 3, 2004. Detailed records of the works that were on view do not exist for this period, nor do there appear to have been any visitor books that Milne might have signed. See also *The Year's Art*, 1918, the National Gallery of British Art (the Tate Gallery), 17. These rooms had been opened in July 1910, and a visit to see them was one of the highlights of a trip to London. Of the approximately twenty thousand works left to the British Nation by Turner in his bequest, all but those directed to the National Gallery were at this time housed in the National Gallery of British Art.

70. These included *Nocturne: Blue and Silver—Cremorne Lights*, YMSM 115, and *Nocturne: Blue and Gold—Old Battersea Bridge*, YMSM 140.

71. Milne to Patsy, April 22, 1919, Milne Papers, Library and Archives Canada, Ottawa, says he was staying in Faulkener's Hotel in Villiers Street beside Charing Cross Station. He had also stayed there on his previous visit.

72. See Sylvie Patin in Lochnan, ed., *Turner, Whistler, Monet*, 179–201.

73. Monet said to the dealer René Gimpel in 1920, "I only like London in the winter. In summer, it's fine with its parks, but that's nothing beside the winter with its fogs, because without the fog, London would not be a beautiful city. It's the fog which gives it its marvellous breadth. Its regular, massive blocks become grandiose in this mysterious cloak." Quoted in John House, "The Impressionist Vision of London," in Ira Bruce Nadel and F.S. Schwarzbach, eds., *Victorian Artists and the City* (New York: Pergamon, 1980), 78–90.

74. Milne to Clarke, December 5, 1918, Milne papers, Library and Archives Canada, Ottawa.

75. Monet's *Water Lilies*, 1903, was shown at the Pratt Institute in Brooklyn, N.Y., in 1910 and sold to Henry D. Hughes, Philadelphia, in 1922.

76. Ruskin, *Modern Painters*, vol. 1, 350–78.

77. See Troyen, "'The Best Essays in Modernism,'" 56.

78. Milne to Clarke, September 1920, Milne Papers, Library and Archives Canada, Ottawa.

79. Henry David Thoreau, *Walden*, ed. C. Merton Babcock (New York: The Peter Pauper Press, 1966), 7.

80. Whistler, "Ten O'Clock," *The Gentle Art*, 144.

81. Kimball, September 9–18, 1935.

82. Milne's diary (winter 1920–21), typescript, entry for January 4, 1921, Milne Family Collection.

83. Ruskin, *Modern Painters*, vol. 1, 350–78.

84. Milne to Clarke, February 28, 1921, Milne Family Collection. Although Milne considered Ruskin the greatest of all art critics, he was well aware of his limitations and referred to him as a "liar" and faulted his knowledge of the Bible. Clive Bell had called Ruskin "that old fraud." See John O'Brian, *David Milne and the Modern Tradition of Painting* (Toronto: Coach House Press, 1983), 96n22.

85. See Carol Troyen, "'A Welcome and Refreshing Note': Milne and the New York Art Scene 1903–13," in this volume, 32.

86. See Carol Troyen, "'Decision, Strength, and Brilliant Colour': Milne's Postwar Watercolours" in this volume, 98.

87. Clarke to Milne, August 30, 1921, typescript, Milne Family Collection.

88. Clarke to Milne, October 13, 1921, Milne Family Collection.

89. Campbell Dodgson, "The Etchings of Theodore Roussel," *Print Collector's Quarterly* 14 (1927): 337. Frank Rutter in *Theodore Roussel* (London: The Connoisseur, 1926), 50, points out that he began to experiment with colour etching about 1895, which "has been his passion ever since." He always "grinds his own colours and takes endless pains to ensure their purity and permanence." He maintains that "in this matter of the colour prints he owes little or nothing to anyone but himself." For more information, see Margaret Dunwoody Hausberg, *The Prints of Theodore Roussel: A Catalogue Raisonné* (Lunenberg, Vermont: Meriden Steinhour Press, 1991 [privately published limited edition]). She writes in the brochure advertising this publication, "During the last decade of his life (1916–26) Roussel developed a new colour printmaking technique using water-based inks printed from textile and paper plates. In his Roussel Medium he combined brighter pigments and texture, at that time available only to painters, with the ability to print multiple originals."

90. Milne visited the Goupil Gallery on the last day of his four-day visit to London in early December 1918. There he saw drawings of camouflaged ships, which inspired his application to the Canadian War Records Office. Roussel's colour drypoints were first shown there in 1899.

91. This device is first adapted from Japanese prints by Whistler in 1860. See Katharine Lochnan, *The Etchings of James McNeill Whistler* (New Haven, Conn.: Yale University Press, 1983), 118–20.

92. Milne to Alice and Vincent Massey, August 20, 1934, 1.

93. Lochnan, notes from a conversation with David Milne Jr., Baptiste Lake, October 26, 2001.

94. K.M. typescript of "Notes for an Autobiography," corrected by D.B.M., April 13, 1947, 3, Milne Family Collection. The entire quotation is "I think we go to flowers as we go to art, because both are useless. We do not reach for either as an aid in our struggle for existence. Our devotion to either or both is a statement of faith, a declaration that for us there is more to life than mere continuance, it is good for itself, without purpose, that heaven is not far away and shadowy and unreal, but here, now and very real . . . In our love of art and love of roses we build our own small heavens in our own small gardens or on our own thin canvas, we accept the imperfect world around us, but within it we build our own perfect world." David Milne Jr. observed that his father "seems to have looked for and identified with a spiritual element in nature." This comes to the fore in his late narrative watercolours, where he links sunrise with the Ascension, and nature and animals with St. Francis. Lochnan, notes from a conversation with David Milne Jr., Baptiste Lake, October 26, 2001.

95. Milne, "Æsthetic Agents," unpublished essay, quoted by O'Brian in *David Milne and the Modern Tradition of Painting*, 98.

96. Kimball, September 9–18, 1935, 17.

97. The Owen Sound Mechanics Institute, the largest town in the area, not far from Paisley and accessible by rail, had Emerson's essays, including "Nature," and Thoreau's *Walden* by 1884. See *Catalogue of Books in the Library of the Owen Sound Mechanics Institute* (Owen Sound: J. Rutherford, Book and Job Printer, 1884). By 1899 it had a copy of Walt Whitman's *Leaves of Grass*. See *Owen Sound Public Library Catalogue of Books*.

98. Mabie, "Ralph Waldo Emerson in 1903," 907.

99. Robert D. Richardson Jr., "Emerson and Nature," *The Cambridge Companion to Ralph Waldo Emerson*, ed. Joel Port and Saundra Morris (Cambridge: Cambridge University Press, 1999), 103.

100. Ralph Waldo Emerson, "Nature," in *Selections from Ralph Waldo Emerson: An Organic Anthology*, ed. Stephen E. Whicher (Boston: Houghton Mifflin Co., 1957, repr. 1960), 30.

101. Emerson, "Nature," 35.

102. Emerson, "The Poet," in *Selections from Ralph Waldo Emerson*, 227.

103. Ibid., 232.

104. Ibid., 231.

105. Milne to Alice and Vincent Massey, August 30, 1934, 2.

106. Milne notes, spring 1922, Milne Family Collection.

The Canadian Watercolours

by Dennis Reid

1. Milne to James Clarke, Monday [May 23, 1921], Library and Archives Canada, Ottawa.

2. Milne to Clarke, [September 20, 1923], Library and Archives Canada, Ottawa.

3. Milne to Clarke, [begun mid-October, mailed October 30, 1923], Library and Archives Canada, Ottawa.

4. Milne, "Notes for an Autobiography," 1947, 5, Milne Family Collection.

5. See Carol Troyen, "'Decision, Strength, and Brilliant Colour': Milne's Post-War Watercolours" in this volume.

6. Milne to H.O. McCurry [November 1929], NGC. The Pissarros were in a loan exhibition, the Thomson in the permanent collection.

7. See David P. Silcox, *Painting Place: The Life and Work of David B. Milne* (Toronto, Buffalo, London: University of Toronto Press, 1996), 250–59.

8. Ibid., 259–61, 292–93.

9. Ibid., 295–97.

10. Milne to Alice Massey, August 2, 1937, Library and Archives Canada, Ottawa.

11. Milne to Douglas Duncan, December 21, 1938, Milne Family Collection.

12. Milne to Carl Schaefer, December 30, 1938, Library and Archives Canada, Ottawa.

13. Milne to Alan Jarvis, January 15, 22. 1939, Milne Family Collection.

14. Milne to Schaefer, December 30, 1938.

15. Milne to Jarvis, January 15, 22, 1939. Miss Cowan did like it well enough to accept version IV, which she kept for forty-six years before donating it to the McMichael Canadian Art Collection in Kleinburg, Ontario.

16. David Milne Jr., *David Milne: The Toronto Years 1939–1940* (Toronto: Marlborough Godard, 1976), 6.

17. Milne to Donald Buchanan, January 19, 1937, National Gallery of Canada; Milne to Alice Massey, January 19, 1937, Library and Archives Canada, Ottawa.

18. Carl Schaefer to Milne, February 3, 1937, Milne Family Collection.

19. Schaefer to Milne, April 3, 1937, Milne Family Collection.

20. Milne to Clarke, November 25, 1937, Library and Archives Canada, Ottawa.

21. Milne Jr., *David Milne.*

22. Milne to Clarke, December 10, 1940, Library and Archives Canada, Ottawa.

23. Milne diary, November 16–17, 1951, Milne Family Collection.

24. Milne, "Notes for an Autobiography," 8–9. Milne has the two of them resident in the "Plaunt Building," although it is clear from contemporary records they were in the Butterworth Building.

25. Most of this information is from contemporary correspondence. Little has been published about Yoshida Sekido. There are very short entries in two Japanese artists dictionaries, *Nippon Bijutsu Nenkan*, 1932 (reprinted by the Asahi Shinbunsha, Tokyo, 1975); *Dai Nippon Shoga Meika Dai Kan. Denki Ka Hen* (Tokyo: Naiichi Shobo, 1976). More useful is a Japanese language website, www.edomae.com/sekido/main_j.html, with a basic biography and images of a range of his work. He landed in Seattle, Washington, in 1921, spent time there, in San Francisco, and in Vancouver before heading to Toronto. He returned to the United States in 1931, landing in New York, then visiting Chicago, San Francisco, Los Angeles, and, it is claimed, Toronto again (although I have found no corroborating evidence) before returning to Japan in August 1941. He was back in the United States again in July 1951, first stopping in Boston but settling in New York, where he lived until his death there on November 9, 1966.

26. Sekido's correspondence with Doris and Gordon Mills and Thoreau MacDonald's with Doris Mills making reference to Sekido is in the Speirs Collection, The Thomas Fisher Rare Book Library, University of Toronto. Doris Mills (later Speirs) owned as many as seven paintings. Four letters to J.E.H. MacDonald, along with a sheet of Sekido's watercolour studies and

an ink sketch, were sold at Ritchie's, Toronto, June 3, 1992, lot 76. In the collection of the Art Gallery of Ontario, Toronto, are two small untitled watercolour studies of 1923, donated by the sons of Carl Schaefer. There is also a floral painting on silk, *Azaleas, Late Spring*, acquired by the Canadian National Exhibition from its annual exhibition in September 1923 and donated to the AGO in 1965.

27. Northrop Frye, "David Milne: An Appreciation," *Here and Now* 1 (May 1948): 48; reprinted in Frye, *The Bush Garden, Essays on the Canadian Imagination* (Toronto: Anansi, 1971), 205–206.

28. Milne to Kathleen Pavey, June 11–13, 1939, Milne Family Collection.

29. Draft of Milne to Alice Massey, July 1940, Milne Family Collection.

30. Lora Senechal Carney, "David Milne: 'Subject Pictures,'" *Journal of Canadian Art History* 10, no. 2 (1987): 113.

31. Ibid., n21.

32. Milne to Schaefer, April 14, 1944, Library and Archives Canada, Ottawa.

33. Milne to Duncan, April 20, 1944, Milne Family Collection.

34. Milne to Clarke, December 10, 1941, Library and Archives Canada, Ottawa.

35. Clarke to Milne, December 23, 1941, Milne Family Collection.

36. Frye, 1948, 48; *The Bush Garden*, 206.

37. John O'Brian, *David Milne and the Modern Tradition of Painting* (Toronto: Coach House Press, 1983), 128.

38. Carney, "David Milne," 114.

39. Milne to Schaefer, October 17–18, 1943, Library and Archives Canada, Ottawa.

40. Some two thousand of these survive in the Milne Family Collection. Three now in the collection of the Art Gallery of Ontario were given by Milne to the Toronto artist Gordon MacNamara, probably in 1952.

41. Milne diary, November 8, 1952, Milne Family Collection.

42. Frye, 1948, 48; *The Bush Garden*, 206.

Domesticated Modernism?

by John O'Brian

1. Raymond Wyer, *An Art Museum: Its Conduct and Concept* (Muskegon, Mich.: Hackley Gallery of Fine Arts, 1914), 9.

2. For an account of the constitution of the modern viewing subject in the United States at the end of the nineteenth and the beginning of the twentieth centuries, see Michael Leja, "Modernism's Subjects in the United States," *Art Journal* 55, no. 2 (Summer 1996): 65–72. Leja takes issue with Jackson Lears, *No Place of Grace: Antimodernism and the Transformation of American Culture 1880–1920* (New York: Pantheon, 1981), and with others who have argued that nineteenth-century American audiences strongly resisted modernism. In his article, Leja distinguishes among different modernisms of the time, as well as among the different receptions accorded them.

3. An unattributed epigraph at the beginning of the section of *An Art Museum* (p. 17) devoted to the permanent collection reads: "Art is a human conception and interpretation of things, unhampered by tradition and apparently rendered with all the spontaneity and unconsciousness manifested in the creation of nature."

4. Leo Marx, *The Machine in the Garden: Technology and the Pastoral Ideal in America* (New York: Oxford University Press, 1964).

5. One oddity that stands out, at least from a Canadian point of view, is the inclusion in the collection of two watercolours by the artist Charles John Collings—"the greatest master in that medium since Turner," according to the book (p. 35)—who emigrated from England to Canada in 1910. The Hackley watercolours were executed in British Columbia; see Ian M. Thom, *Charles John Collings* (Vancouver: Vancouver Art Gallery, 1990).

6. The war album, as I am calling it, remains in the Milne Family Collection. See David P. Silcox, *Painting Place: The Life and Work of David B. Milne* (Toronto, Buffalo, and London: University of Toronto Press, 1996), 89. Silcox's book, along with the two-volume catalogue raisonné prepared by Silcox and David Milne Jr., are the *sine qua non* of Milne studies.

7. Wanda M. Corn, *The Great American Thing: Modern Art and National Identity, 1915–1935* (Berkeley: University of California Press, 1999), 293. There is nothing unusual in the attitudes of the artists Corn writes about. The phenomenon of artistic indebtedness and its entanglements has been investigated by Harold Bloom in *The Anxiety of Influence: A Theory of Poetry* (New York: Oxford University Press, 1973).

8. This is not to suggest that Milne was immune to "patterns of mis-reading" art and artists, any more than he was immune to anxieties of artistic influence giving rise to such patterns. See Paul de Man in *Blindness and Insight: Essays in the Rhetoric of Contemporary Criticism* (London: Methuen, 1983), and Bloom, *The Anxiety of Influence*. Milne could be scathing on occasion about Canadian artists of his own generation.

9. Milne to Alice and Vincent Massey, August 20, 1934, 18, Massey College, University of Toronto.

10. David Milne, "Notes for an Autobiography," 1947, Milne Family Collection.

11. *The Studio* 54, no. 213 (November 1914): 30.

12. Frank Stella employed the term in connection with the work of Friedel Dzubas during a panel discussion, "Critical Painting: The Influence of

Criticism on Art Production," Tufts Art Gallery, February 24, 1998. The occasion was a Dzubas retrospective at the gallery, and the panel consisted of Donald Kuspit, John O'Brian, and Larry Poons, in addition to Stella.

13. Milne to Alice and Vincent Massey, August 20, 1934.

14. Milne, "Notes for an Autobiography."

15. Letter from Milne to James Clarke, January 10, 1920, Library and Archives Canada, Ottawa.

16. Northrop Frye, *Anatomy of Criticism: Four Essays* (Princeton: Princeton University Press, 1957), 5–6. Frye's most developed analysis of Milne's work is "David Milne: An Appreciation," *Here and Now* 1 (May 1948): 47–56.

17. Typescript of a letter from Milne to Donald W. Buchanan, n.d. (mid-1930s), Milne Family Collection.

18. "A work of art has meaning and interest," Pierre Bourdieu reminds us, "only for someone who possesses the cultural competence, that is, the code, into which it is encoded." *Distinction: A Social Critique of the Judgment of Taste*, trans. Richard Nice (Cambridge, Mass.: Harvard University Press, 1984), 2.

19. Letter from Milne to H.O. McCurry, March 17, 1932, National Gallery of Canada, Ottawa. Later in the letter, Milne refers to *Las Meninas* and Velasquez's compositional use of the blank back of his canvas on the left side of the painting as a device comparable to his own.

20. François-Marc Gagnon, "Milne and Abstraction," in *David Milne*, Ian M. Thom, ed. (Vancouver: Vancouver Art Gallery, 1991), pushes his valuable reading of *Framed Etching*, and Milne's writing on it, beyond previous analyses of the painting, including my own in *David Milne and the Modern Tradition of Painting* (Toronto: Coach House Press, 1983).

21. Milne to Alice and Vincent Massey, August 20, 1934. See Lochnan, "Reflections on Turner, Whistler, Monet, and Milne," in this volume, 104.

22. Milne, "His Journals and Letters of 1920 and 1921: A Document of Survival," David Milne Jr. and Nick Johnson, eds., *artscanada* 30 (August 1973): 15–55. In a letter to James Clarke dated December 18, 1919, Milne wrote, "I shall be glad to read the Clive Bell thing. Good reading is scarce here." In another letter to Clarke, from September 30, 1920, he acknowledged the receipt of two more articles by Bell, commenting, "As usual, he does some thinking." Milne Papers, Library and Archives Canada, Ottawa.

23. Roger Fry, "An Essay in Æsthetics" (1909), *Vision and Design* (New York: Meridian, 1956), and Clive Bell, *Art* (1913) (New York: Capricorn, 1958).

24. Jonathan Crary, *Suspensions of Perception: Attention, Spectacle, and Modern Culture* (Cambridge, Mass.: MIT Press, 1999), 1.

25. On different occasions, Milne wrote perceptively about both Cézanne and Matisse.

26. There are exceptions to ordered settings in Milne's work, for example, the watercolour *Glass Candlestick* (1946, cat. 78) and the *The Flooded Prospect Shaft* series of oils painted in 1929, which Milne described as looking "like a collision between Winsor & Newton's and a coal mine." Milne to H.O. McCurry, Autumn 1929, National Gallery of Canada, Ottawa.

27. The inscribed photograph, dated September 1918, is in the Library and Archives of Canada, Ottawa.

28. Kaja Silverman, *The Threshold of the Visible World* (New York: Routledge, 1996), especially the section on "The Productive Look," is suggestive about ways in which an analysis of *Self-Portrait at Black Lake, Québec* might be extended.

29. The painter Peter Doig recently stated that he was interested in Milne's approach to the landscape because of "the distance that he is able to achieve from his subject." (Matthew Higgs, "Peter Doig—20 Questions," in *Peter Doig* (Vancouver: Morris and Helen Belkin Art Gallery, 2001), 16.

30. Northrop Frye, *The Bush Garden: Essays on the Canadian Imagination* (Toronto: Anansi, 1971), vi–vii.

Catalogue List

Unless noted below, the works are exhibited at all three venues.

London and Toronto only: 8, 9, 10, 18, 19, 20, 21, 23, 31, 34, 35, 37, 38, 39, 40, 44, 45, 52, 57, 63, 64, 65, 66, 67, 68, 70, 71, 73, 75, 77, 78, 79, 81, 83, 84

London only: 22, 29, 32, 36

New York and Toronto only: 27, 42

London and New York only: 41

The M&S numbers following the dates in entries are references to *David B. Milne: Catalogue Raisonné of the Paintings*, by David Milne Jr., David P. Silcox et al.

1. (p. 18) *Black and White I*, 1911, M&S103.88
 watercolour over graphite on wove paper mounted on illustration board, 46.2 × 58.2 cm
 Collection of Byrne and Laura Harper

2. (p. 19) *Black and White II*, 1911, M&S103.89
 watercolour over graphite on wove paper mounted on illustration board, with watercoloured wove paper overlays (watermark: "J Whatman"), 45.8 × 57.9 cm
 Private Collection, Toronto

3. (p. 22) *Fifth Avenue, Easter Sunday*, April 7, 1912, M&S104.10
 watercolour on illustration board, 57.1 × 43.8 cm
 Private Collection

4. (p. 154) *Round Tree*, c. 1912, M&S104.21
 watercolour over graphite on illustration board, 50.8 × 38.1 cm
 The Thomson Collection (PC-625)

5. (p. 26) *White Matrix*, c. 1912, M&S104.50
 watercolour over graphite on wove paper (watermark: "J Whatman"), 51.0 × 60.6 cm
 Milne Family Collection

6. (p. 30) *New York Roofs*, c. 1912, M&S104.51
 watercolour over graphite on illustration board, 50.8 × 38.1 cm
 Art Gallery of Ontario, Toronto, purchase with assistance from Wintario, 1977 (77/156)

7. (p. 14) *Three Hansoms*, c. 1912, M&S104.54
 watercolour over graphite on wove paper, 61.3 × 51.8 cm
 Private Collection

8. (p. 34) *Madonna and Child after Taddeo Gaddi's "Madonna and Child Enthroned with Saints,"* c. 1912–13, M&S104.57
 watercolour over graphite on illustration board, 50.8 × 27.6 cm
 Milne Family Collection

9. (p. 34) *St. Lawrence after Taddeo Gaddi's "Madonna and Child Enthroned with Saints,"* c. 1912–13, M&S104.58
 watercolour over graphite on illustration board, 50.7 × 26.4 cm
 Milne Family Collection

10. (p. 46) *Woman at Dresser*, c. 1912, M&S104.59
 watercolour over graphite on illustration board, 50.8 × 38.1 cm
 Private Collection

11. (p. 31) *Dreamland Tower, Coney Island*, 1912, M&S104.64
 watercolour with bodycolour over black chalk on illustration board, 49.0 × 37.6 cm
 The British Museum, London, England, purchase 1993 (1993-10-2-23)

12. (p. 23) *42nd Street Library*, c. 1911–13, M&S104.71
 watercolour over graphite on wove paper, 42.9 × 36.5 cm
 Milne Family Collection

13. (p. 35) *Blue Kimono*, c. 1913, M&S104.73
 watercolour over graphite on wove paper, 41.0 × 22.6 cm
 Milne Family Collection

14. (p. 42) *Cobalt Trees*, c. 1913, M&S104.94
 watercolour over graphite on wove paper, 42.9 × 37.5 cm

Art Gallery of Ontario, Toronto, gift of Robert Dirstein and James Robertson, Toronto, in memory of Mrs. Jessie Ambridge, 1986 (86/313)

15. (p. 47) *Evening Interior*, c. 1913–14, M&S105.46
 watercolour over graphite on wove paper, 46.4 × 41.3 cm
 Collection of Dr. Peter Chan and Mrs. Debbie MacKinnon-Chan

16. (p. 50) *Summer Night, Saugerties*, 1914, M&S105.72
 watercolour over graphite on wove paper, 51.9 × 44.5 cm
 Milne Family Collection

17. (p. 43) *Wood Interior IV*, 1914, M&S105.123
 watercolour over graphite on wove paper, 46.9 × 45.5 cm
 Collection of Greg Latremoille, Toronto

18. (p. 27) *Bronx Park, 1914*, 1914, M&S105.138
 watercolour over graphite on wove paper, 38.0 × 50.7 cm
 Milne Family Collection

19. (p. 55) *Massive Design*, 1915, M&S106.39
 watercolour over graphite on wove paper (watermark: "J Whatman"), 45.7 × 56.4 cm
 Milne Family Collection

20. (p. 38) *A Barge*, 1915–16, M&S 106.55 watercolour over graphite on wove paper (watermark: "J Whatman"), 45.7 × 55.7 cm
Milne Family Collection

21. (p. 51) *Aunt Mary*, 1915–16, M&S 106.61 watercolour and ink over graphite on Japanese paper, 48.6 × 42.7 cm
Art Gallery of Ontario, Toronto, gift from the Douglas M. Duncan Collection, 1970 (70/87)

22. (p. 60) *Boston Corners I*, June 7, 1916, M&S 107.17 watercolour over black chalk on wove paper, 45.0 × 57.0 cm
The British Museum, London, England, purchase 1997 (1997-7-12-121)

23. (p. 52) *The Waterfall, 1916*, August 12, 1916, M&S 107.49 watercolour over graphite on wove paper, 45.5 × 56.5 cm
Milne Family Collection

24. (p. 2) *Bishop's Pond*, October 4, 1916, M&S 107.67 watercolour over graphite on wove paper, with watercoloured wove paper overlay, 44.2 × 54.2 cm
National Gallery of Canada, Ottawa, purchased 1955 (6380 r)

25. (p. 61) *Lee's Farm*, 1916, M&S 107.73 watercolour over graphite on wove paper, 38.5 × 54.9 cm
Private Collection, Toronto

26. (p. 58) *The Mountains (Catskills III)*, September 7, 1917, M&S 107.97 watercolour over graphite on wove paper, 39.4 × 55.9 cm

National Gallery of Canada, Ottawa, purchased 1924 (3019)

27. (p. 59) *Sunburst over the Catskills*, September 8, 1917, M&S 107.98 watercolour on wove paper, 38.5 × 55.3 cm
The Museum of Modern Art, New York, gift of Douglas Duncan, 1961 (384.61)

28. (p. 54) *Reflected Forms*, November 1, 1917, M&S 107.111 watercolour over graphite on wove paper, 38.8 × 56.6 cm
Art Gallery of Greater Victoria, Victoria, British Columbia, AGGV Women's Committee purchase, 1954 (54.17)

29. (p. 69) *Kinmel Park Camp No. 13, Looking toward Rhyl and the Irish Sea*, December 14, 1918, M&S 108.4 watercolour over graphite on wove paper, 29.1 × 45.7 cm
National Gallery of Canada, Ottawa, transfer from the Canadian War Memorials, 1921 (8517)

30. (p. 67) *Kinmel Park Camp: The Concert at the 'Y,'* December 21, 1918, M&S 108.6 watercolour over graphite on wove paper, 29.1 × 42.9 cm
National Gallery of Canada, Ottawa, transfer from the Canadian War Memorials, 1921 (8513)

31. (p. 66) *Kinmel Park Camp: Pte. Brown Writes a Christmas Letter*, December 23, 1918, M&S 108.7 watercolour over graphite on wove paper, 28.8 × 29.9 cm

National Gallery of Canada, Ottawa, transfer from the Canadian War Memorials, 1921 (8499)

32. (p. 68) *Kinmel Park Camp: Location Sketch Made from the Hills above Dyserth*, December 26, 1918, M&S 108.8 watercolour over graphite on wove paper, 29.1 × 45.7 cm
National Gallery of Canada, Ottawa, transfer from the Canadian War Memorials, 1921 (8515)

33. (p. 70) *Ripon: High Street*, February 27, 1919, M&S 108.16 watercolour over graphite on wove paper, 50.8 × 35.6 cm
Art Gallery of Ontario, Toronto, bequest of Mrs. J.P. Barwick (from the Douglas M. Duncan Collection), 1985 (85/127)

34. (p. 74) *Ripon: South Camp from General Headquarters*, March 1, 1919, M&S 108.17 watercolour on wove paper, 35.3 × 50.7 cm
National Gallery of Canada, Ottawa, transfer from the Canadian War Memorials, 1921 (8535)

35. (p. 75) *Bramshott: Interior of the Wesleyan Hut*, April 4, 1919, M&S 108.30 watercolour over graphite on wove paper, 38.5 × 50.6 cm
National Gallery of Canada, Ottawa, transfer from the Canadian War Memorials, 1921 (8541)

36. (p. 72) *Bramshott: The London–Portsmouth Road*, April 9, 1919, M&S 108.31 watercolour over graphite on wove paper, 35.4 × 50.7 cm

National Gallery of Canada, Ottawa, transfer from the Canadian War Memorials, 1921 (8546)

37. (p. 85) *Ablain-Saint-Nazaire Church from Lorette Ridge*, May 20, 1919, M&S 108.44 watercolour over graphite on wove paper, 35.4 × 50.6 cm
National Gallery of Canada, Ottawa, transfer from the Canadian War Memorials, 1921 (8434)

38. (p. 83) *Wrecked Tanks outside Monchy-le-Preux*, May 24, 1919, M&S 108.48 watercolour over graphite on wove paper, 35.4 × 50.7 cm
National Gallery of Canada, Ottawa, transfer from the Canadian War Memorials, 1921 (8438)

39. (pp. 78–79) *Montreal Crater, Vimy Ridge*, May 27, 1919, M&S 108.50 watercolour over graphite on wove paper, two sheets: 35.3 × 101.3 cm
National Gallery of Canada, Ottawa, transfer from the Canadian War Memorials, 1921 (8440.1–2)

40. (p. 86) *From a German Gun Pit at Bailleul, East of Vimy*, June 3, 1919, M&S 108.55 watercolour over graphite on wove paper, 25.1 × 35.3 cm
National Gallery of Canada, Ottawa, transfer from the Canadian War Memorials, 1921 (8446)

41. (p. 73) *Looking towards Thélus and Thélus Wood from a Nissen Hut under the Nine Elms*, June 26, 1919, M&S 108.69 watercolour over graphite on wove paper, 35.4 × 50.5 cm

National Gallery of Canada, Ottawa, transfer from the Canadian War Memorials, 1921 (8463)

42. (p. 62) *The Cathedral, Arras*, July 1919, M&S 108.85
watercolour over graphite on wove paper, two sheets: 70.6 × 50.4 cm
National Gallery of Canada, Ottawa, transfer from the Canadian War Memorials, 1921 (8507.1-2)

43. (p. 87) *Courcellette from the Cemetery*, July 26, 1919, M&S 108.86
watercolour over graphite on wove paper, 35.4 × 50.6 cm
National Gallery of Canada, Ottawa, transfer from the Canadian War Memorials, 1921 (8478)

44. (p. 81) *Zillebeke: Maple Copse and Observatory Ridge from Dormy House*, August 14, 1919, M&S 108.96
watercolour on wove paper, 35.4 × 50.5 cm
National Gallery of Canada, Ottawa, transfer from the Canadian War Memorials, 1921 (8485)

45. (p. 84) *Loos from the Trenches on Hill 70*, August 23, 1919, M&S 108.104
watercolour over graphite on wove paper, 38.4 × 55.9 cm
National Gallery of Canada, Ottawa, transfer from the Canadian War Memorials, 1921 (8493)

46. (p. 82) *Wancourt*, August 30, 1919, M&S 108.109
watercolour over graphite on wove paper, 35.3 × 50.6 cm

National Gallery of Canada, Ottawa, transfer from the Canadian War Memorials, 1921 (8496)

47. (p. 93) *Ice Box and Shelves*, March 7, 1920, M&S 201.67
watercolour over graphite on wove paper, 44.5 × 55.3 cm
Museum London, London, Ontario, bequest of Mrs. Frances Barwick, Ottawa, Ontario, 1985 (85.A.17)

48. (p. 100) *Reflections, Bishop's Pond*, August 22, 1920, M&S 201.112
watercolour over graphite on wove paper (watermark: "J Whatman"), 38.4 × 56.1 cm
Art Gallery of Ontario, Toronto, gift from the J.S. McLean Collection, Toronto, 1969, donated by the Ontario Heritage Foundation, 1988 (L69.45)

49. (p. 112) *Pink Reflections, Bishop's Pond*, August 24, 1920, M&S 201.113
watercolour over graphite on wove paper (watermark: "J Whatman"), 37.7 × 54.7 cm
National Gallery of Canada, Ottawa, gift from the Douglas M. Duncan Collection, 1970 (16128)

50. (p. 113) *Dark Shore Reflected, Bishop's Pond*, c. October 1920, M&S 201.130
watercolour over graphite on wove paper, 36.8 × 54.5 cm
The Thomson Collection (PC-265)

51. (p. 118) *In the Cabin on the Mountain I*, c. March 26, 1921, M&S 202.21
watercolour over graphite on wove paper, 38.5 × 56.3 cm
Collection of Greg Latremoille, Toronto

52. (p. 94) *Camp Porch*, September 7, 1921, M&S 203.22
watercolour over graphite on wove paper, 39.4 × 41.6 cm
Art Gallery of Ontario, Toronto, gift from the McLean Foundation, 1960 (59/36.1)

53. (p. 116) *Across the Lake I*, October 4, 1921, M&S 203.30
watercolour over graphite on wove paper, 39.6 × 56.9 cm
National Gallery of Canada, Ottawa, gift from the Douglas M. Duncan Collection, 1970 (16427)

54. (p. 95) *Porch by the Lake*, October 12, 1921, M&S 203.31
watercolour over graphite on wove paper, 38.8 × 48.6 cm
Milne Family Collection

55. (p. 92) *Verandah at Night IV*, August or December 1923, M&S 205.9
watercolour over graphite on wove paper, 39.6 × 56.5 cm
Art Gallery of Hamilton, Hamilton, Ontario, gift from the Douglas M. Duncan Collection, 1970 (70.86.29B)

56. (p. 88) *Lanterns and Snowshoes (Interior of Tea-House)*, September 4, 1923, M&S 205.12
watercolour over graphite on wove paper (watermark: "J Whatman"), 38.5 × 55.0 cm
Milne Family Collection

57. (p. 97) *Glenmore from under the Porch*, September 26, 1923, M&S 205.18
watercolour over graphite on wove paper, 38.1 × 55.6 cm
Private Collection

58. (p. 117) *Reflections, Glenmore Hotel*, October 1923, M&S 205.22
watercolour over graphite on wove paper (watermark: "J Whatman"), 28.0 × 39.2 cm
The British Museum, London, England, purchased 1990 (1990-3-3-42)

59. (p. 122) *House of Commons*, November 7, 1923, M&S 206.3
watercolour over graphite on wove paper, 39.0 × 55.7 cm
National Gallery of Canada, Ottawa, gift from the Douglas M. Duncan Collection, 1970 (16438)

60. (p. 120) *Parliament Hill from Hull*, December 1923, M&S 206.8
watercolour over graphite on wove paper, 36.9 × 54.6 cm
Art Gallery of Ontario, Toronto, gift from the J.S. McLean Collection, Toronto, 1969, donated by the Ontario Heritage Foundation, 1988 (L69.42)

61. (p. 123) *Old R.C.M.P. Barracks II*, January 1924, M&S 206.12
watercolour over graphite on wove paper, 39.1 × 56.4 cm
National Gallery of Canada, Ottawa, purchased 1924 (3017r)

62. (p. 124) *Black House I*, April 1925, M&S 207.24
watercolour over graphite on wove paper, mounted on paper card, 38.5 × 56.3 cm
Art Gallery of Ontario, Toronto, gift from the Douglas M. Duncan Collection, 1970 (70/88)

63. (p. 125) *Still Life with Black Bottle*, April 1925, M&S207.26 watercolour over graphite on wove paper, 26.7 × 37.5 cm Victoria University in the University of Toronto, gift from the Douglas M. Duncan Collection, 1970 (VUC1987.100.12)

64. (p. 126) *Vinegar Bottle I*, 1937, M&S305.34 watercolour over graphite on laid paper, 40.7 × 53.3 cm Collection of Greg Latremoille, Toronto

65. (p. 127) *Over the Rock I*, 1937, M&S305.49 watercolour on wove paper, 35.4 × 50.7 cm Milne Family Collection

66. (p. 130) *Goodbye to a Teacher III*, 1938, M&S306.80 watercolour over charcoal on wove paper (watermark: "J Whatman"), 38.2 × 56.3 cm Milne Family Collection

67. (p. 131) *Waterlilies in the Cabin*, 1939, M&S306.111 watercolour over graphite on wove paper, 35.5 × 50.8 cm National Gallery of Canada, Ottawa, gift from the Douglas M. Duncan Collection, 1970 (16431)

68. (p. 134) *Eggs and Milk*, March 24, 1940, M&S401.55 watercolour over graphite on wove paper (watermark: "RM Fabriano"), 38.0 × 51.0 cm Milne Family Collection

69. (p. 135) *Window on Main Street*, November–December 1940, M&S403.1 watercolour over graphite on wove paper (watermark: "RM Fabriano"), 37.9 × 50.8 cm National Gallery of Canada, Ottawa, gift from the Douglas M. Duncan Collection, 1970 (16518)

70. (p. 145) *Snow in Bethlehem II*, August 11, 1941, M&S403.59 watercolour and ink over charcoal on wove paper (watermark: "J Whatman"), 39.1 × 55.9 cm Art Gallery of Ontario, Toronto, purchased 1942 (2595)

71. (p. 138) *Bay Street at Night*, November 4, 1941, M&S403.91 watercolour over charcoal on wove paper, 38.8 × 53.7 cm Collection of the Art Gallery of York University, Toronto, gift of the Frances Barwick Estate, Toronto, 1985 (85.2)

72. (p. 139) *Prints*, c. March–April 1942, M&S403.108 watercolour over graphite on wove paper (watermark: "J Whatman"), 37.5 × 55.9 cm Milne Family Collection

73. (p. 142) *The Saint IV*, June–September 1942, M&S403.121 watercolour over graphite on wove paper, 38.3 × 55.2 cm National Gallery of Canada, Ottawa, purchased 1948 (4878)

74. (p. 148) *Resurrection III*, 1943, M&S404.43 watercolour over charcoal on wove paper (watermark: "J Whatman"), 38.1 × 55.9 cm Art Gallery of Ontario, Toronto, gift from the Douglas M. Duncan Collection, 1970 (70/94)

75. (p. 149) *Ascension XV*, c. January–March 1944, M&S404.81 watercolour over charcoal on wove paper (watermark: "J Whatman"), 56.0 × 37.9 cm Collection of Jim Coutts

76. (p. 150) *King, Queen, and Jokers V: It's a Democratic Age*, 1943–44, M&S404.93 watercolour over charcoal and graphite on wove paper (watermark: "J Whatman"), 55.6 × 76.7 cm Art Gallery of Ontario, Toronto, purchase 1945 (2781)

77. (p. 143) *Picture on the Wall*, c. November 1945, M&S405.82 watercolour over graphite on wove paper, 36.5 × 54.6 cm Collection of Mr. and Mrs. J. Hill, Vancouver

78. (p. 146) *Glass Candlestick*, June 1946, M&S406.28 watercolour over charcoal on wove paper (watermark: "J Whatman"), 37.2 × 54.9 cm Collection of Mira Godard

79. (p. 147) *Flowers and Candlesticks*, July 1947, M&S406.111 watercolour over charcoal on wove paper (watermark: "J Whatman"), 36.3 × 54.7 cm

Collection of Mucie and Ron Kaplansky

80. (p. 152) *Storm over the Islands I*, November 10–20, 1951, M&S503.21 watercolour over graphite on wove paper, 27.6 × 37.2 cm Collection of the Art Gallery of Windsor, Bequest of Frances Duncan Barwick, 1985 (85.64.1)

81. (p. 152) *Storm over the Islands II*, November 10–20, 1951, M&S503.22 watercolour over graphite on wove paper, 27.3 × 37.2 cm Collection of the Art Gallery of Windsor, Bequest of Frances Duncan Barwick, 1985 (85.64.2)

82. (p. 153) *Storm over the Islands III*, November 10–20, 1951, M&S503.23 watercolour over graphite on wove paper, 28.0 × 36.9 cm Collection of the Art Gallery of Windsor, Bequest of Frances Duncan Barwick, 1985 (85.64.3)

83. (p. 153) *Storm over the Islands IV*, November 10–20, 1951, M&S503.24 watercolour over graphite on wove paper, 28.0 × 36.9 cm Collection of the Art Gallery of Windsor, Bequest of Frances Duncan Barwick, 1985 (85.64.4)

84. (p. 151) *Tempter with Cosmetics V*, 1952, M&S503.74 watercolour over graphite and charcoal on wove paper, 55.8 × 75.2 cm Collection of Agnes Etherington Art Centre, Kingston, gift of the Douglas M. Duncan Collection, 1970 (AE 13-079)

Selected Bibliography

Manuscript Sources

Massey Papers, Massey College, University of Toronto

Illustrated letter from David Milne to Alice and Vincent Massey, August 20, 1934

Milne Family Collection, Ottawa

David Milne, "Art: Monet," draft essay, 1940s, "Notes for an Autobiography," 1947

Milne Papers, Library and Archives Canada, Ottawa

Correspondence between David Milne and James Clarke

Blodwen Davies, "Interview with James Clarke," 1961

Published Sources

Carney, Lora Senechal. "David Milne: 'Subject Pictures.'" *Journal of Canadian Art History* 10, no. 2 (1987): 104–19.

Frye, Northrop. "David Milne: An Appreciation." *Here and Now* (May 1948): 47–56. Reprinted in Frye, *The Bush Garden: Essays on the Canadian Imagination*. Toronto: Anansi, 1971, 203–206.

Jarvis, Alan H. *David Milne*, exh. cat. Ottawa: National Gallery of Canada, 1955.

_____. *David Milne*. vol. 3 of *The Gallery of Canadian Art*. Toronto: Society for Art Publications/McClelland and Stewart, 1962.

Milne, David, Jr., and Nick Johnson, eds. "David Milne: His Journal and Letters of 1920 and 1921, a Document of Survival." *Artscanada* 30, no. 3 (August 1973): 15–55.

Milne, David, Jr., and David P. Silcox et al. *David B. Milne: Catalogue Raisonné of the Paintings*. 2 vols. Toronto: University of Toronto Press, 1998.

O'Brian, John. *David Milne and the Modern Tradition of Painting*. Toronto: Coach House Press, 1983.

Owens, Gwendolyn. *The Watercolours of David Milne*, exh. cat., Ithaca, New York: Cornell University, 1984.

Silcox, David P. *Painting Place: The Life and Work of David B. Milne*. Toronto, Buffalo, N.Y., and London, England: University of Toronto Press, 1996.

Thom, Ian M., ed. *David Milne*. Vancouver: Vancouver Art Gallery and McMichael Canadian Art Collection in association with Douglas & McIntyre, 1991.

Tovell, Rosemarie L. *Reflections in a Quiet Pool: The Prints of David Milne*. Ottawa: National Gallery of Canada, 1980 (catalogue raisonné of the drypoints)

Photo Credits

Index